ROBIN DARWIN

VISIONARY EDUCATOR AND PAINTER

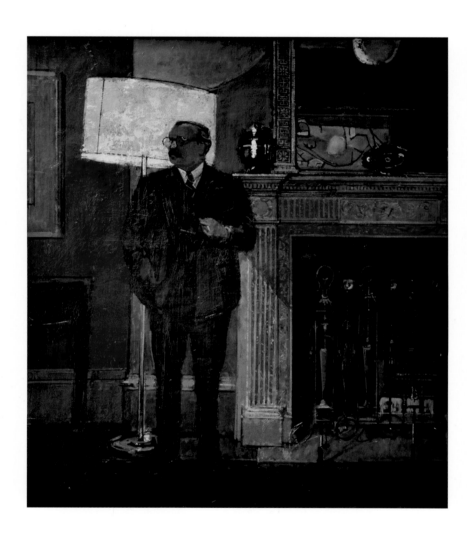

ROBIN DARWIN

VISIONARY EDUCATOR AND PAINTER

HENRIETTA GOODDEN

UNICORN PRESS LTD

First published in 2015
by Unicorn Press Ltd
66 Charlotte Street
London W1T 4QE

www.unicornpress.org

Copyright © 2015 Henrietta Goodden
Introduction © 2015 Sir Christopher Frayling
Designed by Camilla Fellas
Printed and bound in China for Latitude Press

ISBN 978 19100 65396
A Catalogue record of this book is available from the British Library

Endpapers: reproduced from notes in Robin Darwin's sketchbook, undated
Frontispiece: Ruskin Spear: Portrait of Sir Robin Darwin, oil on board, 1961

CONTENTS

FOREWORD

ROBIN DARWIN'S TENURE at the Royal College of Art marks a significant juncture in the institution's 177 year history, creating what Darwin himself described as a ' school of quite a different character'.

Ironically, this educator and reformer never himself completed a degree, dropping out of Cambridge and then the Slade. Nevertheless, he possessed a strong, innate set of convictions about what should be taught in British art schools. And his unflinching force of character and energy dragged a dodo, with no evident mission, into a purposeful phoenix: a highly networked, autonomous university, realigned to the founding vision of the Government School of Design in service to industry, with a strong research remit, focussed exclusively on postgraduate provision.

Henrietta Goodden expertly and entertainingly tells the story of Darwin the man, artist, and administrator, with all of its kinks and paradoxes: the snob and nepotist, who nevertheless had a real skill for hiring talent; the 'eighteenth-century clubman' who recognised that twentieth-century Britain desperately lacked the skills of the industrial designer, engineer, and architect, and that these disciplines could only benefit from a close communion with the fine arts.

Darwin's influence reached beyond the RCA, to shape and inform art and design policy across a swathe of regional art schools, government reports and agencies, national events and celebrations. The alumni of the Darwin years are a roll call of Britain's most distinguished artists and designers, and the anecdotes from that era still inform discussion here at the RCA; it was perhaps his capacity for myth-making, his love of theatrics and ceremony that have made the RCA still, today, so fond of its traditions and its folklore.

Dr Paul Thompson
Rector, Royal College of Art
2014

PREFACE

O N HEARING THAT I WAS RESEARCHING THE LIFE OF ROBIN DARWIN a close relative of mine remarked, with a tone of dismissal, that he could think of several Darwins far more influential and engaging than the subject of this biography. His comment endorsed for me the fact that Robin Darwin, if not misunderstood, has been at least undervalued by those with a limited knowledge of his achievements.

It is commonly known that Darwin was formidable as a leader, often impossibly dictatorial, but few realise how resolutely loyal and encouraging he remained to his peers, his students and those close to him. His blustering exterior and his spirited approach to life were a mask for a gentleness and a generosity which were manifested not only in his personal relations but also in the quality of his painting, which he neglected at times in the interests of encouraging true artistic ability in others.

The name Darwin is synonymous with scientific discovery, but many of his forbears had, like him, artistic talents. His great-grandfather was Charles Darwin, and Charles's own grandfather, the exceptional Erasmus, was not only a physician but a philosopher, a botanist and a poet. Successive generations of Darwins found that they could express themselves naturally and easily in writing and, often, also in drawing, painting and music. Charles's mother was Susannah Wedgwood of the Potteries, daughter of the great Josiah, and Charles married her niece Emma Wedgwood so reinforcing the extraordinary genetic bond between these two exceptional families.

When it came to marriage, the Darwins had a clever knack of choosing partners from other distinguished dynasties. In addition to the recurring union with the Wedgwood family, Robin Darwin's cousins bore the surnames Keynes, Vaughan-Williams and Cornford; his aunt was the artist and writer Gwen Raverat and the name of Huxley was also linked through Wedgwood-Benn connections. His own father Bernard was a writer, as were Bernard's half-sister and several of his cousins. Bernard was also a champion golfer – in his own words 'an odd sort of fancy to spring up in my particular family… I think it was part of my perverseness in youth to try to be as little like a Darwin as possible.' (It is a little-known fact that his grandfather Charles, as a teenager, much preferred sport to academic study). One of Bernard's memories was the 'anti-Darwin League' which sprang up amongst some of those who had married into the family. Its members' mission was to counteract 'a certain solemnity on the subject of the family abilities…to some people just a thought oppressive.'

Pride in Darwin achievements was not to be taken lightly and was almost a religion in this mainly agnostic clan.

Robin Darwin, like his father, strayed from what had been considered the family norm. Although most of his adult life was dedicated to educating others, he shirked his own education once he was able to choose. He had many Darwinesque characteristics but he was happy to be seen neither as an academic nor an intellectual, preferring to work at bridging the gap between establishment and nonconformism, tradition and the future, technology and its need for the support of art. In the latter he must surely have followed the credo of his Wedgwood ancestors whose achievement illustrates so perfectly the successful union of art and industry.

The challenge of being born with a surname of such renown was not lost on Darwin, and although he often found the expectations of a great family a burden, he made assiduous use of his distinguished connections to achieve many of his aims. His resolute belief in the 'old-boy' network and his thrill at being recognised with the highest honours was, however, tempered by a far from conservative element of free-spirited creativity passed on to him by his mother's side of the family; his ability to combine highly responsible academic and administrative jobs with his skill as an artist was unusual, perhaps almost unique.

Learning about Robin Darwin has proved for me, as a former tutor at the Royal College of Art, to be an overdue introduction to a man about whose life I previously knew too little. The quest to find out the details has helped in my understanding of this complex individual whose name has often elicited a robust response, either dismissive or admiring. Nobody's opinion of him has been neutral, and this in itself is a comment on his character and achievements. My hope is that this evaluation will help to establish and endorse the reputation of one of the 20th century's most visionary educators.

ACKNOWLEDGEMENTS

I AM ENORMOUSLY GRATEFUL to Angela Macfarlane for offering me the privilege of researching and writing this biography of her stepfather Robin Darwin

This book has been produced with the generous support of the following:

The Royal Commission for the Exhibition of 1851

Sir Christopher Frayling

Dr Paul Thompson, Rector, the Royal College of Art

The Royal College of Art Archive

The British Library
Cambridge University Library
Durham University Library
Eton College Archives
Leamington Spa Art Gallery
 and Museums
The National Archives
The National Art Library
The Perse School Archives

The Royal Air Force Museum, Hendon
The Royal College of Art Library
The Royal Society of Arts Archive
Slade School Archives
University of Brighton Design Archive
University of Cambridge, Trinity
 College Library
Watford Boys' Grammar School

Special thanks to Neil Parkinson, Philip Trevelyan and Lesley Whitworth

Pat Albeck, Alan Bennett, Madeleine Bessborough, Sir Peter Blake, the late Keith Cunningham, James Dunnett, Nicholas Frayling, Naomi Games, David Gentleman, Karen Goldie-Morrison, Juliet Goodden, Clifford Hatts, the late Frank Height, Ian Hessenberg, Nicky Hessenberg, Virginia Ironside, Cathy Johns, the late Elsbeth Juda, Angela Kenny, Stephen Keynes, Patrick Kidner, Jonathan Kingdon, Teresa Kosmider, Joy Law, Christopher Lewis, Liz Leyland, Frances Loyen, Fiona MacCarthy, Conall Macfarlane, Darlene Maxwell, Rosaleen Mulji, Jeremy Myerson, Twig O'Malley, Claire Pajaczkowska, David Queensberry, Josh Ritchie, Alex Seago, Peyton Skipwith, Emma Smith, Susannah Trevelyan, Natalie Wheatley, Dinah Wood, Carola Zogolovitch.

PICTURE CREDITS

Images are reproduced by kind permission of private collections with the exception of the following:

Cambridge University Library: 26, 27, 28, 29 upper

Darwin Family Archive: 2, 3, 8, 9, 15 left, 18, 19, 30, 31, 33, 39, 45, 53, 58, 60, 61 lower, 62-65, 72, 74, 77, 142, 173, 174 upper, 175, 192, 201, 202, 205

Design Council/University of Brighton Design Archives: 105

The Estate of Richard Guyatt: 57, 83, 108, 122, 135, 140, 141 lower, 196

Imperial War Museum: 84

Leamington Spa Art Gallery and Museums: 70

Royal Air Force Museum London: 82

Royal College of Art Archive © Royal College of Art: 36, 38, 49, 50, 67, 69, 86, 87, 94, 98, 101, 110, 116 lower, 118, 119, 124, 131, 132, 139, 154, 155, 159, 160, 163, 164 upper, 167 lower, 180, 184, 186, 189, 190, 193, 194, 200, 203, 212

Royal College of Art Collection © Royal College of Art: 78, 89, 113, 117, 137, 138, 150, 152, 162, 167 upper, 178 lower

Royal College of Art Collection © The Estate of Edward Bawden: 178

Royal College of Art Collection © The Estate of Ruskin Spear: front cover, frontispiece, 157

Sir Hugh Casson Ltd © Hugh Casson: 85

Tate Images © Tate London 2013: 125

INTRODUCTION

ONLY MET ROBIN DARWIN ONCE – a memorable encounter which is cited on the last page of this book – but he cast a larger than life-sized shadow over the Royal College of Art for the next two decades or more, so I felt close to him in spirit every working day. The Professors who dated from his era and stayed on, would sometimes ask in meetings "what would Robin have done?". There was a photograph of him – in characteristic chalk-stripe suit and spectacles, with the bristles of his moustache still looking like a new broom, clutching a cigarette and looking bullishly at the camera – outside the Rector's office, and it remained there throughout the regimes of his successors Lord Esher, Richard Guyatt and Lionel March. The photograph was the work of John Hedgecoe, head of the course which Darwin had founded, somewhat reluctantly, towards the end of his tenure. Hedgecoe used often to recall that Darwin had asked him to wear a necktie in the Senior Common Room, but in the end had settled for a cravat by special dispensation: the heated debates between the two men about whether Photography deserved to be taught in a department in its own right, and if it did, whether it deserved the dignity of a Professor in charge of it, became legendary; for Darwin, Photography was a subject at best, not a "discipline". When officials from the Department of Education (and its equivalents) were sighted having lunch in the Common Room, some of the old Darwin hands would mutter "Robin would never have allowed it", and when a younger member of the tutorial staff had the nerve to suggest that the governance of the College could perhaps be more democratic and up-to-date, Richard Guyatt was heard to reply "Robin must be spinning". There was the long-standing tradition that the portrait of Robin Darwin standing by the classical fireplace of the old Common Room in Cromwell Road, painted by Ruskin Spear in 1961 shortly before the opening of the new Kensington Gore building, would always be displayed opposite William Scott's semi-abstract Reclining Nude in grey and black, because the Scott was reflected in the ornate mirror which was featured in the portrait: Darwin had his back turned to the mirror – and thus to the Scott – which was said to represent his attitude as a painter to new-fangled modernism. I remember Lord Esher, shortly after his arrival as Rector, in 1973, giving a speech to the assembled staff about how talk of 'the Darwin era' could if we were not careful lead to complacency at a time of rapid social and technological change. Paternalism, he said, had now become out of fashion. "The greater the prestige, the more ignominious the possible tumble". He made the analogy with Winston Churchill in peace-time. It was, we felt, a questionable way to launch a new regime.

But this was not just about an eccentric, big personality with a famously short fuse and a taste for slightly ridiculous pageantry, the man of whom a reporter for the *Sunday Times* observed in March 1955: "It would not be easy to guess Mr Darwin's profession – or, from his face alone, the age in which he lives… The clothes give little away (a sporting Archdeacon in mufti?) and the peremptory voice was once likened to that of 'an inflammable colonel of Marines'." It was about much more than that. For it was Robin Darwin who, more than anyone else, created the recognisably modern Royal College of Art. The College's structure of specialised Departments ("narrow and concentrated fields" he called them) within over-arching Schools – each with their own style of interaction between staff and students – with an end to the old generalised categories of Art and Design as well as to the RCA's responsibilities for teacher training. The College's own teaching – by active and preferably well-networked practitioners who were also given the space to develop their own personal work. Its close connections with the professional worlds of art and design – "a two-way traffic", he hoped. Its independence as an institution – keeping the bureaucrats at bay, through sheer force of personality and, of course, through family connections. Its national and international reputation – through high-profile publications (the Lion and Unicorn Press was his idea), commissions, exhibitions and public events. Its brand – although brands were not called that yet – with Phoenixes and centred crests and redesigned coats of arms on everything. And its students – selected from undergraduate courses for their potential rather than for their slick, already-resolved ideas which might have nowhere left to go. All of these dated back, directly or indirectly, to Robin Darwin's reforms of 1948-1949, to the Report he'd written for the Training Committee of the Council of Industrial Design, to the first ten years of his Principalship and to the many ex-students who did indeed carry the message to undergraduate art schools through their full- and part-time teaching. They also arose from his Napoleonic approach to senior appointments. As Darwin wrote in 1964, with his usual mix of robustness on the surface, deep commitment beneath:

"Not long ago, an African postgraduate who was preparing his thesis asked me how to run an educational institution successfully. I replied briefly that this was a perfectly simple proposition – all you had to do was to appoint the best senior staff in the country and then leave them to get on with their job without interference. I said nothing, of course, about those wayward currents of experience which throw people together and seem in retrospect to have made a pre-ordained pattern of our lives".

In his case, the "wayward currents of experience" moved him in the direction of – among others – his extended family and his colleagues from Camouflage with whom he'd worked at close quarters during the Second World War.

He came from a powerful Cambridge dynasty and – as he said in his inaugural lecture as Principal, 'The Dodo and the Phoenix' – one of his ambitions was to transpose Cambridge academic and community values as he saw them onto art and design education, for the first time in its long and volatile history. He concluded the lecture with these ringing words, as so often in slightly Biblical language:

"As I came back on a winter's evening from children's parties through the great court of Trinity or through King's, the windows of the chapel would still be glowing from the candles lit for Evensong, with lights twinkling in the fellows' rooms upon all sides.The power that has kept them shining day in, day out, for six centuries or more, depends on the deep impulse which makes mature men come together in one place and associate with one another in learning and research, and in the common pursuit of ideas more important than themselves. And just because these ideas are transcendent, most true scholars feel intuitively the need to impart them to a younger generation and find refreshment and inspiration in so doing. This is the spirit which hallows all universities and gives them their timeless traditions, and I believe something of this spirit has begun to move within the Royal College of Art."

This wasn't exactly an educational philosophy, and his own experience as an undergraduate did not chime with it at all. He did not have any time for abstract speculations about the nature and purposes of art and design education. But it arose from something deep within his personality and over the years it certainly created an atmosphere of collective energy, and fierce loyalty to "the College"as he called it, which was just what the institution needed during the post-war period. It was an atmosphere that the students picked up as well: many have written or spoken about it.

The title of his inaugural was characteristic too. A sly reference to his great-grandfather, it also carried the implication that pre-Darwin the flightless Royal College of Art was on the verge of extinction – which succeeded in offending just about every other art school in the country (which he sometimes called "feeder colleges"), not to mention the staff who had survived the transition. The Phoenix was a familiar post-war symbol: out of the ashes of the World War would arise the ever-renewing bird of creativity. Coventry Cathedral was fond of using it. In Darwin's case, he seems to have thought of the College as a Phoenix in search of an arsonist – and he would be the man to light the fuse.

David Hockney's celebrated 1962 print of a defaced College diploma certificate centres on an ambiguous visual image of Robin Darwin, with his spectacles, bushy moustache and Old Etonian tie, his hand beneath the shoe of one of the Painting students. The question is: is Darwin supporting the student, or is he pushing the student against the Royal Coat of Arms at the top of the

diploma, so that he is bumping his head? Is the Principal creating an environment of encouragement for creative young people – or is he more concerned with the upward social mobility of the College, the 'R' in RCA? The student in the print responds to this ambiguity by somehow growing two faces, one bumping into the crest, the other covering the word 'art'. Hockney brilliantly visualises the tension at the heart of Robin Darwin's project, between an establishment College and its often radical inhabitants: there is admiration from David Hockney, but also resistance. Hockney once said that the best kind of art education emerged from the collision between fresh ideas and establishment ones: the cardinal sin in an art school was not to have strong convictions, to agree with everything – and Darwin could never be accused of that. The Principal, for his part, wrote of the generation of 1959-62 of which Hockney was a celebrated part: "[The student] is less easy to teach, because the chips on his shoulders, which in some cases are virtually professional epaulettes, make him less ready to learn". Always "him", of course.

By the time Robin Darwin retired, in 1971, the education scene had become so much more complicated than it had been when he took over in 1948. The wayward currents of experience were flowing towards increasing official Whitehall scrutiny of postgraduates in the name of accountability (another newly fashionable word); towards the post-1968 students not taking anything on trust; towards the absorption of small art schools into big polytechnics; towards a widespread move by fine artists away from the easel and by designers away from pencils and notepads and good-taste typography; towards a new emphasis on social responsiblity at a time of economic recession – with design for need taking over from design for profit. The end of deference and the beginning of equal opportunities. Young tutors were no longer remotely interested in whether or not they were excluded from a 'Painter's Table' in the Senior Common Room. All of which led to a new atmosphere of uncertainty in the Royal College of Art in the early 1970s. As Sir Robin Darwin wrote in his final year: "I personally say every night the opening words of the 'Nunc Dimittis' – Lord, now letteth thou thy servant depart in peace". This was not a world to which he wanted to belong. It did not suit his temperament.

The Bauhaus lasted thirteen years – a few of its emigré alumni taught at the RCA in the Darwin years. The heyday of Black Mountain College lasted just over twenty years. The Darwin reforms at the Royal College of Art – suitably modified, adapted, revitalised after the anxieties of the seventies – have lasted over sixty years and counting, the longest continuous experiment in the history of art and design education, anywhere. Henrietta Goodden's remarkable book – the first-ever biography of Robin Darwin – views this complex man through the prisms of his family background (a blessing and a curse), his patchy experience

of education, his wartime work, his personal commitment to figurative painting, his taste for fine living and travel, his distinctive mix of bombast, sensitivity and shyness, and his good fortune to find himself in 1947 in exactly the right place at exactly the right time. She has succeeded in promoting her subject from a footnote in the final chapter of books about his forbear Charles, to a name above the title. Which is where he certainly deserves to be.

Sir Christopher Frayling

Former Rector of the Royal College of Art
December 2014

1: FAMILY BACKGROUND

O N A LATE SPRING MORNING IN 1910, a boy was born in a tall bay-fronted grey brick house in Chelsea. The five female servants at 32 Elm Park Gardens bustled about with discreet respect, happy that a brother had arrived for two-year-old Ursula. Their master and mistress, Bernard and Elinor Darwin, had produced a son who would grow up to honour and endorse the renown of the great family name. The date was 7 May, and the boy would be christened Robert Vere Darwin.

It is unnecessary to explain in detail the provenance of the family surname and the baby's illustrious origins on his father's side. What is appropriate as a prologue, however, is to explore the background of his immediate forbears, with the intention of understanding an individual whose preoccupations and attitudes were so very clearly influenced by strong characteristics from the two sides (distinctly different if both mildly nonconformist) of his notable parentage. The exceptional personality who emerged, while he directed his own fairly turbulent journey through life, owed much to the considerable cultural heritage he was able to absorb from both branches of his family.

The child's father, Bernard Richard Meirion Darwin, was the son of Francis Darwin (1848-1925), the third son and seventh of the ten children of the celebrated biologist Charles Darwin and his wife Emma Wedgwood, daughter of Josiah Wedgwood II of the great pottery dynasty. The two families were inextricably interlinked: Charles Darwin's grandfather, Dr Erasmus Darwin, had been a close friend and advisor to Josiah Wedgwood I; they had both been members of the informal but formidable Midlands group of mid-18th century intellectuals and industrialists known as the Lunar Society. Charles's mother Susannah was a Wedgwood, and his older sister Caroline married Josiah Wedgwood III. Continuing the Darwin family's dedication to the cause of scientific discovery, Francis Darwin first studied mathematics at Trinity College, Cambridge, before changing to natural sciences and becoming a botanist, frequently assisting his father with experiments on plant movements. In 1874 he married Amy Ruck (born 1850) who tragically, two years later, died at the family home, Down House in Downe, Kent, four days after the birth of their son Bernard on 7 September 1876.

Francis's intense grief at Amy's death is recorded by his father in a letter to a close friend and fellow botanist Joseph Hooker: "I never saw anyone suffer so much as poor Frank. He has gone to North Wales to bury the body in a little church-yard amongst the mountains". Amy Ruck's father, a Kentish landowner

Studio photograph of Amy Ruck c.1860.

Amy Ruck in her wedding gown, 1874.

Mr and Mrs Ruck (back row right) with Amy (middle row left), her brothers, and Francis Darwin (front, second left) c.1870.

Charles Darwin on the verandah at Down House, 1881.

with an estate near Sittingbourne, had on marriage settled at his wife Mary Anne's home in the village of Pantlludw in the Merioneth hills. Early in their married life the couple enjoyed prosperity, looking after and benefiting from the hill-farms on their large estate, which also included a remote abandoned slate quarry. However, the decline of property values in both Kent and the Welsh mountains eventually made life less prosperous for them, and Mary Anne's legendary generosity to many of their neighbours, tenants and friends did little to help an already straitened financial situation.

Francis Darwin became very close to his mother-in-law, and during the year after Amy's death began to write regular letters to her about little Bernard's progress. Because of his frequent absences in Germany to work in the laboratories of Wurtzburg and Strasbourg (then annexed to the German Empire), he was a doubly devoted father when at home with his small son. After Amy's death, Francis moved into his parents' home to live with them and his unmarried sister Bessy, and in his absences little Bernard grew up with his grandparents and maiden aunt. He had no idea that his grandfather was 'more important than anyone else's grandfather' and enjoyed his company until he was five years old, when Charles Darwin died in 1882. Emma, Bernard's grandmother, then moved from Downe to be near family in Cambridge, finding a large property surrounded by 'great park-like meadows'[1] on the Huntingdon Road where Francis and his brother Horace both proceeded to build their own houses, respectively *Wychfield* (the site of which now houses graduates of Trinity Hall) and *The Orchard* (latterly New Hall and now Murray Edwards College).

Down House, kept in the family, became a summer escape for Darwin holidays, magical for the children if a little cut-off for some of the more urbane adults, particularly those who had married into the large and unorthodox family.

According to Bernard's cousin, Gwen Raverat, 'Uncle Frank' was charming: "…the musician, the writer, the artist, in a family which might well have been called benevolently Philistine."[2] Although many Darwins would openly admit to knowing and caring little about the arts, those involved deeply in the sciences still showed a sense of style, proportion, of passion for their subject and the importance of perfection in their work. This attention to detail may have inspired a poem that Bernard later wrote:

> *Fussy people Darwins are*
> *Who's the fussiest by far?*
> *Several aunts are far from calm*
> *But Aunt Etty takes the palm.*

They had little feeling for philosophy or religion although tolerant of faith in others, and were single-mindedly honest in their approach to art and literature. Gwen Raverat records that in spite of these limitations they did have 'good taste' and though conservative the current appearance of the interior of Down House, much as it was in Charles Darwin's day, suggests less of the typical, rather oppressive Victorian ideal and more of an interest in space, light and air.

Francis loved music and played wind instruments including the flute, the oboe, the bassoon (with which he sometimes serenaded his father's earthworms in order to observe how their behaviour affected soil conditions) and the tenoroon (tenor bassoon) which he bought at the Great Exhibition of 1851. He wrote and drew beautifully. Though he had an 'enchanting' sense of humour the shock of Amy's death increased the fits of melancholy he had experienced since childhood, and he often slipped into deep pits of depression. He loved his work and was the only one of Charles Darwin's sons who was a field naturalist, becoming his father's assistant at Down. When he returned to Cambridge after his father's death he worked in the Botany School, although was not sufficiently ambitious to stand for Professor, modestly preferring the post to go to a younger man who needed it more.

From May 1877, whenever Francis was home, he sent frequent and very touching reports on young Bernard's progress to Mary Anne Ruck. The letters, a compassionate and finely-detailed paternal account of a boy growing up, were eventually privately published as *The Story of a Childhood*.[3] They show the fondness and humanity with which his grandparents, uncles and aunts surrounded him at Down House, a Victorian child integrated to an unusual degree into an adult world:

June 8 – Admiral Sullivan of the Beagle [the ship which took Charles Darwin on his voyages of scientific research] *came to Down. He took B with exactly the right mixture of boldness and tenderness, so that he didn't mind.*

June 19 – B… is dreadfully sweet. He won't stop with anyone if I am near, which is aggravating for them, but not for me…He has an egg for dinner now which pleases him.

July 23 – Anniversary of our marriage. B's tooth no. 5 nearly through.

(Undated) – I stood him on a pedestal in the hall, and my father pretended to be frightened of him when he roared.

At the age of three years, Bernard's character began to show, that of a normal if solitary little boy. He started to invent imaginative games, peopled by characters with highly inventive names, and he loved 'poentry', creating rhymes for himself. Francis's letters to Bernard were often illustrated with beautiful coloured drawings, those of the German military being particularly well-received, and these enhanced Bernard's passion for miniature soldiers. He staged complicated battle scenarios with sets of metal musketeers whose uniform was improved with real fabric cloaks added by Francis when he was home. Bernard also invented military games of his own, based in the secret sentry box constructed by the family butler and hidden behind shrubbery in the garden.

Feb 1 – It is very odd what dull things he likes: he will be interested in absolutely any kind of narrative with no events in it.

Aug 11 – the most important quality about anything is always its colour.

The great understanding shown by his family meant that he did not feel isolated or too lonely. His grandparents made sure that he was invited to meet other children, and there were often invitations to games or tea-parties with various other Cambridge families (the young Bonham-Carters, along with Wedgwoods and other branches of the Darwin dynasty) but the diaries suggest that Bernard may have preferred his own or the grown-ups' company to that of other children. He enjoyed drawing and painting, and was praised at the age of 3 by the head of the College of Surgeons who said he drew '*much better than most children of his age*'.

Nov 16 [age 3 years 2 months] – *In trousers he looks very nice, but dreadfully old.*

ings; he told me a long rigmarole about the guinea fowls that were coming "roaring after us"; he said they "eat Zulus and door-handles and neckties, what people don't want—and that's all." He is much delighted with our little house (in the clouds) with a green door and a brass plate with Dr Ubbadubba and Dr Dada on it. We have a large household of animals, all of which are named. Tadpole the dog, because he has a big head, and

Harlequin the cat, which he calls "Harlepin," etc., etc. We sit in the boat rocking and I tell him all about the creatures. At last the boat reaches the shore, and he mounts on my back, and we gallop off to doctor Mr Slud's unfortunate girls who are whipped several times a day.

No. 57. *November* 21, 1879.—I am very glad that the little duck talks about me, and I like to hear of it very much: also about the bicycling joke. We used to draw tremendous bicycling tours with B. tumbling off, and Dada running to pick him up. [Shown in the above sketch.]

Francis's drawing of Bernard falling off his bicycle, from *The Story of a Childhood*, 1920.

A touching note from Francis to Mary Anne dated 13 September 1881, five years after Amy's death, states '*I should like B to know about his mother some day, and I should not like anybody but you to tell him.*' Although Francis never completely recovered from the tragic departure of his first love, he remarried in 1883 when Bernard was seven. His new wife was Ellen Crofts, lecturer in English literature and Fellow of Newnham College.

Francis's letters in 1884 record that Bernard began to develop a passionate interest in sport. In Bernard's own memoirs he writes that 'being a lonely little boy, a good deal the oldest of my generation' he became an avid spectator of the many sporting events attached to the University – athletes running for the college teams, cricketers on Parker's Piece, the rowing eights whom he would often see on the river. 'A kind gardener' made Bernard some miniature rugby goalposts; high-jump and hurdles took over little-used parts of the garden, and golf matches were invented taking the names of 'all dogs, cats and horses, whether our own or our relations', and adding to them either titles or surnames.

So, according to the letters:

> *June 2 – B has taken to lawn-tennis, and I see that he has a good eye.*
> *September – progress in cricket, a good bowler.*
> *Dec 6 – B very happy with new golf club – a driver cut down.*
> *Dec 11 – he hits very well.*

Bernard records that although he lived in this solitary 'odd little kingdom', quite alien from the rest of Darwin life, he was fond of reading, and interested in his lessons in which he did well. Facts about his early education are not clear, and it is likely that he had lessons privately with other Darwin children, or even individually as he was older than his cousins. When in 1886 Bernard's half-sister Frances was born he was, at the age of ten, no longer the only child. Perhaps he had always wished for a brother, for Francis quotes him as grumbling 'Hang it, I'd rather there was no baby than a girl'. It is possible that this may also reflect on the fact that Ellen was not a naturally maternal stepmother, and Bernard, understandably, must have felt neglected in the company of a new baby sister. However, there was a consolation: Bernard had gained an engaging uncle, Ellen's brother Ernest, who took an interest in his new young nephew and, even more important to a ten-year-old boy, was a well-known painter of splendid military scenes.

Gwen Raverat remarks that Ellen was very modern in her attitudes. Evidently a classic bluestocking, she smoked, cut her hair short and subscribed to the 'greenery-yallery' Arts and Crafts style of interior decoration, strangely at odds with Francis's quieter and more traditional taste. Although she was always surrounded by literary female Cambridge friends and by her precious dogs 'quite as important as the people', and although she loved her husband and their child, she generally appeared to be less than content. Perhaps, happiest in the company of academic women, she should not have given up her work at Newnham. As Raverat suggests, perhaps she 'ought to have been an early member of the Anti-Darwin League'. Throughout her life literature continued to be her passion, but her dislike of the works of Dickens must latterly have created a barrier between her and Bernard, who became an expert on the great writer and his work.

Disaster once again befell the undeserving Francis. Ellen died when she was only forty-seven, leaving him a single father for the second time. Much later in life, at the age of sixty-five, Francis was to marry again. His third wife was a beautiful widow called Florence Maitland, but she too predeceased him only seven years after the marriage. The sad fact that Francis Darwin, such a delightful and artistic father and uncle, was never able to find lasting fulfilment

Francis Darwin with Scottie (dogs were the favourite Darwin pets), c.1915.

in marriage must have contributed considerably to the compassion and the solicitous pleasure he took in observing and being involved in the development of his children, as well as that of his nephews and nieces.

In 1885 Bernard had started at The Perse School in Cambridge, which he enjoyed. Francis writes that he was '*very good*' in mathematics, but he showed aptitude in most other subjects too. Though he possessed a strong work ethic, sport continued to be the passion of his life, and Francis noted (27 Sept) 'I am sure B will be a great swell at golf some day'.

Bernard's time at the Perse was short, and in October 1886 he was sent to 'Mrs. Maclaren's school in Oxford' to study for Eton entrance. Summer Fields School, in Summertown off the Banbury road, was then in the countryside and surrounded by playing fields bordering on the River Cherwell for swimming. Many aspects of the school referred to Eton – the uniform, the games which included a version of the 'Eton Wall Game' (a kind of football), the academic structure. Summer Fields had an impeccable reputation for getting scholarships to Eton, and its boys who did not achieve this target, being thoroughly grounded and well taught in the necessary academic subjects, were easily able to find places at other distinguished schools.

Bernard was happy at Summer Fields, but he and his father missed one another hugely. The letters record '*sad without poor B*'. Nothing could equal Bernard's joy on the Sunday halfway through each term when his father would

Francis Darwin, c.1920.

take him out. Francis, staying in Headington, would send a hansom-cab which waited at half-past-eight in the morning outside the school gates, and driving through Oxford the anticipation of a day out with his father, beginning with sausages for breakfast, was an excitement which continued throughout the day until the parting and the miserable return journey in the evening.

The experience and the coaching at Summer Fields proved successful, and Bernard became an Eton scholar in the winter half [term] of 1889 when he was just thirteen. One of his anthologies notes that it was his answer to the question 'what is your favourite book' that swung the examiners' favour – his lively account of *Treasure Island* was evidently full of boyish passion and enthusiasm. Scholars lived inside the College buildings whereas non-scholarship boys ('Oppidans') had lodgings in the town in houses belonging to the school. By Bernard's own admission he was an idle pupil, his success in the entrance examination having been due to the drive and coaching of the Summer Fields staff. He coasted through his lessons in a 'superficially virtuous manner'[4] which allowed him to enjoy as much free time outside as possible, as a spectator and participant in the many available sporting pursuits. He played all the regular games (including golf) except Fives, the unique Eton game similar to squash but played without a racquet, and watched others excelling in their athletic achievements.

Bernard Darwin left Eton early, before the Sixth Form, and later may have regretted not having made the most of the contacts and friendships on offer. Although Scholarship boys felt that they were special, their life was less open and gregarious than that of the Oppidans. However, he felt privileged to have experienced the easy and grown-up relationships between Eton masters and boys,

14-year-old Bernard Darwin wearing a felt doll's cap presented to him by his cousins Frances and Gwen. Drawing by Gwen Raverat, from *Period Piece*.

the natural understanding between two generations, and the unselfconscious yet courteous manners that he felt the school engendered.

Trinity College, Cambridge, was the natural choice for Bernard. Although there were family connections with Christ's (Charles Darwin's college), Trinity had always been 'considerably infested with Darwins'[5], and two of Bernard's cousins, Ralph Vaughan Williams and Ralph Wedgwood were there in his own time. Bernard often wondered if it would have been wiser as a Cambridge boy to have gone to Oxford, but family tradition overruled any idea of a change, added to which, in the opinion of all Darwins, Oxford existed solely as an institution to be upstaged by Cambridge. He became an undergraduate in 1894 when just eighteen (which he later felt was too young) and lived in College, but always felt like a day boy because he knew the city so well. Naturally he got into the golf team, and this took up much of his time, again causing him to reflect later that he could have made more of his university experience. Although during the term he diligently attended all the necessary lectures, he felt that the sociable time that undergraduates could have in the summer vacation which 'resembled a little informal term', choosing to live in the College community without the pressures of the school term and indulging in all the summer sporting activities, was 'pleasant and good for one' and did actually engender a certain amount of work. To begin with, Bernard studied Classics, but after two or three terms

changed to Law in which he excelled. He got on well with his tutors, and was involved in the Union debating society. He enjoyed watching rugby in the winter and cricket in the summer and though not an oarsman was a member of the Third Trinity Boat Club, many of whose Etonian members rowed for Cambridge in the annual University Boat Race.

Throughout Bernard's youth, and especially after his Darwin grandmother died in his second year at Cambridge, Bernard adored visiting Mary Anne Ruck, or 'Nain'. A tall, proud and dignified woman, with a warm and generous heart, she had a prodigious memory and a 'fine flash of indignant fire' when her temper was ignited. She had a delightful sense of humour and her long, informal letters to all the family were much-valued. Nain lived in Wales at the end of a long winding slate-speckled drive in a house hiding on a mossy plateau carved out of a steep slope covered with trees and rhododendrons: a magical house which was so tiny that Bernard often slept in a curious old shed or in a little cottage at the bottom of the garden. It was an exciting place for a boy's holidays – the mysterious paths for exploring on a bicycle, the brook and the river Dovey where the family would fish, the ever-encroaching woods which gradually, owing to Nain's sympathy for trees, came to completely obliterate the beautiful view of the Dovey valley. Bernard's mother had been one of six siblings, and the eldest, his favourite Uncle Arthur, was to found the famous Aberdovey golf course when he had the idea of sinking a series of flower pots in the meadows bordering the town. This act also triggered a passion which would affect the rest of Bernard's life.

On moving to London at the end of 1897, Bernard and two young lawyer friends lived in very cheap chambers in the Temple (the rent was £90 a year, taking account of all bills including the services of Mrs Churchill or 'the Duchess' who came in every day to clean). It was a fascinating, rather Dickensian place to live and the proximity of Fleet Street and its tall luminous never-sleeping newspaper offices seemed specially romantic. Social life was busy: theatre, dinners, clubs and for Bernard, golf every weekend. He was articled to a firm of City solicitors where he passed his final law examination and gained a job in Lincoln's Inn Fields with a salary of £100 a year. Although he found life in Chambers enormously friendly and companionable the work he was undertaking began to interest him less, and he decided to train as a barrister. He finally qualified, and was called to the Bar by the Inner Temple in 1903. He enjoyed the daily involvement of listening to fine rhetoric during high-profile cases. Since Bernard's youth he had nurtured a fascination for murder trials and the reporting of them; he loved the Inner Temple Library's secret bookcase devoted to eminent criminals but he was rarely in criminal courts, his cases more likely to be complicated libel or divorce proceedings.

In July 1906 Bernard married. He had been introduced to the vivacious Elinor Monsell by his friend Willie Pike, who was married to Elinor's sister Anne. The Monsell girls, fairly recently arrived in London, and their two brothers were from a great Irish family whose original home was the grand 17th-century country house Curragh Chase, Adare, County Limerick in the west of Ireland, originally built by their ancestor John Hunt. In 1833, for reasons which are not clear, the family name was altered by Royal Warrant from Hunt to de Vere. In the mid 1830s Elinor Monsell's grandmother, Ellen de Vere, married Robert O'Brien, whose family was reputedly of direct descent from Brian Boru, High King of Ireland in the 9th century. Robert was employed as agent to his elder brother Lucius O'Brien, Baron Inchiquin, who had inherited the O'Brien family home, Dromoland Castle in County Clare. During the dreadful years of the Irish famine in the late 1840s, Robert and Ellen O'Brien and their children (five sons and three daughters) lived at Dromoland. Several branches of the family 'all joined up together…in different wings of the castle, complete with nurses, servants and hordes of children, as a family citadel through the Bad Times.'[6]

Eleanor Vere O'Brien, one of Robert and Ellen's eight children, grew up to marry William Thomas Monsell, also from County Limerick, in 1876. The Monsell family had originally come from Normandy, the most likely provenance of the name being the French word *manse*, meaning 'home of a feudal tenant'. William was the second son of Rev. William Monsell, a great hymn writer, and

Jack Monsell: Curragh Chase, County Limerick, watercolour.

Jack Monsell: Curragh Chase interior, watercolour.

his wife Anna Maria (née Wyndham-Quin). He was a big jovial handsome man, colossal and bearded – 'a good shot, a great yachtsman, and extremely good company'. As a Government inspector for the education of children employed in factories and workshops, his life was spent travelling around Ireland and England. Daily letters written to Eleanor throughout their long and sometimes erratic courtship show him as a man of passion and commitment whereas in his absences, in the early days of their relationship, she was liable to have her head turned every now and then. They finally became engaged on 21 June 1876.

Eleanor and William Monsell had four children. John Robert (Jack) was the oldest, born in 1877, followed by Elinor (Eily) in 1878, then Anne and finally the youngest, Charles. After William's untimely death on February 22 1887, reputedly from 'a fall from an overturned dog-cart' (in family papers there is also a suggestion of an unnamed illness) the family was invited to live at Curragh Chase. Eleanor was ostensibly to help keep house for her unmarried uncles, the classical scholar and politician Sir Stephen de Vere and his eccentric brother Aubrey, a distinguished poet who was inclined to wander around the enormous property in one of his three full-length velvet frock-coats, a skull-cap on his flowing white hair. In his youth he had been great friends with Coleridge and Wordsworth; it is recorded that Alfred, Lord Tennyson, had stayed too, and rewrote his 'Princess' at the great writing-desk in the library.

After the rest of the family had settled in with the kindly great-uncles, Jack arrived at Curragh from school in London to find the enormous house, with its lake and vast landscaped gardens, an exciting and romantic new home. Eily and her younger siblings had embarked on a firm Catholic upbringing in the Irish household. From an early age the girls were educated at home, while enjoying the freedom of a privileged country childhood. The family was very musical and the children had piano lessons in Curragh's cavernous and draughty reception rooms, practising until their fingers were stiff with cold. They learned to dance Irish jigs with a local fiddler. Jack and his younger brother Charlie, once they had left prep-school, were sent to board at St Columba's in Rathfarnham, Dublin, which the family had helped to found; Jack's school reports show an impressive pupil who consistently won prizes in subjects as diverse as mathematics and drawing, while also being piano soloist in the end-of-year concerts and excelling in both football and cricket. (His lively and frequent letters also describe in great detail the fairly regular canings he sustained.) As the children grew up, social life centred around riding, hunting and dancing. Eily, like Jack, was spirited and artistic and while she and Anne remained at home she taught herself to draw and paint. As soon as she was allowed to she would leave at weekends to visit Jack, who had gained a place at Trinity College, Dublin. Ever since he had left the family for his school in London he had shown an enormous interest in spectacle and drama, writing and illustrating extraordinarily detailed letters about such events as pageants and processions, and now he was able to immerse himself in the world of art and theatre, finding a lively new circle of cultured friends which included the poet W.B. Yeats and his entourage. Life in Dublin was sophisticated, glamorous and highly social, and Jack's writing took an increasingly dramatic character – in answer to his mother's solicitous query about her younger son, 'I really could not tell you how Charlie acts as he was behind a phalanx of tights and doublets'. Eily's whirlwind visits sometimes left even him exhausted – 'Eily has gone and I begin to breathe again…the air was blue'.

In 1896, Eily decided to apply for the Slade School of Art. Her cousin, the artist Charles Furse, had early recognised the quality of her drawings and sent a selection to Henry Tonks, who was then a painting tutor at the school. To make her application she went to spend some time with her relations Bolton and Mary Monsell in Gordon Square, where Jack had previously lodged when at prep school. Her racy and excited letters about life in London – dinners, theatre, new acquaintances – ingratiatingly address her mother as 'Little sweetheart' and 'darling' – and include such admissions as 'a confession: I lunched with Desmond in his studio. Uncle Bolton and Aunt Mary said I could…'. She was making up for lost time and enjoying an introduction to a new and bohemian life. After the entrance examination she remarked '…can't do things in light and shade…must

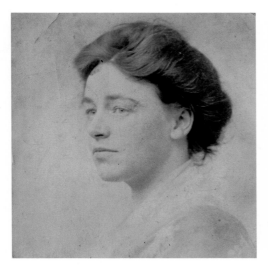

Elinor (Eily) Monsell, c.1898.

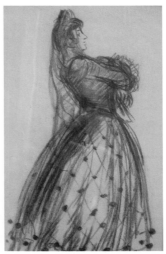

Elinor Monsell: Spanish lady
(charcoal/white chalk).

get Charlie to explain it.' However, her work must have impressed and still in her teens Eily won a scholarship to the Slade, where as well as painting and drawing she learned the basic skills of wood-engraving, the rudiments of which she later taught her aunt Gwen Raverat. Her fellow students included Augustus John (two years above her) and his sister Gwen of whom she made several drawings, as well as William Orpen and Ambrose MacEvoy.

After Eily graduated from the Slade in 1899, she found work illustrating magazines and books. She had been asked to illustrate the Pall Mall Gazette series *Tom Tug and Others – sketches in a domestic menagerie*[7] in 1898 while still a student. The subsequent book contains sensitive finely-drawn red chalk portrayals of domestic and farmyard animals, presented in an informal 'sketchbook' format, several to a page. Eily said that she was influenced by the drawings of Charles Keene in *Punch* and by the work of Randolph Caldecott. She was to illustrate many books, later collaborating with Bernard on a children's series. In 1904 she was commissioned to design the logo, used to this day, for Dublin's Abbey Theatre. In middle life she turned to sculpture, carving substantial yet unusually delicate stone figures with grace and a rare sensitivity. These qualities seem to sum up her character: always full of gaiety, humour and charm, her compassion for family and friends nevertheless constantly affected her, and later, when her dearest brother Jack died she wrote the remorseful words, perhaps too self-critical, that 'I'm afraid I often failed him as I have all my life failed the people I love most in the world'.[8]

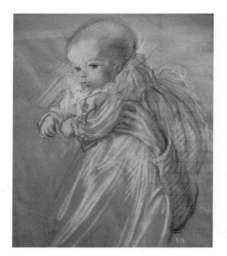

Elinor Monsell's drawings of Aubrey Pike, son of her sister Anne. (left: pencil, white and coloured chalk right: Conté crayon, white chalk).

On the death of 'Uncle Aubrey', in 1902 Eleanor O'Brien moved to London, to 9 Foulis Terrace, South Kensington, where she began a new English life. It appears that she lived there and then at 95 Elm Park Gardens, Chelsea until the end of her life in April 1920. Her children had all left Ireland and must have been instrumental in encouraging her to do the same; while it must have been such an extreme change for her after life at Curragh, it would also have been a comfort to be living nearer her daughters in London. Eily's sister Anne was married by then to William Pike, and it was shortly after Eleanor's move that he introduced Eily to his friend Bernard Darwin, by now a successful barrister. This somewhat unlikely union was the beginning of a lasting and committed marriage.

Although Bernard was always interested in the power and eloquence of a good case, and loved talking 'shop' to his barrister friends, he began while he was a member of the Bar to write 'casual' articles on golf which were published by such magazines as *Country Life* and *Tatler*. In 1907, he was asked to write a weekly article for the *Evening Standard*, and soon after this *The Times* approached him and commissioned several pieces. The work snowballed and by the next year, his writing was much in demand by several national dailies and weekly magazines. However, realising that writing on golf for four different publications a week was not a sound proposition, he soon reduced the number of journals and limited his weekly columns to pieces for *The Times* and *Country Life*. His manner of writing was easy and lyrical, sensitive while retaining a gentle edge of humour, and *The Times* extended his work to non-golf subjects, often royal

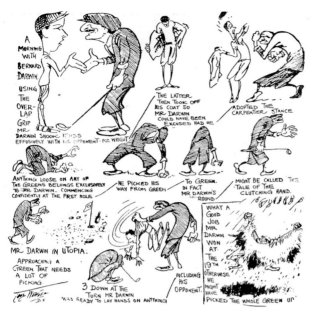

On reaching the semi-finals of the Amateur championship in 1921, Darwin earned the distinction of featuring in a Tom Webster cartoon in the 'Daily Mail'. Three down at the turn against the last American left in the tournament, he won at the 19th.

Tom Webster's cartoon of Bernard's 1921 golf victory against America.

visits and processions as well as other sporting events such as horseracing at Ascot, rugby and boxing, and university matches. His accounts of these events were vivid, his observation of colour and spectacle creating clear written images. When Lord Northcliffe took over *The Times* he made a point of finding special subjects for Bernard, such as a Charles Dickens pilgrimage, or a series of pieces on golf-courses on the French Riviera – an expedition for which Eily joined him, although usually staying at home and suffering the life of a 'golf-widow'.

So began Bernard Darwin's long and very happy relationship with these two journals, for both of which he wrote until his death (also finding time to set *The Times* crossword once a week). Countless readers, golfers and non-participants alike, were seduced and charmed by the breadth, the knowledge, the wit and the compassion of his writing. In Bernard's pieces, every game watched or played 'took on the proportions of an epic encounter'.[9] He was constantly interested in new developments, for example the game in America, but faithful to old traditions. His reports (often from memory) always opened with a look at the day's playing conditions, and he wrote after lunch, always by hand, often

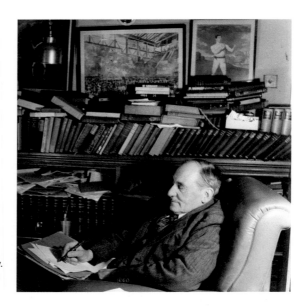

Bernard Darwin in his study. Note the interest in boxing as well as golf.

fuelled with a small glass of port. He could settle and write wherever necessary, particularly well on trains or in the corner of a pub lounge. Occasionally, as a champion golfer (he played for England and won in the first Walker Cup match against America) he had to write anonymously about his own game, in which case he was usually disparaging and always modest. In addition to his journalism, he completed more than twenty books, many naturally on golf but also covering a number of other subjects (he was passionate about classic British writers – Stevenson, Scott and particularly Dickens) and including several volumes of personal memoirs. Bernard lived until 1961 and amongst many eulogies written in his memory was a quote from the former Prime Minister Herbert Asquith, whose memoirs recalled that this delightful and kindly man, this unrestrained, fluent and prolific writer had, in his opinion, held the honour of being 'the greatest living essayist in the English language'.[10]

The unassuming Bernard would have been surprised and quietly impressed with this accolade, which put him on a par with the illustrious reputations of Dickens and his other literary heroes.

2: GROWING UP

T HE COMFORTABLE VICTORIAN TERRACED HOUSE in Elm Park Road, a short walk from Foulis Terrace where Eily had lived with her mother until her marriage with Bernard, was their first home. Ursula, born in 1908 at the home of her father's aunt Bessy in Cambridge, was pleased to have a baby brother, whose name was soon softened to 'Robin'. Details of the children's early years are scarce. Family life was inevitably interrupted by the First World War, when Bernard Darwin served in the Royal Army Ordnance Corps and was latterly posted far away to Macedonia where he became acting major. It seems that Eily and the family were despatched to the safe Darwin family haven in Cambridge, an agreeable change from London for the young Ursula and Robin. A baby sister, Nicola, arrived in 1916.

After his marriage to Eily, Bernard had made a decision to end his career in law and, to the regret of his senior colleagues who had seen him as an important future asset, finally left chambers early in 1908. In addition to starting a family, he began to appreciate a new, less formal style of professional life. He enjoyed the variable schedule of a freelance writer, having the security of several regular commitments. His work involved a certain amount of travel which meant that Eily was often left with the children when he was away, and this made his time at home with his young family all the more important to him.

The atmosphere of the London household in which the Darwin children grew up was informal and creative. To Eily, it was natural that the children were involved in as many musical and artistic activities as possible. Each one was taught to play an instrument. Ursula (nicknamed 'Bia') learned to play the 'cello; Robin ('Bo') studied the flute which he, in the steps of his grandfather, played effortlessly. Nicola, eventually finding that her voice was her natural instrument, was much later to become a professional singer. Whenever Bernard was at home he made up for his absences by spending as much time as possible with his children (even though, when he was working, Eily often had to

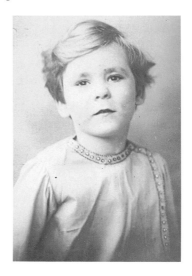

Robin Darwin, c. 1914.

Elinor's illustration for *Every Idle Dream* by Bernard Darwin, showing Robin with Rufus the dachshund.

be strict about noise near his study). One of his pleasures was reading aloud to them in the way that his own father had done for him. Outdoor life, even in the city, was important, and they would go for long walks through London with Rufus the family dachshund, enjoying the parks and the river. Bernard's memoirs recall a regular Sunday expedition with Ursula to deliver a piece to *The Times* in Printing House Square, going there by Underground and walking back part of the way along the Embankment. Special chocolates bought near *The Times* office from a shop that, a great rarity, was open on Sundays, were consumed at certain strategic intervals on the way home.

Religion did not play much of a part in Darwin family life, but when Bernard's cousin Joyce Ruck came to stay, she would take little Robin to Chelsea Old Church. Enjoying drama and ceremony like his Uncle Jack, he was fascinated by the 17th-century interior with its vivid stained-glass windows, and liked the formality and ritual of the service. Although he could not follow the order of worship and had no idea of the meaning of it, the solemnity and rhythm of the rhetoric appealed to him and he would go home and repeat the words of the Lord's Prayer over and over again.

Family festivals were important occasions, the more so because Bernard remembered the less-than-celebratory Christmas days of his childhood. Having grown up in a household of agnostic adults who ignored the feast (although, happily, always remembered birthdays) and first seeing a Christmas stocking at the age of thirteen when his half-sister was three years old, Bernard made sure that his own children were indulged with a proper Christmas. His writing refers to one particular Christmas Eve when Ursula, getting up to open her stocking, crept upstairs to wake her younger brother only to be intercepted and escorted back to bed – the chimes of midnight had not yet struck, and the rest of the

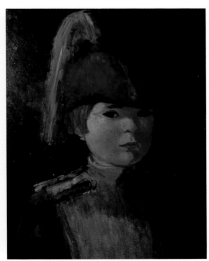

Elinor Darwin: Ursula with bow and arrow, oil on board, c. 1915.

Elinor Darwin: Robin in plumed helmet, oil on board c. 1915.

interminable night was yet to be endured. When morning finally arrived, the children found that the stockings were properly stuffed with all kinds of delights. Robin, 'an implicit believer, a true fundamentalist'[1] where Father Christmas was concerned, would find all sorts of treasures – one year, a fleet of tiny tin cars in different colours to feed a passion for motors which would last all his life; another year, pencils, brushes and paints. Hanging up his own modest little striped sock on Christmas Eve, he was worried when persuaded to exchange it for a longer stocking that Father Christmas 'might not like it' – in spite of the obvious advantages. After the stockings the real presents would arrive at breakfast-time, and then followed a day of endless feasting, with Christmas lunch, tea and dinner in blurred succession, all equally important parts of the celebration.

Bernard, although a mild-tempered man, had a sometimes gruff outward manner which occasionally showed surprising flashes of what his acquaintances described as 'spectacular rudeness'. In contrast to this he, like his own father, loved the company of children. He looked on games with the younger generation much as he looked on sport – a pastime to be enjoyed seriously. He and Eily would encourage the children's creativity and fantasy. The doll's house presented to a delighted Ursula one Christmas replaced a glass-fronted cupboard which had been generously and imaginatively given up by her parents so she could invent domestic scenarios for her dolls. Hours spent with children building miniature castles, arranging battles, racing motors, were as important as games

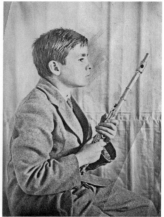

Watercolour by Elinor Darwin, and a photograph of Robin with his flute.

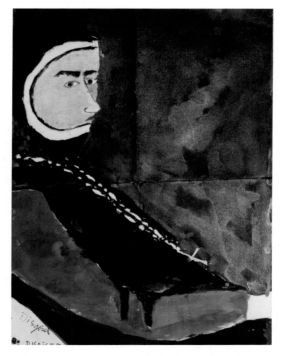

Robin's self portrait as a Black Knight (captioned 'Disgised by R V Darwin'), c.1920.

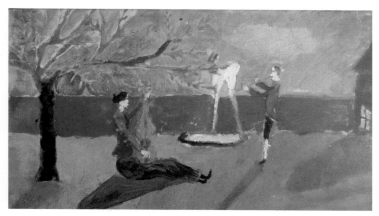

Robin Darwin: *A Piece of Music*, 1920. Painted when Robin was 10 years old, the inclusion of historical costume and what appears to be a modern sculpture give some clues to the artist's future.

of pretence and invention, and when sport came into it the vital element was that the child should win – if only just.

In Bernard's memory, privileged as his upbringing may have been, the servants of the house had been the 'best friends of childhood', particularly to a solitary small boy. Beyond the dark green baize door which divided the house into two regions were mysterious and exciting goings-on in the kitchen, the scullery and the butler's pantry, with the opportunity of long inquisitive talks, frequently interrupting the busy domestic atmosphere. Outside was the stable-yard with another set of attractions. These relationships continued in their importance, and Bernard's memoirs indicate that some of the maids from his father's house who had 'stayed there for ever' continued later to support his household in Chelsea, which was staffed (according to the UK census of 1911) by an impressive total of five females ranging from mature 'old retainers' to very young housemaids. Ursula, Robin and Nicola loved them as members of their family. There were similar relationships with staff of other familiar households, in Cambridge and elsewhere: one of the best moments every year was when, on their peripatetic annual summer holiday, they arrived at their great-aunt Etty's house at Gomshall in Surrey and raced through the green baize door into the kitchen to greet their devoted, long-lost household friends.

Bernard was away for frequent short stretches of time, and Eily, when not too busy with the children, occupied herself with her drawing, wood-engraving and sculpture. She was always busy with her own work and with small commissions. The illustration work she had done at the Slade was followed by several other books including two by the distinguished poet Walter de la Mare. Later, in the

Elinor Darwin: illustration for *Mr Tootle-Oo*.

1920s and 30s she and Bernard collaborated on a series about 'a sailor jovial and brave', Mr Tootleoo. They are boldly and simply illustrated and written in rhyming couplets:

> *One day when, in the Southern seas*
> *He danced a hornpipe at his ease,*
> *He felt a most unpleasant shock –*
> *The Ship had run upon a rock.*
> *Now Tootleoo could never tell*
> *Exactly how it all befell.*
> *He'd scratch his head and try to think*
> *When people asked him "Did you sink"*
> *Or "Pray what happened to the crew?"*
> *But this in fact was all he knew,*
> *On coming to himself he found*
> *That after all he was not drowned.*

Although Eily and Bernard began to produce these books when the older children were beyond nursery-rhyme age, they continued to enjoy the process, and Tootleoo was followed by *Oboli, Boboli and Little Joboli* (published by *Country Life* in 1938). This was a series of fantasy tales about animals and

children. The title names belonged to 'the King and Queen's elephants' and other stories involved Demetrius the tortoise, and the Princess, the Porcupine and the Cockyollybird. The Cockyollybird appears in the Tootleoo books, and Bernard records[2] that it was also the subject of the first play (at which he assisted) proudly written and directed by 'one small girl', most probably Nicola.

Oboli, Boboli and Little Joboli was illustrated with Eily's line drawings and competently coloured lithographs especially sensitive to landscape detail, showing her ability as a serious painter. *Ishybushy and Topknot*, also published by *Country Life* in 1946 as a War Economy Standard book (using rationed paper and government guidelines on production), was a dream fantasy seen from the point of view of a brother and sister. The illustrations, based on earlier drawings of Ursula and Robin, were line drawings interspersed with full-page watercolours.

After Eily's brother Jack had worked in theatre for several strenuous years, endlessly touring Britain as stage-manager, designer, actor and director, he too turned his talent to writing and illustrating many children's books. He was a highly competent designer, and in 1913 collaborated with Bernard to provide the images for *Elves and Princesses*, seven fairytales exquisitely bound and produced in the classic tradition. The book had embossed linen covers with a colour illustration and contained many beautifully drawn and finely reproduced colour pictures reminiscent of the early style of the brothers Charles and Heath Robinson. In 1914 Jack, aged 37, disguised his age to enlist and fight in Northern France. Owing to casualties at Ypres he became first Major and then Acting Colonel with the 56th (London) Division. He was in the trenches for most of the war, and in spite of appalling conditions and devastating losses, managed somehow to record daily life in numerous sketchbooks containing a prodigious number of drawings. One of these is a sketch diary, with poignant ink/wash and watercolour drawings of everyday wartime life in Northern France, accompanied by written explanations: his beautifully laid-out pages, natural sense of design and colour, and very strong style make it an impressive and poignant document. His drawings of colleagues at work and leisure are no less moving. After the war these were exhibited at the Macrae Gallery, 95 Regent Street – 'With the 56th London Division – sketches in France'.

Although shell-shock left him badly affected after the war, Jack went on to illustrate many books for other children's authors, and he produced some of his own too – notably *Polichinelle*, a beautifully illustrated volume of old French nursery rhymes with musical scores and English translation. The three Darwin children must have been delighted and proud to read these books produced by their lovable and talented uncle.

Summer meant family visits to Downe, Cambridge and Aberdovey. When

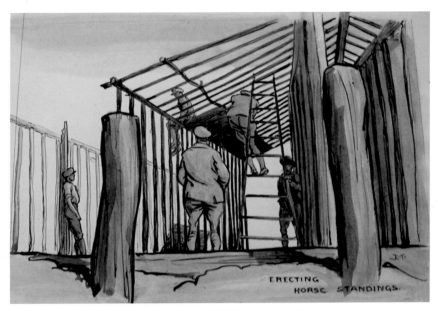

Jack Monsell: *Erecting Horse Standings* c.1915 (ink and wash).

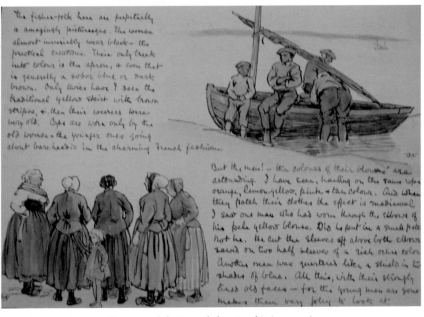

Page from Jack Monsell's Normandy journal showing his interest in costume.

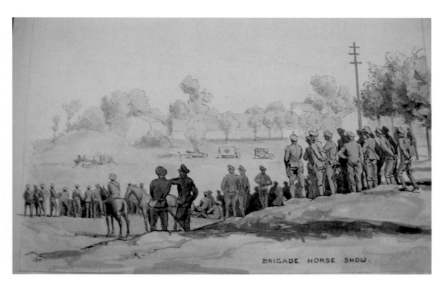

Jack Monsell: *Brigade Horse Show* c. 1915 (ink and wash).

Jack Monsell: soldiers in a train c.1915 (pencil, ink and wash).

Jack Monsell: a game of chess in the Officers' Mess c.1915 (pencil).

in Wales as teenagers, Ursula and Robin would enjoy climbing Cader Idris, the mountain not far from the family home. They would stop and bathe in the lake halfway up (where, according to Ursula, their grandmother Amy had enjoyed swimming naked in the moonlight). Another happy and important holiday highlight was the picnic. In Bernard's view 'The essential quality of a picnic is doing perfectly normal things in an abnormal place or manner'.[3] To a certain extent his life as a golf commentator dictated the outdoor lunch, and he never ceased to enjoy the pleasure and freedom this gave. Picnics with his family became a feature of summer holidays. The organisation of the 'fairy basket' containing so many good things, all the better for being eaten outdoors, was as key an element as the selection of the venue, and this magic was to continue for Robin who as an adult would organise wonderful picnics, memorable open-air gastronomic events. In Bernard's view solitude, away from other picnickers, was essential to the full enjoyment of the experience and whether within view of a golf-course or at the seaside, on turf or shingle, in sun or shade, the family's pleasure was complete when they had finished their sandwiches and fallen into a 'heaven of laziness and digestion'.

So the Darwin children grew up in a relaxed and creative atmosphere where, although they were not 'bookish', they were surrounded by art, literature and music. While in Cambridge during the war, Ursula, Robin and their cousins attended a small local school in Storey's Way, which skirted the back of some

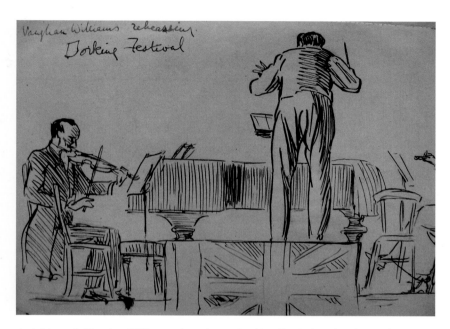

Jack Monsell: *Vaughan Williams rehearsing at Dorking Festival*, undated. Vaughan Williams, a Darwin cousin, was conductor for the Leith Hill Festival, Dorking, from 1905 – 1953.

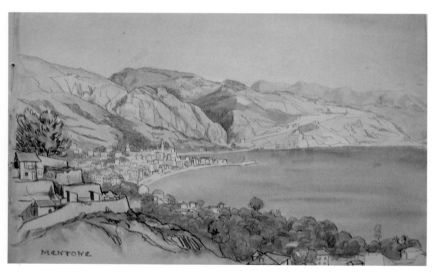

Jack Monsell's watercolour view of Mentone, undated. The curve of the harbour with its mountainous backdrop anticipates Robin Darwin's later attraction to similar settings.

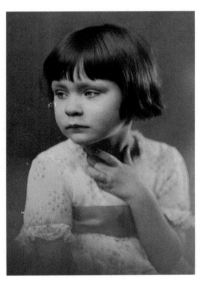

Top left: Ursula Darwin, c. 1922.

Above: Robin Darwin, c. 1921.

Left: Nicola Darwin, c. 1921.

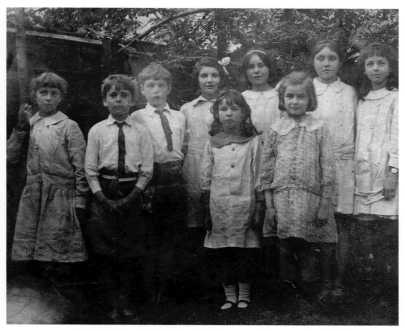

School at Storey's Way. Robin second from left; Ursula back row, third from right, c.1919.

of the large Darwin gardens on Huntingdon Road and was run by a spirited and enterprising schoolmistress. When the family moved back to London they continued to visit Cambridge frequently, staying with Francis or, often, with Aunt Bessy at Traverston (Ursula's birthplace), the home on West Road to which she had moved after her mother's death. The young Darwins enjoyed the very sociable Cambridge life, letters from both Ursula and Robin regularly describing lively parties and in particular the delicious suppers supplied at them. Food was of prime importance, and they were often allowed to experiment with cookery in the family kitchens, Aunt Bessy having taken her mother's domestic staff with her when she moved. Robin developed a great love for the city, and as he grew older naturally tended to be there in vacation time when, although there were few students thronging the streets, life seemed no less exciting. He remembered this period as one of 'good fortune'. It was a magical experience to walk through the Great Court of Trinity College, or to pass King's College Chapel on winter evenings with its windows romantically glowing from candlelight and the sound of the choir echoing into the night; in contrast, the long summer vacations were a blissful sequence of picnics, punting, tennis and cricket, the idyllic weeks coming to an end all too quickly.

When the family returned to Chelsea after the war, Ursula and later Nicola attended St Paul's Girls' School. Robin, being a Darwin boy, was naturally expected to go to Eton. In preparation for this he was sent as a boarder to Durnford School in the village of Langton Matravers near Swanage, Dorset. The school's headmaster, Thomas Pellatt, and his heiress wife had bought Durnford House in the village's High Street in 1893 in order to set up a preparatory school which groomed boys exclusively for Eton. The school took pride in its 'progressive' and spartan character, far tougher than the Eton life intended to follow. The Pellatts were naturists (much to the amusement of small boys spying through the garden hedge) and perhaps a little masochistic too - the pupils were made to swim naked in the sea early every day, weather conditions regardless, from the rocks named Dancing Ledge at the perimeter of the estate. Pellatt, who oversaw these sessions, later had a swimming-pool specially blasted out of the craggy cliff – perhaps in answer to complaints from the local population, for whom the daily vision of unclothed and shivering boys might have been a little too much.

The school was not a comfortable place to be educated. Its progressive nature as well as its Eton success rate must have been the reason for Robin's being sent there, but at this point he may have felt somewhat rejected by his family. The burden of being a Darwin was a lot to live up to and Robin, though clever, had no intention of being an academic. A lover of domestic comfort, he was furthermore hopeless at games, which may have been a disappointment to his father and may have contributed to the choice of this school which put such an emphasis on outdoor life. The writer Ian Fleming, a fellow-pupil slightly older than Robin, recalled unpalatable food, unnecessary physical hardship and plenty of bullying. In milder moments Mrs Pellatt would read to the boys from the adventure stories of John Buchan and from Anthony Hope's *Prisoner of Zenda*. However, the school succeeded in placing several boys every year at Eton and Robin gained a place as an Oppidan in Mr Whitworth's house, outside the college gates, in 1923. Like Bernard, who had loved his schooldays (though his pre-Eton experience was easier than that to which he subjected his son), Robin was an extremely happy Etonian, and he consistently won prizes for both art and music throughout his time there, including the Harmsworth Music Prize (Junior) in his first year; the Senior Music Prize in 1926, and the School Music Prize in 1927. He excelled in art, and won the Drawing Prize as a first-year; two prizes, the Gunther Memorial Prize for Drawing, and the School Drawing Prize for 'a head from life' in 1927, and a further Gunther Memorial Prize (portrait) in 1928.

A written report to Aymer Whitworth from Robert Birley, dated 29 March [1928], gives a clear illustration of Robin's teenage character. Birley, the history

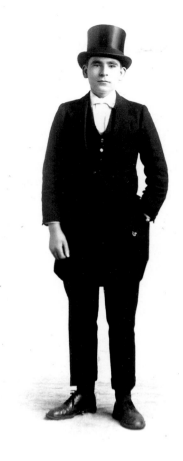

Robin in his Eton suit, December 1925.

master, was in charge of Robin's form during his final year at Eton and he described the experience as 'rather like that of passing through a really heavy gale at sea. I shall in future read 'typhoon' with interest. It calls out all the greater qualities of the captain (or master), courage, endurance, and cunning. At the same time the ship (or division) is apt to be blown immense distances from its course. At the end the captain is a weary man, but he has behind him a supreme experience. Above all he has been in the presence of the elemental forces of nature over which he has little or no control.'

Birley's report went on to say that in spite of this volatility, Robin's presence in the class was not unhelpful, 'keeping the division awake' with his enquiring mind and his often 'quite valuable' diversionary tactics. His art master, Eric Powell, praised him for working hard at areas of difficulty in drawing and painting, proving that Robin could apply himself to subjects he found interesting; Birley

remarked that 'Nothing shows his versatility so well as his ability to sketch and to question at the same time'. Robin's facility in art, music and writing tended to encourage him to coast along easily (emulating his father's attitude to his schooldays) and not to challenge himself; Birley saw this lack of self-discipline as a danger to Robin's development. However, Robin's written work had improved considerably and his essays, when he concentrated, were usually fluent and logical. Birley went so far as to comment admiringly that Robin had 'stumbled on the real mystery of writing, which cannot really be taught at all, a kind of automatic shuffling of facts and ideas in his mind so that he gets a point of view about a subject.' This promising ability meant that Robin's writing always had something new in it, a personal 'twist' which would be seen again and again in the future.

Regarding the subject of history, Robin, not uninterested, usually took a romantic point of view, unless a political idea attracted his attention and stirred his curiosity. Divinity really caused 'guerilla warfare', causing strong disputes while raising interesting and provocative questions which Birley felt were rarely more than rough sketches needing development. But Robin was always keen to start discussions on almost any subject. 'Fortunately he is really ready to be suppressed, and his abominable arrogance and intolerance disappear at once. His incredible perversity, his stupid attitude on certain subjects...are not really fundamental. He has the seeds of grace in him on various points where you might think him lost.'

The reason this report was written in March and not at the end of the academic year was that Robin was leaving Eton to go to France. This premature exit was most probably made in order that he could take up the prestigious offer of studying the flute in Paris with 'the greatest flautist of the age'[4] who had heard him playing at Eton; it seems curious that his parents may have suggested his leaving with one half [term] to go, but the unique chance was not to be missed. He must already by then have secured a place at Trinity College, Cambridge. Birley, extremely sorry to see him go, regretted that he would miss Robin's good company and sense of humour, and wrote that although it was impossible to prophesy the future of such an unpredictable scholar, Robin's fundamental sanity would ensure that in the end good use would be made of his talent.

In true Darwin tradition and possibly under family pressure, Robin was admitted as a 'pensioner' (fee-paying student) at Trinity in Autumn 1928. He was a student of the tutor, historian and great politician J.R.M.Butler, who had been born in Trinity where his father was Master. Robin was allocated College rooms which he shared with a fellow student at 14 St John's Street, but (setting a mysterious recurring pattern for his student life) appears only to have stayed for one term, sitting no examinations. Perhaps, like Bernard before

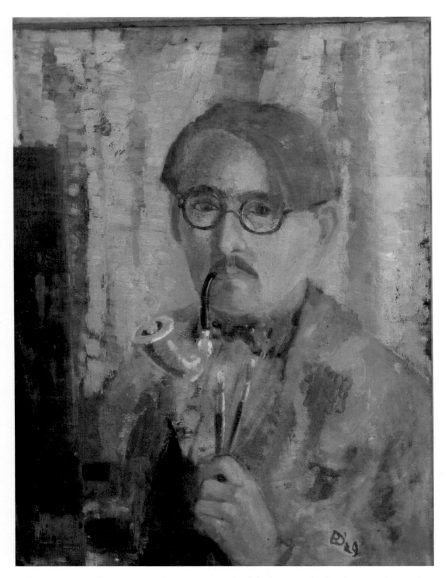

Robin Darwin: self-portrait in oils, 1929. A studied 'bohemian' look is being cultivated, and already, at the age of 19, the moustache which will become a lifelong characteristic.

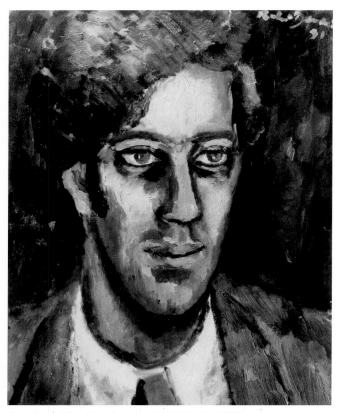
Portrait of Julian Trevelyan by Robin Darwin, 1931.

him, he suspected that he knew Cambridge too well to be a student there; more probably, it became clear that his real passion was for art though he had all the capabilities for academic study. Robin did not see himself as an intellectual, and once inside the hallowed walls he realised that, unlike his Darwin predecessors, a Cambridge life was not for him. While in his first term at Trinity he must have applied for an interview at the Slade School of Art, because he successfully gained a place there and enrolled in January 1929. It is easy to imagine that this speedy change of direction may have upset Bernard but perhaps it secretly pleased Eily, who had hugely enjoyed her time as a Slade scholar.

The Slade was at that time under the leadership of Henry Tonks, with Wilson Steer an influential tutor. Robin Darwin was part of a fairly rebellious generation of students including Rodrigo Moynihan and William Coldstream. A postcard dated 13 February 1929 to his friend Julian Trevelyan, whom he had met at Trinity, suggests 'Meet me at the Slave [sic] (University College,

Gower Street) at 12.45'. A barely legible scrawled note adds his feelings and the reason for his sudden exit from Trinity: '...I suddenly realised that Cambridge was obviously ludicrous and futile...[and have] forced my family to the same conviction. Consequently I am now drawing from real life and enjoying myself enormously'. He saw the rest of his life 'swirling away' in a maelstrom of paint and canvas, and enjoyed the debate and discussion with like-minded students, feeling excited about current movements in British art: 'I think that at last some kind of permanent and definite school of painting is emerging in England led by Derain and Vanessa Bell and Meninsky, the Nabis'.[5]

One of Darwin's more surprising characteristics as a young adult seems to have been his fairly relaxed attitude to academic commitment. Having abandoned Cambridge and secured for himself, mid-year, a place at the Slade, a further letter to Trevelyan written on 20 May 1929 suggests that again he is thinking of 'bunking off' (if only temporarily) to join him for a summer trip: '...looked in my Cambridge diary (kept for sentimentality's sake) and find that your term ends on the 10th [June]...I have no idea what Tonks will say as my term does not end till 30th'. So it seems Robin and Julian were away together, possibly in Paris, during June and July, as a postcard written to Julian on 13 August tells him 'Your portrait awaits you...on loan for 1 year for sale for £5. It might of course be a good speculation; if you decide to be one of the "great thinkers of the 20th Century" it will be of untold value. If you show signs of becoming a celebrated wit, I'm afraid it will be of value only to yourself. Best of all, die young – say in the middle 20s leaving behind a memory of precocity and studied idleness'.

True to character and although his work showed competency in the painting of both portraits and landscapes, Robin left the Slade early in 1930, having barely spent a year studying there. He indicated later that his abrupt departure was fuelled by frustration at not having his own ideas heard and considered: it appears that he and Tonks did not see eye-to-eye about the work of certain artists and after a dramatic row, Robin walked out in a fury. His long-suffering parents, despairing of their volatile son, nevertheless continued to support him in his search for the right education. It seems likely that it was at this time he spent a term at the private Académie Julian in Paris, the *alma mater* of the post-impressionist group Les Nabis whose work and philosophy Robin so admired.

The money, or more likely the enthusiasm, must have run out after one term and by April he was back in London. He found a job in the Strand offices of *John O'London's Weekly*, an upmarket gossip-sheet, working there 'for £5 per week for 6 months' simply in order to survive. 'Let me say... that suburban culture & tittle-tattle about authors and their housekeepers their dogs their food and their intimate life... do not interest me in the least'.[6] Away from work, Robin found plenty of time to continue painting and in October 1930 showed work in what

Robin Darwin: untitled, c.1930. Probably painted while a Slade student.

was probably his first exhibition. The Atelier Barnard in Eccleston Street was a gallery whose mission was to help impecunious young artists by giving them exhibition space and displaying their work to the press and the public.

Whether he regretted quitting the Slade is not clear, but he had no remorse about leaving Trinity: '…at all events…I never was a highbrow at Cambridge.' His later colleagues would describe Robin as urbane and sociable and, though not literary or 'donnish' in any way, worldly and well-informed. His culture came naturally from his background. Though he found it impossible to settle for either the high scholarship of Cambridge or the bohemianism of art school, the underlying influence of each of these worlds was to have an undoubted and far-reaching effect on Robin's future life.

3: MARRIAGE AND RESPONSIBILITY

'I AM ENGAGED!! ("FANCY").' Written just before Christmas 1930, this exclamation opens a spirited letter from Robin Darwin to Julian Trevelyan, which goes on to ask if Trevelyan will consider being best man at the wedding, possibly to take place at Eton, the next May.

Darwin had met Margaret (Yvonne) Darby, a painting student, when he started at the Slade in January 1929. Yvonne, having arrived at the school herself in summer term 1927, was in her second full year there. She was a Londoner, a solicitor's daughter from Clapham (by coincidence she had been at school with the sisters of Hugh Casson, whom Darwin was to know so well in later life). A year older than Darwin, Yvonne must have seemed sophisticated and worldly. Charmingly well-mannered, she was always smartly dressed with an interest in fashion perhaps unusual amongst artistic females at that time when a more 'creative' style was often adopted. Darwin, with his studied 'bohemian' look, his moustache and floppy hair, must have seen her as an exciting contrast to his academic and rather nonconformist family background. Vivacious and amusing, Yvonne could nevertheless be fierce too, and her uncompromising character must at times have challenged Darwin's own volatile nature. She graduated from the Slade in 1930, after he had walked out in the spring term, and they became engaged at the end of the year.

Unlike Darwin, Trevelyan had continued his studies at Trinity College, becoming immersed in the stimulating intellectual life of the University at that time. His circle of friends included undergraduates who would become great thinkers, writers and artists of the 1930s. One of them, Humphrey Jennings, introduced him to current French painting and to Surrealist ideas, which appealed to Trevelyan's interest in dreams and the sub-conscious. A note scribbled from Darwin to Trevelyan on 31st January 1931 (still at *John O'London's* – 'Can't write properly now as I am supposed to be working')[1] acknowledges the fact that

Yvonne with dove, and Robin's shadow.

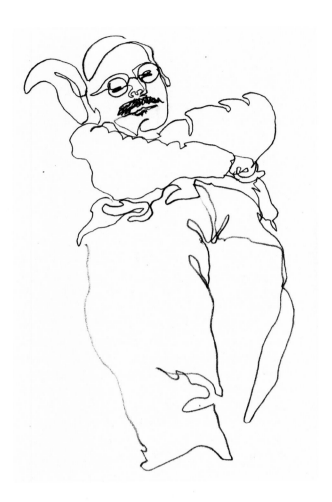

Julian Trevelyan:
pencil drawing of
Robin Darwin, 1929.
Executed with one
continuous line.

Trevelyan had made a decision, well into his final year, to abandon his studies and leave Cambridge. He had already shown his work in 1929 with the London Group, and now felt that the only option for him (to Darwin's envy) was to go to Paris and become an artist.

As a country retreat from London, Bernard and Elinor had several years before bought a house named Gorringes in the Darwin family village of Downe, Kent, at the opposite end of the village to Down House. Set in a large garden with open views towards the North Downs, Gorringes became a haven of creativity, with Eily in charge while Bernard was off on his golf reporting assignments. A letter to Trevelyan from Robin Darwin's aunt, Gwen Raverat, describes the atmosphere: 'Gorringes is such a lovely place to stay – everybody

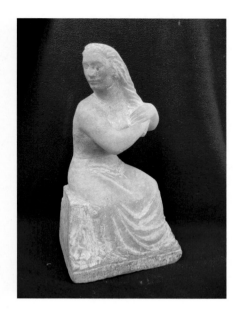

Elinor Darwin: carved alabaster figure, 1920s.

doing things – modelling & potting & painting & playing instruments all over the place… Eily is modelling & Robin talking & I **can't** write sense…'[2] Robin and Yvonne would spend weekends there, and a February letter sent from Gorringes to Trevelyan makes it clear that he still intended to become a painter and that he was attracting regular commissions as a portrait artist. However, money was tight and sacrifices had to be made. 'Yesterday we said farewell to the studio. It was all very sad. Eton and Cambridge and the Slave and then I suppose the offices of *John O'London's* one can revisit if one is so minded. But leaving a house or studio of one's own is heartbreaking.

p.s. There are I'm afraid no portraits for you to see, they are all SOLD!!'

In the same month, almost as soon as Trevelyan left Cambridge for a studio in Montparnasse, he sent Darwin a suggestion of work as translator of a Parisian art journal for the salary of £100 a year, part-time. Darwin and Yvonne, looking for somewhere to live together, had recently seen 'a delightful flat in an old Regency house which is directly on top of the river' at Hammersmith, and Darwin indicated in his reply that they needed more than that sum to live on. He was looking for a teaching job and doing his best to make use of the considerable family network to find one. 'The other day I managed to get an introduction to a certain Professor Gleadowe who is Slade Professor at Oxford, a director of the National Gallery and art master at Winchester'. He also visited 'Will Rothenstein…who simply fawns on my family in the most sickening way'. This last comment seems a little hypocritical in view of the fact that Darwin was

unashamedly using him as a means to find alternative work. Clearly, although he must have had his contract extended, Darwin continued to do the minimum possible at *John O'London's* – 'Now I must stop as I have wasted hours of the Office's time'.[3]

Someone must have pulled the right strings, because on 28 April that year, Darwin started a job as art teacher at Watford Boys' Grammar School. In order to keep up appearances, he had adjusted his curriculum vitae for his interview to make it seem that he had completed the first year at Trinity, and two years at the Slade (recorded by Watford as 'Slave School of Art'). He altered his date of birth accordingly, increasing his age by two years – he was just under twenty-one, but it appeared to Watford that he was about to be twenty-three, distinctly more mature. Perhaps visually adding a few years to his appearance, the moustache which he had cultivated at art school probably did him a favour. It became one of the lasting and most recognisable characteristics of his personal appearance.

The plan that Julian Trevelyan would be best man at the wedding did not materialise. Robin and Yvonne were married on 11 August 1931. A bill from Ann Blake Ltd., 45 South Molton Street, London W1, dated 4 August to Miss Darby, 59 Bromfield Road, Clapham SW4, itemises her wedding purchases:

Wedding gown coatee & veil	15gns	–	15.15.0
Check flamingo gown	7 ½ gns	–	7.17.6
Making velvet pyjamas	4 ½ gns	–	4.14.6
Evening coat	6 gns	–	6. 6.0
Slip	32/6	–	1.12.6
			£36. 5.6[4]

A letter to Trevelyan explains: '…My great excuse [for not writing sooner] was due to all the business and trouble of getting married…we are as you may imagine safely married at last. The ceremony went off all right up to a point – the bells rang the choirboys chortled…the bride looked lovely and the bridegroom did his best in a new sprigged waistcoat!' Darwin expresses that '…there was an aching void' in Trevelyan's absence, and then gives an account of the early part of the honeymoon. 'We went first of all to a delightful little pub (exceedingly primitive re. sanitation) on the Dorset coast where we learned to play shove ha'penny, went for long walks in the rain and bathed off rocks when it was possible'.[5] Yvonne's pencilled notes give a more detailed account:

Tues 11th Wedding & to the Hawthorn Hotel, Ockham nr. Cobham
Wed 12th to C for papers – rested
Thurs 13th left H Hotel at 8.15 – puncture after Farnham – breakfast at

Holybourne – Winchester Cathedral – lunch on hill near Stonehenge. To Stonehenge – Salisbury Blandford tea – Studland Mr. Gibbon – Swanage – Worth Matravers – lovely.
To Ship Hotel Swanage. Fisherman
Fri. 14th to Worth Matravers – sleeping at the dairy & feeding at the 'Square & Compass'. Steak for lunch & back to S. to buy shoes & books.
To Langton M to 'dancing ledge' & to bathe & eat *chincher* [ginger?] cake. To bed at 8 o'c!. Gt rain & wind in night.
Sat. 15th Lovely weather – long walk O to Encombe & Kingston – sleep after lunch
To Lulworth Cove bathe. Swanage.[6]

The choice of Langton Matravers and Dancing Ledge as part of their honeymoon must have meant that Darwin's memories of his spartan prep school were not wholly unpleasant ones. After Dorset, the couple travelled to Paris for a long weekend at the Castille Hotel-Restaurant, 37 Rue Cambon: 'such fun… that we have decided to stay on another week. We have never been to Paris before together.'

While Robin Darwin was teaching at Watford, he and Yvonne rented The Bury Mill House in Hemel Hempstead, Hertfordshire. He supplemented his teaching wage by accepting commissions for portraits, and at the time of the wedding had five on the go, one 'a group for 50gns'. He was worried about becoming a 'portrait nut at this early age, for I must pick up every crumb that falls if I am to keep up this house in HH'. To this end, he and Yvonne had decided that after a year or so they would pack up and starve for a year in Paris. Would it be possible to do this on 'we think £200? including food, rent and the nightly Dome… I must assimilate new ideas before it is too late… you will chuckle and think that I am at last yearning to paint abstracts!' A postscript from Yvonne adds '…will you buy some photographs of mosaics, wallpaintings etc that are exciting and good and bring them back for us [from central Europe, where Julian was about to travel]. It is a commission. R is going to mosaic so he says – but do you think he will? Spending months chipping & chipping & fitting? Did you ever find… that HE did not always tell the truth?'

In autumn 1931 Darwin and Trevelyan showed their work in a joint exhibition at the Bloomsbury Gallery, the first of a series of shows there for Trevelyan. During the exhibition Trevelyan was introduced to Darwin's sister Ursula. They found one another engaging company, and Trevelyan began a correspondence with her from his Montparnasse studio, writing her frequent letters about life in Paris. Ursula was studying pottery at the Royal College of Art, having begun her training at the Central School of Arts and Crafts, and

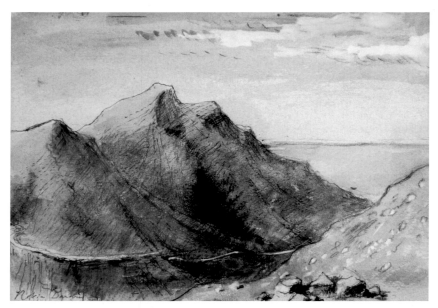
Cader Idris. Darwin's sketch of the mountain near his Welsh grandmother's house, which he would often climb.

when Trevelyan was in London they would meet in private so as to keep the intimacy of their relationship secret from Bernard and Eily.

A teaching job suited Darwin. He and Yvonne were keen on exploring Europe, and began a tradition of making frequent school-holiday pilgrimages to Belgium, France and Italy to explore cathedrals, churches and monasteries as well as to visit art galleries and to study classical architecture. They had by now (as did Darwin's parents in earlier days) acquired a dachshund, Konrad, who appears to have travelled everywhere with them and to have been very spoilt. To Trevelyan, from Yvonne, Easter Saturday 1932 in Bruges: 'Konrad is so naughty that we feel the only possible cure is a course of lessons from you so will you please come and spank him and stay a long time. He now eats salted almonds between sips at our cocktails.'

In September 1932 Darwin and Yvonne were in St Malo at the end of a 5-week holiday travelling the British Isles with Darwin's parents. A barely-readable scrawled letter to Trevelyan complains: 'In 5 weeks we have travelled about as many miles as you. We have "done" the whole of Wales, the Lakes, Scotland, Cumberland, Westmoreland (sic), the Midlands & south, and now Brittany – a fine Philistine holiday. Tennis & Golf all day, saddle of (Welsh) mutton for supper & my father reading aloud "Ivanhoe" at night. I have tried to paint but it's hopeless…'

Above: Yvonne and Konrad, c.1931.

Left: Three generations of Darwins –
Bernard, his uncle Leonard, and Robin
at Cripp's Corner, Leonard and Mildred's
house.

Darwin's handwriting at this stage was truly hardly legible, and its style changed frequently from letter to letter. This could have been as a result of a studied *laissez-faire* attitude, a wish to make an impression of informality, but it is more likely that his very active 'stream of consciousness' did not allow time for a disciplined hand. He was soon to train himself to write in a more controlled and elegant style but at this stage it appears that the important thing was to get the emotions down regardless of the appearance on the page. Although proud of his provenance, Darwin's letter bemoans the fact that coming from a distinguished family means that one can become trapped in other people's expectations. 'Often I wish I was…the son of a Wigan haberdasher…You can't rid yourself of "family" you will never shake off the veneer of Cambridge. Help! Help!… Just for a year to stand naked, as a "Smith" or a "Jones", & know nobody & think of nothing but paint, & think of the lights of Tottenham Court Road & the harlots thereof, & Vauxhall bridge, & the plutocratic advertisements of Piccadilly…Anyhow here am I, at any rate, sent into life all higgledy-piggledy, half highbrow half lowbrow, half painter half 'sportsman' (ugh! how loathsome!) neither one thing nor the other & all because a father was sent to the greatest school in the world and his son after him where he enjoyed every minute of it. And if it were not so, the Bury Mill House wouldn't exist…Darwinism wouldn't exist and alone oh Yvonne wouldn't exist. I feel all things…stand in one's way…I can't wait to get back to hard work; a month's idleness is more than I can stomach.' [7]

However, even in this rebellious state of mind, Darwin still found things to enchant him. While in Brittany, at St-Servan-sur-Mer, he discovered 'the world's most wonderful musical box …where a whole regiment of butterflies throw themselves indefatigably at a row of tiny bells…while fine 18th-century *jeunes gens* pirouette in sailor suits. A franc for six tunes.' And, later that year, he told Trevelyan to come to London and see 'the most wonderful exhibition I have ever been to, of sculpture from the 3rd millennium BC till today. Every nation is represented… so that you find primitive Mexican next to….Chinese next to Tahiti etc. Painting wouldn't stand such a test.'

Sensibly enough, they did not (or could not) follow up the idea of being penniless artists in Paris. In a letter of 22 November 1932, typically written in the middle of Mass at Watford, Darwin shows that while he is envious of Trevelyan's bohemian existence he enjoys his civilised, surprisingly conventional style of life. 'In all your letters you always end with "send news now and again more news" but that is like someone in the middle of a feast of caviar and candy eating just a husk of bread or equivalent to offering a peanut to an elephant. In fact it is hard to imagine our quiet domestic life in England can faintly satiate your hunger; even the news that we have now a butler and a car bigger than the Shiffolds [Trevelyan's home] Vauxhall, events of immense excitement and moment with us, cannot be of any interest to one who is in the process of stirring up central Europe to revolt and of making Picasso dictator of the Balkans, of toppling over corrupt and defunct governments and like Little Jack Horner pulling out a virgin plum from the others (and probably burning your fingers in the process.) Poor Byronic Julian!'[8]

Darwin genuinely enjoyed teaching and his daily contact with the Watford pupils. His mastery of the flute drew him to become involved in musical events, and the school magazine, the *Fullerian*, records that in the School concert in March 1932 he played a solo flute sonata by Handel, 'with great purity of tone and the contrast between the meditative slow movements and the gayer spirit of the allegros was well thought out'. In the school's Christmas concert that year he performed in a trio for flute, violin and piano.[9]

Yvonne, who had recently had an exhibition of her paintings at Agnew's gallery and had sold several oils and watercolours, had been giving painting lessons to a group of local pupils, one of whom was 'a remarkably talented footman at a neighbouring house' who ended up working for Darwin and Yvonne 'for very little but makes it up in paints and canvas etc! …He expects us to dress for dinner every night… When he thinks we are out of hearing we hear him booming out operatic arias over an omelette or whistling Beethoven to a steak… [he] has read Paradise Regained, carries about Rupert Brooke poems (!), shoots questions at Yvonne about 'The Origin of Species' which he has read

Robin Darwin: bay window and beach huts, showing an almost feminine delicacy of colour, c.1933.

and we haven't, is learning French, has studied for the Church, is interested in primitive music and above all is a first-rate cook. This paragon of earthly virtues is only 24.'

As a wedding-present, Darwin had acquired something that represented the fulfilment of a lifelong passion. With gifts of money from family members, he had bought at auction the large car mentioned above, a second-hand Buick. 'Think of the number of times I can now slam the doors a day!' But in his letter to Trevelyan, 'the car is less exciting but newer. Last week our Buick ... broke

down. I determined to get a really good one this time. Got a loan from the Bank and on Saturday found a most marvellous Sunbeam saloon which cost over £700 new and for which I paid £110. It's a real luxury bus, very fast and a delight to handle. The doors are so well fitted that the very suggestion of a SLAM is unnecessary!'

It is clear that Darwin really missed the stimulating company of his closest friend: 'I feel defriended & in need of your Homeric wit. We will give another party in the London of one who has sunk a fortune in a hopeless enterprise, slept with a gypsy & drunk imperial Tokay.' His letters, and Yvonne's, frequently implore Trevelyan to come and stay. In January 1933 there are plans for a big party: '…we shall commandeer all the pubs in HH. There will be heaps and heaps to drink and in addition to cocktails sherry liqueur punches etc. Mr. Darby is providing us with several magnums. You must come some days before and decorate the studio with 'abstract pornography'. Yvonne continues: 'Did Robin tell you that he wants proper music first – about an hour – and then low class music for the rest of the night?'

In order to supplement his teaching income, Darwin had begun to take on freelance work as an illustrator for the publishing house of Putnam's. His early designs for the book cover of *Fear No More* by Margaret Askew show a clear understanding of composition, with the second improved version including the use of pattern so current at that time in the work of such artist-designers as Eric Ravilious and Edward Bawden. Further designs, mainly for the books of John McNeillie, indicate a mature understanding of the briefs he was set. The later, less stylised cover for Putnam's publication of Karen Blixen's *Out of Africa* is executed in a manner much closer to the paintings Darwin was producing at the time.

Yvonne, already making a success of her painting and tuition, got herself a place at 'the Courtauld Institution [sic] as an 'occasional student' – doesn't it sound lovely? – I go up when I like to work or read or attend lectures'. She must have been a fee-paying student, and their comfortable way of life must have been quite a strain on Darwin's teaching salary of £150 a year. In February, Darwin showed a selection of his paintings in a high-profile Agnew's exhibition at Cambridge – '… terrific business in Sickert, John, both Nashes, Stanley Spencer, Grant, Vanessa Bell etc. I pray that amid all this welter of genius my poor things will be noticed and sold as I am on the verge of literal bankruptcy'.[10] In March *The Times* reported on an exhibition at the Bloomsbury Gallery: 'Mr. Darwin must continue to plug away at his drawing…there are no signs that he shirks the exercise'. The critic considered that the work should progress towards '…better generalising' rather than 'academic literalness', and admired Darwin's talent for portraiture. A head of Yvonne, against '…crimson, green and gold, is the most accomplished piece of painting.' Finally, any doubts about the artist's talent

Draft book cover for Putnam, showing the use of texture and pattern.

Cover for *Wigtown Ploughman*, one of a series of lithographs for John McNeillie's books published by Putnam.

Cover image for Karen Blixen's *Out of Africa*, executed in a more painterly manner.

would be removed by his watercolour landscapes. His reputation was growing, and in November the same year he was invited to show in the 31st exhibition of the London Group at the New Burlington Galleries, where he exhibited a nude alongside works from such renowned artists as Sickert, Vanessa Bell, John Nash, Roger Fry, Ivon Hitchens, and Rodrigo Moynihan whom he was to know so well at a much later stage in his life.

Restless again (but for financial reasons more than anything else) Darwin was once more on the move. He applied for a job at Clifton College, Bristol, as senior art master and with references from distinguished family friends as well as the endorsement of his own artistic talent, he got the job. An embarrassed letter to Trevelyan on Friday 14 July 1933 admits that 'I have sinned against heaven and before thee and am now no more worthy to be called an artist being in fact a public school master the senior 'art' man at Clifton College, Bristol!' Bernard and Eily were delighted. For Darwin, the main advantage was that the salary was triple that which he had been receiving at Watford, and in reasoning about his new post he mused that though portrait-painting was a way of making money he was not really very good at it - 'now when I paint more easily and more quickly the business of dozens of sittings and a likeness and the eventual appearance of the bastard work of some Academician is unendurable'.

Robin Darwin: riverscape, 1933. This shows the painter's skill with neutral, 'almost invisible' colours.

Robin Darwin: trees in a landscape 1933, watercolour.

However, Darwin's summer vacation was to take an even more momentous turn. On 21 August, a eulogy by the former headmaster of Eton College, Dr Alington, appeared in *The Times*. It was in memory of four Eton masters who had tragically been killed in a mountaineering accident, one of whom was Eric Powell, the popular and much-loved art master. Darwin, suffering another family holiday in Killearn, Stirlingshire, received a telegram from 'Elliott, Jesus College, Cambridge' – Claude Elliott, who was Alington's successor, was a fellow of Jesus – 'Would you consider immediate post teaching drawing Eton?' An interview was arranged for the very next day and, in Darwin's words to Trevelyan: 'I have had a very hectic holiday – in fact it hasn't been a holiday at all... since I saw you last I have become drawing master at Eton and start straightaway next half, taking the place of poor Eric Powell who was killed in the Alps a fortnight ago. Of course this is great fun to me as it is the job I have always wanted, assuming I've got to teach.'[11] (In fact, he was to replace the Second Drawing Master Llewellyn Menzies-Jones, known as Mones, who was to succeed Powell.) Darwin carelessly admits to breaking two contracts, the first at Watford and his new one at Clifton, and in another post-rationalisation also remarks 'I began to realise how horribly far away Clifton would have been'. On finally handing in his notice at Watford on the eve of the new academic year, Darwin received a curt and dismissive note from the headmaster acknowledging receipt of his letter dated 28 August, berating him for breaking his engagement with the governors of the school and 'not coming back next term. I have nothing further to say on the matter'.

Darwin had loved his experience as a pupil at Eton, and this new period in his life was an exciting prospect. After their initial surprise at the rapid change of direction, his parents must have been pleased and proud of him. He and Yvonne were given College lodgings at an elegant stucco double-fronted house called St Christopher outside the Eton gates, and a new life was about to begin, with Trevelyan their first invited guest – 'It will be amusing having you to stay at Eton with us'.

Trevelyan's relationship with Ursula was developing, in spite of the hurtful fact that he admitted the odd inconstancy. She visited him in Paris towards the end of 1933, meeting and becoming absorbed into his circle of close friends (one of whom, Alexander Calder, took such a liking to her he gave her a small sculpture). After this visit, Trevelyan finally allowed himself to decide that they should marry, and because of his fear of a formal church wedding, that the marriage should take place in a registry office; however, as a test of their compatibility, they should first have a holiday together to see if it would really work. The Darwin parents insisted that Bernard's cousin Gwen Raverat should accompany them as chaperone on a journey to Spain. She and Trevelyan were fond of each other, and she had been solicitously concerned about Ursula throughout the 'courtship',

Exterior of St Christopher, with the Eton chaplain, a pupil (probably Antony Palairet), Robin with ubiquitous cigarette, and Yvonne.

worrying for her happiness and a little concerned about Trevelyan's elusive nature. Once they had all settled on a date, the three of them travelled south and thoroughly enjoyed one another's company on a visit to Granada, where the Alhambra and its Moorish style became an important influence on Ursula's work. The marriage finally took place in the autumn of 1934.

In the aftermath of the wedding, there was a painful disagreement between Robin Darwin and Ursula, who as siblings had always been extremely close to each other. It seems that Yvonne did not see eye to eye with Ursula and Trevelyan, and evidently there had been some sort of row at a Guy Fawkes bonfire party. Ursula had sent an impulsive and angry letter to her brother, criticising Yvonne as cool and undemonstrative, and accusing both of cold-shouldering her marriage to Trevelyan. It seems very unlikely that Darwin would have behaved in this way to his favourite sister and his closest friend, but perhaps Yvonne's outwardly impassive manner was the problem. Trevelyan evidently derided Yvonne's taste for 'smart clothes' and thought it an indication of shallowness and 'snobbish, selfish ideas'.

Darwin's reply was that it was difficult to forgive '…things said to one about one's wife…now you admit that you didn't even believe what you said'. His letter indicates that he knew Ursula disapproved of Yvonne, and he also referred to plans for Christmas at Gorringes with Eily, Bernard and Nicola (a rare mention of their younger sister), worried about spoiling Christmas for Nicola and their parents and saying how impossible it would be for both couples to stay there together.

After a surprisingly vicious exchange with Trevelyan (possibly suffering post-wedding anxiety), Darwin wrote to acknowledge that apologies had been made and 'let us now forget all about it…there's nothing to discuss…so now the whole affair is over and closed.' However, he was bewildered that Ursula had shared Trevelyan's 'grotesque notions… I think that by this letter you have done something which I should never have thought possible with us – driven a wedge between us'. He was devastated that such a rift had become possible between him, his beloved sister and his most valuable friend.

On 9 November 1934, a further letter from Darwin to Trevelyan suggests that they forget about the row and 'keep away' for a while, until it might be possible to take things up later when feelings had cooled down. Trevelyan responded and on 16 November, after acknowledging his efforts to close the disagreement, Darwin (back to original form) wrote '…we have just spent a very good weekend at Cambridge. We saw a lot of Anthony Blunt [Darwin had met the great art historian as a student at Trinity] whom I like enormously – a great deal more than his Poussins (sic) (I was on the point of saying his Sickerts (pouss)!)'

Previous relationships, if distressingly a little damaged, appear to have been restored. A final letter from Darwin at Gorringes, some time after, admits with regret '…it has all been so silly'.[12] The most upsetting family row of Darwin's life was over, and it was time to move on.

The above and next page (detail) are illustrations for *Johnny and Jemima* by Bryan Guinness, gouache on paper, 1935. They were never published as Darwin did not feel confident with his style. Note the self-parody as mounted policeman.

4: ETON DAYS

ARWIN WAS OVERJOYED TO BE BACK AT ETON, a place for him of many happy memories. He and Yvonne were delighted with their lodgings at St Christopher, where they made an inviting home, frequently entertaining staff and pupils. It was full of light and elegantly comfortable, mostly furnished with antique furniture picked up in junk shops, and with upstairs rooms in a plainer 'cottage' style. With their paintings on the walls and vases of flowers in every room, it was warm and welcoming. The Eton schoolboys adored Yvonne, and Darwin loved teaching them (in a letter to Trevelyan about being unwell with a cold, he complains 'I still have to go on teaching those bloody little boys. Thank God, at any rate, I'm a good Etonian and honestly think [they are] vastly nicer than those vile Watfordians!')[1]

With weekdays dedicated to his teaching post, 1934 was also a busy year for Darwin the artist. A mixed exhibition of contemporary watercolours at Agnew's in February was followed by an invitation to show at the Redfern Gallery in August, where he exhibited an oil painting entitled 'Flowers in a Window'. His first one-man show of recent oils and watercolours was also at the Redfern, in November. The art critic of *The Times* found him 'a genuine painter' with a

Robin Darwin: skaters (ink and wash, 1935). Images of moving figures framed by a rink or ring were a recurring theme in Darwin's work.

Yvonne and Robin, Cumbria, Easter 1934.

Darwin at Gorringes, spring 1935.

sensitive approach, often deploying neutral tones to suggest 'almost invisible colour'. He was interested in 'continuity of movement', and was most confident when using watercolour 'in which he employs a light-handed scribble'.

One of Darwin's first tasks in the Drawing Schools was to become involved in the organisation of a constant series of exhibitions, supported by major London galleries, which were aimed at nurturing the boys' awareness of art as potential future collectors. Plans for an exhibition of Byzantine artefacts led him to write a letter to Old Etonian Bryan Guinness (later Lord Moyne) to ask if he would 'lend us anything'; this resulted in a generous offer of the loan of several artworks which Guinness had brought back from Greece, and the beginning of a less and less formal acquaintance which was to develop as one of the most influential and lasting friendships of Darwin's life. In the Easter break of 1934, Guinness joined the Darwins for a walking holiday in the Lake District. Guinness was recently separated from his wife Diana Mitford, who had left him for Sir Oswald Mosley, and there had been plans that Ursula would join them for the holiday, but she was unable to do so as she was leaving for her Spanish trip (with Trevelyan and Gwen Raverat). Although efforts were made to find one or two more companions for the walking party, it seems that the three of them went off happily together, with Darwin's instructions to Guinness: 'I shall bring a penny whistle, you'd better too; then we can all go Dolmetsh[2] [sic] + play rounds in the evening!'

Lodging in local farm accommodation the trio spent the days fell-walking and sketching; with packs on backs and Darwin playing them along on his whistle they walked between Windermere and Patterdale.

At the end of the same holiday they stayed at Biddesden, Guinness's home near Andover, with a house party including Diana's sister Pamela Mitford, the painter Henry Lamb and assorted titled friends. The Guinness entourage orbited around the pinnacle of London's artistic and social scene, illustrating a hedonistic world recreated in the novels of Evelyn Waugh (a close friend) and his contemporaries. The Darwins visited Biddesden again in July, the party this time including the designer 'Ted' McKnight Kauffer, Marion Dorn the textile designer, Frances and Ralph Partridge, and Peter Quennell. A letter from Yvonne suggests that they are then to visit Guinness in Ireland: 'Everyone tells us that a wild mob may appear at any moment & burn down the house…so please to put out your howitzers before our arrival'.

After spending time in London (one day taking a steamer from Westminster to Greenwich), and then visiting Darwin's venerable aunt Mildred and uncle Leonard, the inevitable family holiday had to be endured. On the way they made stops in cathedral cities between King's Lynn and the Scottish borders, finally crossing the Firth of Forth to arrive at Killearn for a few days' golf.

Guy Burgess, posing with Weymouth Harbour as backdrop, 1935.

A group of photos from January 1935, taken in Weymouth harbour, shows Darwin's glamorous, and later notorious, friend Guy Burgess, whom he knew from Eton schooldays and Trinity. Following what was probably seen as a 'duty' visit to Gorringes in the spring of that year another stay at Biddesden followed, this time in the company of Aldous Huxley (tenuously related to Darwin by marriage) as well as McKnight Kauffer again. Darwin particularly enjoyed this visit, complimenting Guinness on a 'marvellous weekend' and his choice of guests, particularly the Huxleys whom he found specially good company. While at Biddesden, the Darwins entered into the rhythm of country life there, helping with lambing, or 'belling' the cattle before they were released into the pastures.

The Darwin's life had taken a new and alluring direction. Bryan Guinness and Robin Darwin became almost inseparable friends, and weekend visits to Biddesden became more and more frequent. Guinness's sensitivity in selecting compatible groups amongst his distinguished circle of friends really worked, as endorsed by Darwin's letter of January 1935: an 'enchanting weekend… so rare to meet a lot of people…& to like them all – at least rare for me!' The most generous of hosts, Guinness would often send the Darwins, back at Eton, personal presents (once, a beautiful portfolio for Yvonne) and large bouquets of flowers from the garden – lilies, or striped tulips, Darwin's 'passion'. These last elicited a letter remarking how 18th-century artists adored them, and then berating the Victorians for insulting the Darwin family name by 'destroying systematically the natural decoration in a flower'.

Guinness was also an accomplished writer. He published a number of novels, poetry and a series of children's books, for which he ventured to ask Darwin to supply illustrations. Early in 1935 a letter from Darwin discusses layout: 'I should rather like to see it rather particularly "modern" …with each left-hand page telling the story and each right-hand page to be a picture, without any margin whatsoever, the simple flat colours going right to the edge'; similar to some French children's books Darwin had noticed, 'thrilling as productions and

Robin Darwin: Biddesden House, Bryan Guinness's country home c.1934.

Pamela Mitford, the painter Henry Lamb and Robin Darwin at Biddesden.

Bryan Guinness and Darwin at Biddesden.

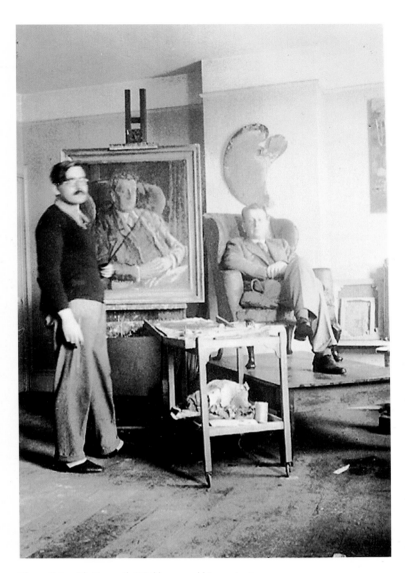

The artist, with Kenneth Wickham and his portrait.

The rose garden on the roof of Fortezza Brunelli, Aulla, Easter 1935.

Aulla, from the Fortezza.

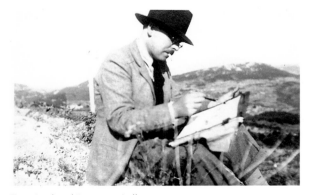

Darwin sketching near Aulla.

Yvonne in Venice, 1935.

very cheap'. As few colours as possible should be used, for economy's sake, and Darwin suggests Putnam's as publishers.

One of Darwin's closer colleagues amongst the Eton staff was Kenneth Wickham, a housemaster whom he had known when a pupil, as teacher of modern languages and history. Darwin embarked on a portrait of him, which later hung in St Christopher. In the Easter break of 1935 the couple went with him on a tour of northern and eastern France (Soissons, Rheims and Nancy), crossing the Swiss border to put the car on a train at Lucerne, and then driving from Lake Como to Aulla in northern Italy, taking in churches and cathedrals at various halts on the way. However, the Darwins began to tire of Wickham's keenness to visit numerous ancient monuments and art galleries in preference to 'an aperitif or a curiosity shop' and criticised his assiduous use of Baedeker guide books, rushing about 'ticking off sights like a cash register'.

Fortezza Brunella at Aulla, where they arrived on 11 April 1935, was owned by the Waterfield family. It was in a spectacular position, a 16th-century bastion with staggering views high above the meeting of two rivers, near the Carrara marble quarries. Darwin found it an inspiring place to paint, while Yvonne sunbathed in the rooftop rose garden with the largely male house-party which again included Guy Burgess. She always took an interest in the staff of their lodgings wherever they were staying, and delighted in taking snapshots of them and their children. From Aulla she and Darwin travelled south to see churches

and monasteries in Lucca, Pisa, Ravenna, Padua and finally Venice, where they witnessed a 'fascist birthday party' in Piazza San Marco.

Darwin, busy with his teaching, still managed to find time to paint and to pursue other projects. As well as undertaking commissions for portraits, in May 1935 he provided specimen drawings for Guinness's book 'The Adventures of Johnny and Jemima'. However, he felt less than comfortable with this genre and stressed in a letter to Guinness that it was not obligatory to use him as illustrator. Uncomfortable with the brief ('can't help wishing you hadn't introduced quite so many animals'!) and despairing of the results, he suggested the artist and designer Roland Pym as a substitute. Pym went on to provide the final pictures and, later, to continue working with Guinness on certain decorative projects at Biddesden.

Summer 1935 was largely enjoyed in England. After celebrating the excitement of King George V's silver jubilee procession through Windsor (passing directly outside St Christopher) in May, the Darwins spent the summer vacation motoring around to visit various friends in country houses in Essex and Kent. The weather was good enough that year to allow outside drama performances – Shakespeare's 'Twelfth Night' (an all-female cast) at Langford Grove near Maldon, where Darwin escaped to paint scenes of the Blackwater estuary, and the ballet 'Rosamunde' at Hayes Court in Kent, evidently performed with reference to the fashionable style of Margaret Morris, based on classical Greek dance. The rather austere costume design may have seemed unexciting to Darwin with his love of pageantry and ceremony. Like his uncle Jack he revelled in dressing up and his cousin Peggy Pike later remembered a visit to Glyndebourne when he flatly refused to wear evening dress, insisting on turning up in the grand ceremonial jacket which belonged to his father as Captain of St Andrew's Golf Club.

After the customary annual visit to Uncle Leonard and Aunt Mildred, the most exciting part of the summer was to come – a September expedition at the end of the holidays, much further afield, to Russia. Virtually no record exists of this ambitious journey and, sadly, the album filled with photographs is now missing. The only mention of the trip is in a letter sent to Guinness afterwards, remarking that Yvonne travelled back separately by train instead of boat, bringing Darwin 'a magnificent priest's robe. But even my figure + 3 cushions aren't enough to fill it!' It is unclear whether Darwin made his sketches for his 'Russian Ballet' series on this visit or in Paris or London, but at some stage that year he was invited to work both backstage and in performances of 'Les Sylphides' and 'Lac des Cygnes', recording the ballet for an exhibition the following year. *The Times* reported that 'the artist they occasionally recall is Gauguin'. Performance continued to hold a fascination for Darwin, and during

Robin Darwin: ballet class, dancers sketched in rehearsal, 1935.

the same period he produced vivacious paintings of the circus and of dancing skaters, using the rink or ring as a framing device for the performers.

The artist continued to be busy. At Eton's 1936 Fourth of June celebrations, the school's cricket professional Mat Wright was presented with a portrait by Darwin to mark his retirement after 50 years. *The Times*, reporting on this, also found space to praise the exhibition of boys' work and a collection of modern pictures in the Drawing School. On 1 July, Agnew's opened a one-man show, 'The Russian Ballet – a painter's impressions'. With Darwin's interest in movement and dance, he had produced a remarkable number of paintings and sketches. His 'very personal taste in colour' recalled to some the intensity of Gauguin's palette, and the forty-two works were full of animation and grace. Some of Darwin's work from this period shows an interest in creating more abstract images, a departure from his customary figurative point of view; his abilities could adapt to producing both detailed naturalistic representations of his subjects, and much looser, emotive impressions. It seems that at this period he may often have made painting expeditions with Adrian Daintrey, some of whose work shows remarkably similar subject matter.

Holidays followed the customary peripatetic pattern. Letters from both of them to Guinness make it very clear that funds had not allowed them to

Robin Darwin: *A ballet dancer – Lac des Cygnes*, 1935, oil on canvas.

Robin Darwin: *Corps de Ballet*, 1935-36.

join him on an Easter riding holiday that year: 'I wish we could wait until next September when (with any luck) I shall be rolling after my show at Agnew's. Spending a week at Gorringes, Yvonne wrote that after discussing 'lovely plans' to visit various European countries, lack of money and the thought of '36 hours of third-class railway' had decided them to stay in England and 'be good', the only excitement being to join her parents in Bruges 'thus being doubly good – after this we shall be able to be bad for quite a long time as our family credit is excellent'.

Following the Russian Ballet exhibition, the Darwins were invited as guests of the British Legation in Sweden to make a visit to Stockholm in August 1936, which resulted in a series of atmospheric new paintings. Early in the following year, the couple stayed with the Partridges in Kent, and a photograph of a derelict and pretty nearby farmhouse suggests the possibility that there were thoughts of one day moving from Eton. Easter brought another busy French itinerary, four weeks completely packed with cathedrals and churches, beginning at Chartres and heading south-east via medieval sites in the Dordogne, to the Roman towns of Avignon and Orange. They did stop for two weeks in Beaumes de Venise, where Darwin was able to sketch and paint the spectacular landscape around

Robin Darwin: *From the Town Hall, Stockholm*, 1936.

Robin Darwin: canal basin, 1936. This shows a departure from the customary figurative images into a more abstract style of painting.

Mont Ventoux, and where Yvonne made friends, as she always did, with the hotelier's family. The coronation of King George VI is recorded in May 1937, and it seems that the summer that year may have been spent nearer home, with photographs of parties at Downe, in London, and idyllic picnics by the Thames at Eton. The reason for this more economical holiday option may have been that Darwin had fallen in love with his ultimate car – he had bought a 1925 Rolls Royce, with bodywork painted in a pale yellowish 'woodgrain' effect, that he had spotted for sale in Windsor. (The crazy expense of running a Rolls for one English summer vacation was, in fact, quite possibly more costly than a month travelling around Europe).

The idea occurs that these packed holiday itineraries may have been arranged as a diversion from a relationship possibly beginning to show signs of strain. After a busy term at Eton, although he loved his work, Darwin must have wished for periods of tranquillity where he could simply enjoy painting on his own, or for the quiet company of a few close friends; on the other hand, any chance to drive around proudly in his spectacular car must have been an encouragement to travel. Alternatively Yvonne may have looked forward to getting away from home, where she naturally spent more time than he did, and enjoying the socialising and house-parties arranged during the vacations. At any rate the

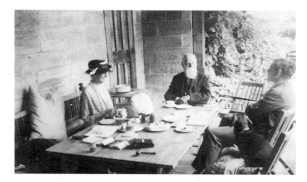

With Mildred, Lenny and Konrad at Cripp's Corner 1937.

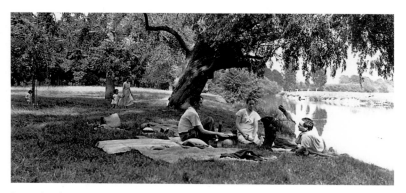

Picnic by the river at Eton, 1937. Antony Palairet, Yvonne and Robin.

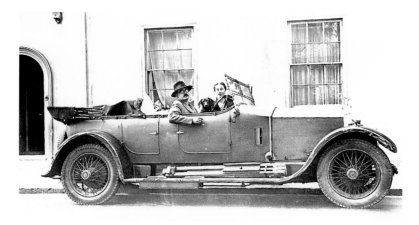

The yellow Rolls Royce, with easel strapped to the running-board.

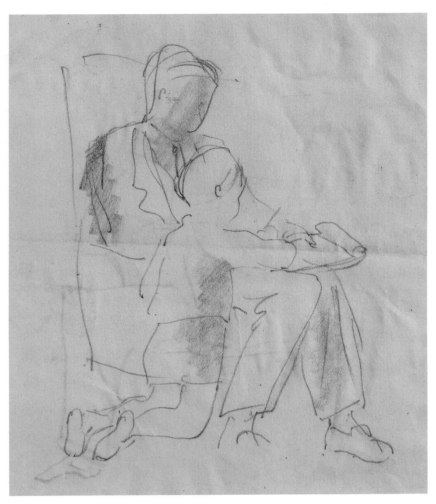

Robin Darwin: Jonathan and Bryan Guinness reading at Biddesden, 1936, pencil sketch.

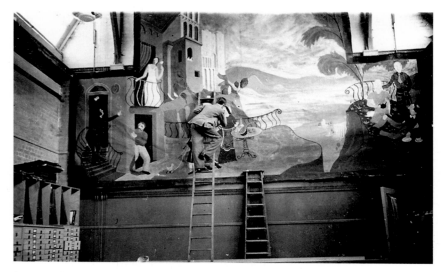

Dennis Pullein-Thompson working on a somewhat surreal stage set at Eton.

The Drawing Schools, master and pupils.

John Pym MA ARIBA: Drawing Schools, Eton College. Sketch plan of additions, February 1935.

holidays were almost always based (like those Bernard had organised for his family) on a constant sequence of visits, each destination following quickly after its predecessor with no time for much relaxation in between.

Darwin's post as Second Drawing Master was as perfect for him as a job could be. Although the beloved Eric Powell was a difficult act to follow, the subject of art had not been a popular one amongst the boys, and a 'bribe' of £6 per head had even in his time been offered to any boy willing to join the classes. Darwin's dedication to the school and its pupils, and his ability to inspire and communicate with them, made him a popular teacher; the boys admired his somewhat rebellious attitude, signed up, and the bribes had to be discontinued. Darwin's somewhat anarchistic approach (Eton legend records that he was responsible for destroying the casts used in classical drawing lessons) had already revolutionised the old-fashioned traditional teaching of watercolour painting: the pupils quickly responded to his suggestion of a more abstract use of colour and form. His main method of teaching was to inspire and encourage, rather than physically demonstrating a technique. In addition to fostering a lively interest in painting in oils, which had not previously been a major part of the syllabus, Darwin introduced an element of theatre into the curriculum, encouraging the skill of puppetry: setting up a stage and getting the boys involved in the complete production from the creation of the marionettes, the

scenery and publicity posters, to the voices, music and action of the final show. This became a long-standing Eton tradition though now it no longer exists. For each of the next three years there was an ambitious programme of end-of-term shows, with three marionette plays each season. The boys were also involved in creating full-scale scenery for plays by the school's dramatic society; Darwin, with his love of drama, enjoyed the involvement in a live theatre production.

A piece in *The Times*, 5 December 1935, about 'Art at Eton College – Talent and Technique' compliments the method of teaching: '…the general impression is that of a tactfully guided release, as if the teaching were based upon the common sense view that the aesthetic instinct is in some degree as universal as the sporting instinct and ought to be given an equal chance of disciplined expression.' It highlights paintings by de Grey, Benthall and Scarlett, notable puppet theatre posters by Longman, and modelling and carving by O'Hagen and Boyle, as well as a competent 'architectural' model by Cleminson. Robin Darwin was a dedicated teacher and his success was clearly due to his method of individual tuition, nurturing each boy's skills and bringing out his best.

Earlier that same year, Darwin had begun to agitate for an addition to the Drawing Schools. Set up by Dr Alington, the previous Head Master, the large and well-equipped art department was in a classical-style 1920s building facing the Parade Ground. Thanks to Darwin's introduction of so many new subjects into the curriculum the Schools had outgrown their accommodation, taking over all possible areas including the exhibition space. Darwin, able to visualise how an extension would work, asked the architect John Pym (brother of Roland, whom he had recommended to Guinness as illustrator) to draw up a plan for new studio and schoolroom spaces to be added each side of the existing building. In agreement with the College, he then scrawled out a draft for a two-page 'begging letter' to be sent to a small selected group of potential donors, old Etonians (such as Guinness's father) whose sons had also studied there. He sent this draft for Guinness's approval, accompanied by a personal letter making it clear how disgraceful and humiliating he felt it was that Eton should have to appeal at all, and that the college should have dealt with the problem long ago; however, '…unless people do help it <u>won't get done</u>. And that would be a real mistake.'

The *Eton College Chronicle* for 9 December 1937 reviews an 'Exhibition at the Drawing Schools'. It remarks that the new discipline of ceramics is already much improved since last year (Darwin had worked hard to support Mones' dedication to the teaching of this subject, in the working pottery Mones had established in a corner of the studio) and praises painting exhibits in watercolour and oils. However, the highlight of the show is the Grocer's Shop. Darwin, always wanting to encourage new (and in this case commercial) abilities, had promoted an interest in graphic and interior design and the boys had not only produced

Design for packaging and display by Eton pupils, 1937, underlining Darwin's awareness of the importance of commercial design.

designs for packaging, but also a very competent effort at modern shop display. This shows an early example of Darwin's awareness of the importance of teaching industrial design, which would shape his career in the years after the Second World War. It was a triumph that the trade magazine *Store*, February 1938, thought fit to print a review of the exhibition, indicating that 'designs were carried out with an economy of line and a full appreciation of colour massing and blending. Printing and display techniques were also considered. The arrangement of the shop' (many units of which had been prepared unaided by the boys) 'showed that Mr Darwin's skill was behind the general scheme'.

However, Darwin had new ideas. In a letter earlier that year, thanking Bryan for his own donation towards the Drawing Schools extension, he admitted 'I have resigned as from Xmas next'. Three years since he started agitating for the new studios, with the building now becoming a reality, he had decided that it was time to leave. He had adored teaching and enjoyed the company of the boys, but had been known to describe the staff in general as 'an asylum of blockheads'. At times he had felt completely consumed by his work at Eton, and '…you can't think how happy I am to feel there's an end in sight to this life of convention and ceremonial!' (As it happened, the 'ceremonial' aspect was deeper-rooted in his emotion than he realised, and later in his life it was to resurface as something he considered a necessary element of the educational experience.) '…I shall have a real holocaust of white shirts + ties + collars, caps + gowns and a lot else, on Fellows Eyot!'

Coastal Landscape, undated, showing Darwin's new 'control of colour', and a composition remarkably like that of Jack Monsell's 'Mentone'(see p.29).

The edition of the *Chronicle* for 5 May 1938 mentions that, finally, 'a pottery room was built on to the Drawing Schools... This venture was as successful as all the other brilliant innovations that have been effected from time to time in this department of the School.' It would be Darwin's legacy to Eton, along with the Marionette Theatre and the other improvements he had made; his inspired touch had turned the Drawing Schools from a department with a solid reputation but rather a conservative outlook into a 'vital centre of the college's daily life'.[3]

During 1937-38 Darwin continued to exhibit at Agnew's and also, quite significantly as it would turn out, in a show celebrating a new extension at Leamington Art Gallery. July 1938 brought another one-man show at Agnew's. The title of the exhibition was 'The Conquest of Colour' and from the reviews it appears that Darwin was challenging himself. Leaving aside the neutrals, he was now 'tackling the direct relations between one colour and another', experimenting and not always in control. But 'it is in the southern landscapes that the control of colour is most successful'.[4] Darwin was also beginning to experiment with odd and unexpected viewpoints, the angles from which he observed and recorded his subjects often adding an oblique interest to his paintings.

Photographs from the previous December, preceded by several interior shots, sadly record 'the Move' from St Christopher. Darwin actually continued to inspire and teach at Eton until Easter 1938, possibly covering for his successor Wilfred Blunt (brother of Anthony Blunt), but must have had different lodgings in his final term. Leaving his beloved Drawing Schools was a brave move. It may have been a joint decision with Yvonne, or possibly even led by her, that Darwin gave up his Eton career to move to the country in order to concentrate on his own painting. They found a relatively small but rather grand Regency manor house at Winson, near Cirencester (probably quite affordable at that time, in an England of sadly abandoned country estates) and settled there to begin a different kind of life.

Robin Darwin: *Clown*, 1938. Continuing fascination with performance, and a more relaxed style of painting.

5: WARTIME

T HE DARWINS, HAPPILY INSTALLED in their new country home, were already entertaining a full house of family guests by Christmas. They began to enjoy a new and much more rustic existence, punctuated with the inevitable social occasions (all the more necessary now that the demands of Eton were becoming an experience of the past). Yvonne in particular took great pleasure in a different pattern to her life. A letter written in August 1938 from Darwin to Bryan Guinness, married since 1936 to Elisabeth Nelson, thanks him for the initially disturbing present of a baby goat: '...I am now more than reconciled to it. Yvonne insists on spoiling it and takes it for walks through the village! It gets very lonely without its Mamma and bleats a lot still'.

The same letter mentions Darwin's large and diverse show at Agnew's in June/July. He exhibited sixty-five paintings of many subjects, completed over the previous few years, almost a mini-retrospective of his life in the mid-1930s. 'Considering...that there is supposed to be a bad slump [they] decided to keep prices the same if not lower than 2 years ago and I think they've turned out to be right'. Rapturous at once again being able to devote his time to the skill he loved, it seemed that life was now going in the right direction.

However, the idea of a tranquil country existence in the Cotswolds was not to last long. War was declared in September 1939 and in the latter half of 1940 Darwin applied for a posting in the Civil Defence Camouflage Establishment, whose headquarters were in the Regent Hotel in the gracious Georgian spa of Leamington, about forty miles from Winson. The spa's municipal skating rink was transformed into a huge studio for the creative department, and nearby Baginton airfield became the base for the essential aerial surveys which underpinned all camouflage designs.

Officers to be recruited to Camouflage were selected by the Central Institute of Art and Design. This was a body set up in 1939 with the object of supporting British artists in times of war; its distinguished panel included Kenneth Clark (then director of the National Gallery) and Jack Beddington, advertising director for Shell-Mex and British Petroleum. They worked with the government in compiling a register, separate from that for the Official War Artists, of designers and artists who would be eligible for special wartime work which included camouflage, propaganda and publicity.

The Chief Camouflage Officer, Captain Glasson, was responsible for interviewing and recruiting a team of officers 'having good artistic training and in many cases some experience of industrial design'.[1] Amongst the first

Camoufleur Anne Newland's sketch of the Rink at Leamington, c.1941, with Darwin-like figure far left.

Camouflage officers were painters Thomas Monnington, Cosmo Clark and Richard Carline, and successful applicants in the first series of job allocations were designers Richard Guyatt and Christopher Ironside, painter Edwin LaDell and sculptor Leon Underwood. Amongst further notable recruits from art and design were architects Hugh Casson, Basil Spence, Robert Goodden and R.D.Russell; designers James Gardner, Ashley Havinden, John Lewis, Oliver Messel and Victor Stiebel; artists Frederick Gore, John Hutton, Roland Penrose and Julian Trevelyan. By October 1939 the register was closed, having been inundated with sufficient numbers of would-be camoufleurs, many of whose names would later become highly influential in the world of post-war art and design.

Numbers grew at the Ice Rink, and by December 1940 the local population was becoming accustomed to seeing an unfamiliar but amiable group of new residents, unorthodox and often eccentric in appearance with their 'hair of varying lengths' and off-duty navy blue donkey jackets. The newcomers included not only artists, architects and designers, but also scientists, engineers and photographic specialists. There was an inevitable spirit of camaraderie amongst this maverick group of uprooted creatives, who would regularly amuse themselves after hours by throwing lively parties and on summer weekends, much to the entertainment of the locals, embarking on spectacular picnics.

The graphic designer Richard (Dick) Guyatt was one of the team of original recruits, having moved to Leamington as a camouflage officer when the

Richard Guyatt and Robin Darwin constructing a scale model.

headquarters relocated from Holborn. He recalled the arrival early in 1941 of a 'new boy' in his section who 'immediately took control' – Darwin's expectations did not include the idea of being in a subordinate position. True to form, his first inspection flight was a drama – the aircraft was attacked in error by inexperienced 'friendly fire', mistaking it for a Messerschmidt. He became an expert, with Leon Underwood, in the disguise of electrical sub-stations, the two of them motoring grandly around the midlands countryside in his Rolls (Darwin in a black fedora and Underwood in a brown velour pork-pie hat) much to the suspicion of the local police. One morning not long after his arrival, Darwin announced to Guyatt that, while on fire duty, he had (naturally) looked into the Director's office and gone through a few papers on the desk. He had found that Guyatt was to be made Regional Camouflage Officer for Scotland and that he (Darwin) was to be on Guyatt's staff. Retorting 'I'm damn well not having that!'[2] he immediately managed to have himself re-employed as Secretary to the Camouflage Committee, a position, according to Guyatt, of much more suitable stature. Leamington remained Darwin's base (a letter from Guyatt to his wife Elizabeth records '…Daddy Darwin returns tomorrow to stir things up again') but he frequently had to attend meetings in London, which suited his urbane nature. Always by that time wearing a formal suit, with the moustache he had grown at the Slade a mask for his shyness, he hid behind a 'bluff of aggression' which concealed the insecurity of his true character.

The architect Hugh Casson, after training in camouflage at the Air Ministry in London, took up the post in 1940 of Regional Camouflage Officer for no. 9 Works Area based in Cheltenham, and was responsible for a region stretching from Oxford to Cardiff and from Stratford-on-Avon to Salisbury. He remembers

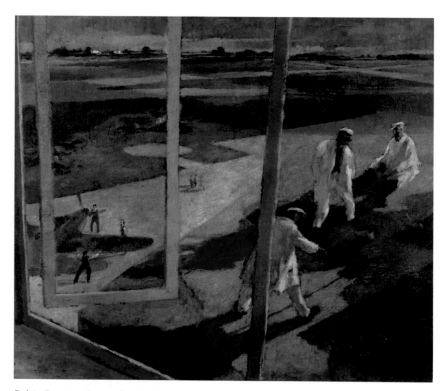

Robin Darwin: *Camouflaging the new Flight Shed*, 1941. Members of the Camouflage team were given time to record work in progress.

his first meeting on site with Darwin, a 'Captain Biggles' lookalike heaving his 'considerable bulk' (enhanced by padded leather) out of a two-seater plane, very cheerful but slightly alarming with his moustache, goggles and flying-helmet;[3] it was like meeting 'a pressure-cooker in flying boots'. Casson recalls that he only met Darwin two or three times in the war, but these meetings were enough to ensure that their paths would cross and recross at a later stage in their lives.

Darwin's experience in Leamington opened his eyes to the huge importance of the work carried out by the camouflage teams, and to the need that a faintly disapproving Government should better understand and endorse this. As a trained artist and member of 'the Establishment' he was uniquely able to see the issue from both points of view. In answer to a request from the Ministry of Information, he wrote a paper[4] explaining why it was so important for artists and designers, this 'race of carefree individuals', to work alongside the engineers, architects and scientists involved in the creation of successful camouflage. His eloquent and persuasive report, the first of many influential communications,

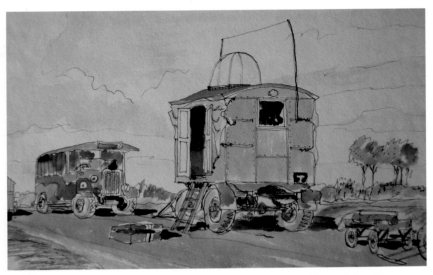
Hugh Casson: caravan and camouflaged bus. It was during World War 2 that Casson developed his skills as a watercolourist.

made it clear that 'so far from being black magic', the officer's artistic training would enable him to understand how to conceal or alter the appearance of a potential target. It was essential to have an artist's powers of observation, in addition to an intimate knowledge of form, in order to contrive 'the very best concealment possible within the limits allowed'. After a reconnaissance trip (usually by air) where detailed notes and sketches would be made, a scheme would be developed, using perspective drawings and, if necessary, scale models. These would be delivered to the contractor allocated to the task.

Darwin's paper concluded with the observation that the two parties, perhaps previously imagined as incompatible, had learned to work together by understanding one another's point of view. His words emphasised the significance of an issue that was to become for him a lasting credo – that of the crucial relationship between science and art, whose mutual support underpinned the successful development of camouflage schemes and without which the post-war renaissance in industrial design would not have been possible.

Throughout the war, Darwin's paintings had been shown in several exhibitions at Agnew's and at the Leger Gallery. There was an exhibition at the Stafford Gallery in May 1940, and in October 1943 he was given a second one-man show at the Redfern. The slightly derogatory *Times* review remarked that his sense of colour was 'pretty' and that his 'misty style' was 'akin to that shown by the Euston Road Group'. The drawing and modelling of the nudes was less

Robin Darwin: *Friday Street*, c.1943, a record of bomb damage in the City of London.

than convincing, but a portrait of Richard Guyatt was 'firmly conceived'. In contrast to a previous reviewer's words, 'Mr. Darwin is more successful when he has clearly worked hard at a picture' than when it is left as a sketch. It may be that the commitment to a full-time job, as opposed to one in education where vacations were available for painting, created noticeable restrictions on the artist's time and inhibited the quality of his work.

During Darwin's employment as Secretary, and subsequently Senior Administrative Officer to the Camouflage committee, he rented rooms in Cheyne Walk (by the river in Chelsea) which he shared with the modest Peter Barker-Mill. Dosia Verney, whose husband, the artist Barry Craig, had met Darwin at the Leamington headquarters, remembers it as a 'snob's boarding house' owned by James Lees-Milne and Richard Stewart-Jones; there were fifteen lodgers, a dining room and a common room. Yvonne Darwin had been successful in applying for a War Office appointment in the Women's Auxiliary Air Force, and was often away. The couple would meet in London when possible, or for rare weekends at Winson where they would invite guests such as Dick and Lizzie Guyatt. Darwin enjoyed London life and managed to sustain his previous extravagant style: even though his resources may have been slighter than those of some of the other tenants, he bagged the grandest room on his floor and continued to entertain regularly and somehow to find enough fuel for trips to the country in his trusty Rolls Royce.

Robin Darwin: *Yvonne*, c.1943.

The Camouflage operation's output after the battle of El Alamein in 1942 took a radical change of direction. The main battles of the war had been diverted to North Africa, where the Royal Engineers (whose camouflage team included Julian Trevelyan) found that in the desert, the barren landscape dictated that deception rather than concealment was the only way to fox the enemy. They began to construct dummy anti-aircraft sites to lure attention away from the actual emplacements, and this method of decoy led to the remarkable plan of deception and counter-deception which finally defeated Rommel's troops at El Alamein. This victory, in its turn, meant that a new perspective on camouflage (combining former methods with alternative ways of trickery) would be the way forward in Europe – decoy and display, rather than disguise and concealment, would encourage the enemy to make crucial mistaken assumptions in their fatal attack on northern France.

The Leamington centre, scene of so much genius and invention, was disbanded and in August 1944, the army camouflage unit at Farnham, the base for the master-plan of Operation Overlord and the Normandy landings, was closed. Although further military appointments were found for those officers working at Farnham, the creative team at Leamington was another matter. Several of them, architects and designers including Dick Guyatt, were found positions in the Ministry of Town and Country Planning, set up in 1943 (later to become

the Ministry of Local Government and Planning) which dealt with the national redevelopment of bomb-damaged areas and the consequent reinstatement of public services. Darwin, benefitting from his Government experience with the Camouflage Committee, was offered the post of Administrative Officer to the Ministry in 1944.

Under the Town and Country Planning Act of 1943, it was the function of the Minister (the Right Honourable Lewis Silkin, M.P.) to organise a programme of post-war reconstruction assessing the 'use and development of land throughout England and Wales'[5] and the infrastructure – housing, roads, agriculture – dependent on it. The Headquarters Planning Committee would co-ordinate policy while allowing each area to meet its own requirements, giving general direction to the Regional Committees, whose representatives and planning officers worked with the main Government departments which included the ministries of Health, Agriculture and Fisheries, Fuel and Power, and the Board of Trade. One of Darwin's main responsibilities was to ensure an effective relationship between the Headquarters and the work of the Regional Committees. There were twelve of these bodies nationwide, and the first action was to prioritise remedial measures which would deal with unemployment. Existing sites and essential services were to be improved, and empty buildings given over for temporary accommodation; the efficiency of local industries examined, and new factories and enterprises encouraged. A programme was set up to offer vocational training and retraining, and where necessary, labour migration was promoted in order to supply regional need.

An essential part of the work of the Regional Committees was the redevelopment of war-damaged towns. There were between forty and fifty badly in need of rebuilding, a dozen or so being exceptionally severe cases. The damage was usually concentrated in the city centre which was the hub of business, commercial and social life. Greater London, Manchester and Merseyside were early prime cases, and the cities of Bristol, Coventry, Exeter, Hull, Plymouth, Portsmouth, Southampton and Swansea were high on the list, many of these having lost their docklands as well as their commercial centres. The major aspects of the Ministry's work were valuation and acquisition, estate development, and of course finance. Grants and loans were made available in order to 'facilitate speedy redevelopment in accordance with a satisfactory layout'[6].

In August 1945 the Ministry of Town and Country Planning was appointed the advisory body to the Reith Committee for the Development of New Towns, and a number of the architects for these were ex-Camouflage designers who had had previous architectural training. Hugh Casson, amongst others, was 'dragged'[7] to the Ministry to work on the residential and commercial centres,

Robin Darwin: *Hugh Casson*, 1957. Casson continues to wear his forces-issue duffel coat.

nascent new towns aiming to decentralise settlement and industry from London. (It was there that he would have met Sir Stephen Tallents, the Ministry's charismatic public relations officer, with whose organisation 'Cockade' he was to work so closely in the Festival of Britain and afterwards). The Civic Design manual set out the priorities for residential neighbourhoods: as well as layout, grouping and circulation for domestic properties, shops, schools, local industry, public services and worship, its remit included the provision of important open spaces, and the 'garden cities' of the late 1940s began to take shape.

Robin Darwin enjoyed renewing his acquaintance with a number of colleagues from the Camouflage group, particularly as those working on the New Towns were architects, for whose disciplined way of working he had a great admiration. He was fascinated with the essential balance of science and art that underpinned their work, and the fact that a drawing office seemed to be the ideal *atelier*, having the attributes of both studio and workshop. He became very friendly with Casson, painting his portrait in lunch-hours, all the while 'exploding like a geyser…with his ideas for the future'.[8] When Darwin was

genuinely interested in his subject, as he was in this case, his portraits really came alive. While his self-portraits were critical, truthful records of how he saw himself, perhaps painted to exorcise his discomfort with his appearance, it was his paintings of those who were close to him which most often demonstrated a sincere and empathetic understanding of the sitter.

Darwin was not to stay long with the Ministry. Well before the war was over the government had begun to think about the future restructuring of the nation. As early as 1943 the President of the Board of Trade, the Right Honourable Hugh Dalton, had formed the Weir Committee which proposed the creation of a Central Design Council and in December 1944 the Council of Industrial Design, a grant-aided body supported by the Board of Trade, was set up. Its main aims were to promote a better understanding of design in industry, in order to stimulate the sale of British-designed goods, and, crucially, to work with educational authorities in the training of designers. The Council's first director was S.C. Leslie, and of the eighteen-strong committee of members the majority were eminent industrialists. In the council's first Annual Report of 1945-1946, the head of the Training Committee (which worked closely with the Ministry of Education) is listed as Christopher Ironside, and its Secretary (quite possibly recommended, on the strength of Camouflage experience, by Ironside) Robin Darwin. The idea of working for the Council, with its distinguished panel and its desire to get industry and design working together, appealed to Darwin, and the educational aspect was particularly close to his heart. A new instalment of his life was about to open, one in which his influence would forever change the nature of British art and design education.

6: THE COUNCIL OF INDUSTRIAL DESIGN

O N 12 JANUARY 1945, a rare gathering of distinguished names took place in London. This impressive group, which included such influential heavyweights as Sir Kenneth Clark, Gordon Russell, Allan Walton and Josiah Wedgwood, had convened to hear Hugh Dalton speak at the inaugural meeting of the Council of Industrial Design (CoID) of which they were all members. The message was that although the subject of design in Britain's industries was by no means new, it had a new urgency: the ravages on the nation's economy meant that the export market had been overtaken, not only in the war years but also before, by the advent of sophisticated machine-made goods mainly from America but also from Sweden, Germany and Czechoslovakia. Dalton highlighted the inescapable fact that 'Something like an industrial revolution has taken place... a revolution of industrial design'[1], and Britain's manufacturing potential, diverted by the war, had been left behind. Following this up in a later memorandum, Nikolaus Pevsner with the objective view of a recent outsider, remarked that in spite of its remarkable heritage England had for too long a time suffered from an aesthetic inferiority complex: '...the land of Chippendale, Wedgwood, Morris...[and] Eric Gill cannot be devoid of design genius.'[2]

Dalton's speech emphasised how fundamentally important it was for industry and its leaders to recognise the need to reinvigorate Britain's foreign and domestic trade. A sustained effort must be made to improve British design, in order to reinstate and surpass the volume of the pre-war export market, as well as to supply the home market with goods that would attract the discriminating consumer. One way of doing this would be to establish Design Centres for the public, with the Council co-operating closely with industry, but the only way of tackling the problem at its roots would be to radically rethink the methods of training young industrial designers.

In the years before the war and immediately after it, state education had somewhat negated the need for industry to offer apprenticeships where young trainees would traditionally learn design skills as well as production methods; or, at least, industry had seen an easy way out of training apprentices. The new technical colleges, many of them ill-advisedly set up at the expense of art schools with worthwhile design courses, were offering vocational training to prepare students for industrial employment. This, although commendable, meant that many of the art schools which had managed to survive had become 'remote from reality', concentrating on handcraft and the fine arts, and design

as a subject fell behind. Industrialists could not be expected to employ as designers art students, however aesthetically inclined, who had no knowledge of production processes or business methods; conversely the students emerging from the technical colleges, while well-trained in industrial needs, had no idea of design. The remedy would be for industry to support and influence the teaching taking place at the art schools, therefore being proactive in producing designers specific to its needs.

'The Designer and his Training' in the CoID's first annual report is clearly a collaboration between Christopher Ironside and Robin Darwin, in his position as Training Officer acting as Secretary to the Training Committee. The writing shows a complete understanding of both the aesthetic and the technical points of view: rather like the message in Darwin's wartime 'Role of Artists in Camouflage', the emphasis is on the belief that science and art should be mutually supportive, that in many branches of design one must be 'almost as much of an engineer as an artist'. If it would be impracticable to amalgamate the technical colleges with the art schools, then perhaps industry should step in and assist in creating designers with the right qualifications. In addition to this, Design Centres could help educate managers, buyers and sales executives by organising special courses and exhibitions to enable them to keep up-to-date on design developments.

Darwin's work at the CoID must have offered a complete contrast to his painting. He had since the war continued to show at the Leicester Galleries, the Contemporary Art Society and the Wildenstein Galleries. He was very proud to be included with a self-portrait in the 1945 Royal Academy Summer Exhibition although *The Times* found his painting 'poorly constructed'. The main figure was 'almost lost', and though the painting had atmosphere, it appeared to evade many difficulties with composition. However, a review of his exhibit at the Leicester Galleries in 1946 praised him: '…such remarkable virtuosity that he seems to be positively asking one to find a lack of feeling in his work'.

Early in 1946 Darwin may well have been feeling a little overstretched. According to Wilfred Blunt, his successor at Eton, Darwin was temporarily re-employed there for three to four months to stand in for Mones, whose fragile and idiosyncratic temperament had resulted in some sort of breakdown. It is difficult to imagine how Darwin coped with this double workload (and puzzling that the CoID allowed it). As Secretary he was already deeply involved in his main task which was to undertake with the Training Committee the writing of a comprehensive report investigating all the issues discussed in 'The Designer and his Training'. This massive piece of research was to be produced in close collaboration with the Ministry of Education, with heads of art and technical colleges and with industrialists and relevant experts. The work put into it and

Robin Darwin: self-portrait with nude reflected in mirror, c. late 1940s. With little time to paint, Darwin's style became looser and more impressionistic.

the results of Darwin's enquiry would, by possible coincidence, prove absolutely pivotal to the future growth of his career.

In 1936, the Hambleden Committee had made its own comprehensive and critical report on 'Advanced Art Education in London'. The Committee also considered the possible issue of a new building plan, to accommodate any resulting developments. The report's main conclusion was that 'the study of art in all its forms with reference to industry and commerce' should be the special purpose of the Royal College of Art. As it then happened, six years of war interrupted any action on the reorganisation of the College and, ironically, created a much more urgent need for good designers, whose previously available training based on traditional methods had now become almost obsolete owing to the advances in materials and technology (particularly in light metals and new plastics) created by the war itself.

The Royal College, originally set up at Somerset House in 1837 as the Government School of Design was, in the 1930s, in a less than healthy state, having lost track of its original Government-sponsored mission to provide a training-ground for 'design for the industries'. Nurtured through the 1840s by Henry Cole, it had moved to Marlborough House in 1853 until, mid-decade, Prince Albert and the Royal Commissioners for the Exhibition of 1851 offered Cole a large site adjacent to Brompton Oratory on which to build accommodation for both the School and its Museum of Ornamental Art where

The book of attendance in the painting school at the RCA, c.1920.

design students drew and studied from exhibits. The Museum eventually grew into the Victoria and Albert, and the renamed National Art Training School occupied a purpose-built section of the building to its rear on Exhibition Road. With Queen Victoria's gracious consent, it became the Royal College of Art in 1896. Throughout the late 19th and early 20th centuries, right up to the Second World War, the College expanded and its studios were distributed amongst various buildings throughout South Kensington, occupying a growing number of spaces in and around Exhibition Road as the student population grew.

Having been conceived as a source of designers for industry, the College's *raison d'etre* had diverted somewhat. In the early 20th century there was a conflict between those tutors who believed in an 'arts and crafts' philosophy and those who wished to instigate a more technical approach; and in the main, the College came to be seen as a training school for art teachers. Just before the First World War, the emphasis had swung towards the study of fine art as the predominant subject area; this was a direction which would continue, albeit as 'fine art in the context of design'[3], into the 1920s and 1930s under the enlightened direction of William Rothenstein. As Principal, he set in motion reforms of the outdated and over-academic methods of teaching art and design, realising that to work in industry required a broad knowledge of the selected field coupled with specific talents. Rothenstein also pioneered the concept (which exists to this

day) of employing high-profile practising artists and designers as tutors, and in the inter-war years the College did experience a golden age of emerging talent, producing such graduates as Henry Moore, Barbara Hepworth, Enid Marx, Edward Burra, Edward Bawden, Eric Ravilious and Ruskin Spear – all fine art students, many of whom were equally able to turn their talented hands to a variety of design applications, several returning later as members of staff.

The 1936 Hambleden Report recommended that the College appoint a new board of governors to oversee a reorganisation of the College, which would include emphasis on design for mass production and the opening of new courses in Weaving, Furniture, Commercial Art and Dress Design. It suggested that the subject of Art History be taught by members of the Courtauld Institute, and supported the disposal of Teacher Training as a vocational course. The College's most serious physical issue was lack of equipment due to severe restrictions on space, and an appropriate new site would have to be found.

Rothenstein had already moved on (to the Central School of Arts and Crafts) two years before the Report appeared. The beleaguered College, now without a principal, was once again thrown into disarray. After discussions with the great Bauhaus designer Walter Gropius[4], then in England (whose appointment, if it had happened, would surely have radically changed British art and design education and possibly much of the vernacular appearance of the nation's buildings) the painter Percy Jowett was elected in 1935, an appointment which pleased Rothenstein as 'the College was unlikely to be industrialised'. Between 1936 and 1939, in an attempt to respond to Hambleden, Jowett ensured that new courses were opened in Woven Textiles and Dress Design, that technical instructors were employed in design subjects, and that the College made some effort to involve its students with industry, teaching them presentation skills in order to deal with potential clients.

Well after the outbreak of war, the Ministry of Works was holding discussions on the possibility of a new College site next to the Royal Albert Hall. However, once it was clear that war had really started the senior staff and the students were evacuated to Ambleside in the Lake District where the College was billeted to two local hotels. Studies were, necessarily, mainly in fine art subjects – it was impossible to relocate the all-important workshops, and though resourceful students built a pottery kiln and a weaving shed there was a limit to creative output. When they arrived back in 1945 from this somewhat Spartan existence, they found South Kensington and the main V&A building badly blitzed, their own facilities much depleted, and their numbers eventually swelled by returning colleagues who had been in war service. The Board of Education was muttering about an amalgamation (albeit temporary) with the Central School, and things were not looking good.

Darwin's weighty and comprehensive 27-page document was approved by the Council on July 12th 1946. The 'Report on the Training of the Industrial Designer'[5], produced in belated response to the Hambleden Report and to a post-war memorandum by the Society of Industrial Artists, set out to analyse the English art school teaching system as a whole, with particular reference to the RCA as the[6] pinnacle of the educational experience. The introduction to the report points out that though the Ministry of Education was ultimately responsible, it was imperative that industry itself took an active interest in the education of its future designers. The Council's existing scheme in which it endeavoured to place designers within industry was 'not working out successfully' as designers did not have the necessary draughtsmanship. In the opinion of Milner Gray, because of lack of instruction, 'so often the would-be designer had little idea what he wanted to design'.

The first section of the report lays out a definition of 'design and its implication in respect of training'. In this case the word 'design' means the concept of creating mass-produced goods, regarding aesthetics and function with equal importance, right through to the selection of the most appropriate and economical manufacturing processes. Goods designed and produced by hand production methods (glass, ceramics), theatre design, display and commercial art, are not covered as they are not considered eligible for mass-production. The categories which the report discusses divide naturally into two groups: two-dimensional (mainly textiles of varying natures) – called 'decorative' design by the writer, and three-dimensional, a more extensive field covering the output of all branches of the engineering industries – 'formal' design. Other fields of design would connect with each group: fashion, although its products are of three dimensions, appears to slip into the 'decorative' section while furniture can be included in formal design. Mass-produced ceramics and glass can straddle the two. The resident designers in all these industries are trained craftsmen for whom the English provincial art school system was set up, an Arts and Crafts tradition supporting regional industry, which has become in some ways outmoded with the advent of new engineering methods and materials. However, the fundamental root of design couples an aesthetic sensibility with an appreciation of function and practicality, and industry must in no way lose sight of this.

The report goes on to say that the training of the architect, where 'the root of design is an aesthetic root', was the ideal model for an industrial designer – the combination of artistic talent and technical knowledge is the key. In the words of Nikolaus Pevsner, 'Architects have proved such successful industrial designers in Europe' because of their broad training combined with a practical office background.[6] The report states that the designer must have the ability to

plan; to understand the relevant economics; to be objective about his product, and to work in a team: in other words, an 'alert and trained intelligence together with broad social interests'. The question is raised (or, reading between the lines, it is doubtful) as to whether British art schools were able to provide this training, a way of education which the European Bauhaus idea had long understood. The underlying fact that industry had little faith in the art-school system generates the main topic of the report. For students wishing to study the fine arts, the experience can almost be a dream – encouraging, stimulating, sociable and not necessarily vocational though potentially useful as an informal way of training to be a teacher. Designers, who are also technicians, need a completely different education with aesthetics, technique and related special subjects all being taught concurrently. The report debates whether these two opposite products of the art-school experience could be trained in the same establishment: at the early stages, the dual system could be mutually beneficial, but at a later, more specialist stage, separation would be important in order to concentrate on more technical aspects. These criteria, however, would not relate to the RCA where 'practice of the fine arts should be taught and fine artists trained alongside of craftsmen and industrial designers in these fields' – a 'finishing school of a very special character'.

Continuing with the dichotomy of the relationship between, broadly, science and art (the subject on which Darwin had in his wartime employment written with such passion) the report then suggests that regional art schools and technical colleges should combine forces and each one contribute to a joint course of instruction. This would certainly attract more attention from future industrial employers. The 'decorative' stream of designers would benefit more from the art-school element; the 'formal' designer, where the distinction between artist and technician is less obvious, needs a more rigorously technical training. 'It is not impossible to train designers...by what may be termed drawing-board methods', providing that 'aesthetic considerations' are not lost in the process. The training of an architect is again highlighted, contrasted with that of the technical draughtsman in industry who, though able to draw with knowledge of specialist techniques, has not been made aware of the aesthetic issues of design. In fact, the designer and the engineer should work together, each one's skills complementing those of the other.

However, the report then acknowledges that, with long-standing feelings of disapproval between the two types of institution (probably mostly down to fear of the unknown), artistic and technical, this amalgamation of disciplines will not be an easy task. Darwin comments that 'If artists are sometimes impractical, technicians are at least as often philistine' and this is where joint advisory committees and governing boards could come into play, with

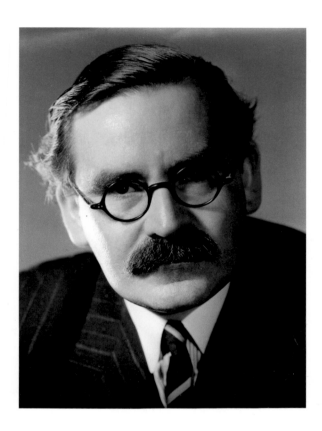

Robin Darwin,
photograph by Robin
Adler, c. 1946.

representatives of each discipline being available to the other in order to create mutual understanding. Darwin's disapproval of the national system (or lack of one) led to a later comment that 'some art schools were secret societies for the suppression of art'.[7] The report deliberately omits any attempt to detail the necessary curricula, and recommends that the Ministry of Education should chair a joint committee with the CoID, appointing expert panels which would lay out training plans for the individual needs of the various industries, with examinations to be set by the Ministry in association with the Society of Industrial Artists.

The next section of the report concentrates specifically on the question of the Royal College of Art. Darwin always felt passionately that 'This metropolitan experience is absolutely necessary... for it is only in London that he will meet contemporary trends and ideas face to face'.[8] The report acknowledges that a training period in London was probably essential to a student of design, whether that student then became a practitioner or a teacher (up to this time, the provincial art schools had run on the incestuous unofficial system of employing

their own graduates or those from similar schools, thus stultifying student creativity). This disputes the Hambleden recommendation that the College should abandon its teacher-training courses; however, the CoID's opinion was that if industry was willing to employ more designers, the need for graduates to teach would become less and the situation would rebalance itself. Students could receive advanced training at the College in two ways – one culminating in a post-graduate qualification, the other as a part-time course for those already in industry, with a design 'top-up' to conclude this. The College would need to rebalance its current offer of a broad education in fine art, design and some basic technology, and to provide 'advanced basic training' in all of its disciplines. In addition to this, it should offer further short courses to those already in industry, particularly designers whose work had been interrupted by the war. There would be mutual benefit amongst these different groups of students.

In the following paragraph, the report confirms the College's suitability for students of the 'decorative' design disciplines but is doubtful that it could sustain those with 'formal' tendencies; it would not be possible for training for the two disciplines to exist in the same school, partly because the areas do not naturally relate at an advanced stage, and partly because 'formal' designers require more costly equipment and accommodation. This rejection of the idea for an industrial department of 'light metals and plastics' was the second main point of difference with the Hambleden report: in general, the CoID had accepted and supported its recommendations.

The final part of the CoID report applies itself to a discussion on the desperate need for post-graduate training in industrial design, the area which the College was at that point unable to deliver. Indeed, if proof were needed of the idea that the College students had no specialised knowledge it could be found 'among the more resolute few who did succeed in becoming successful designers, but who, when they first applied for jobs in industry, were careful to suppress the fact that they held the College diploma'.[9] The report points out that some colleges were already dealing competently with training for industries such as Printing, but there were no realistic facilities for two fields crucial to industry: Fashion, and Light Metal and Plastics. Although schools existed for basic fashion training, and for the study of cutting and tailoring, there was a need for a London school offering advanced training in design at a couture level for the fashion industry, much as was available in Paris. With regard to metals and plastics, development of new technology had emphasised the need for trained designers of anything from an automobile to a hair-grip, and as well as advanced designers, industry was looking for researchers and consultants. The training of the architect is again mentioned, many industrial designers having received that education, but it had become clear that industrial design must be a more specialised subject,

with its own courses. Therefore, although the Central and Birmingham schools both offered courses, a 'new institution' should be planned with all the relevant technical back-up – teaching workshops resembling a 'small factory' where short production runs could be undertaken - and with subsidiary courses such as furniture (to which the new materials were already lending themselves) and photography. The backbone of the school would be the study of materials, and it would be (as would the RCA Fashion course) staffed by professional designers and researchers. As at today's RCA, established practitioners would be attracted to the school for research purposes and for the generation of fresh new ideas. The new school should be 'free from the traditional atmosphere of the Royal College'.[10] Products generated there would be 'commodities with no ancestry' for the new technological age, and the school would therefore be 'to some degree experimental'.

Robin Darwin's first draft of 'The Training of the Industrial Designer', delivered in February 1946, was written 'while I had 'flu… so it suffers not only from repetition and general slovenliness but, what is worse, from wrong emphasis in some places. Nevertheless, it will do to argue over'. It generated much debate from members of the CoID and selected industrialists to whom it had been sent. In response to a letter from Sir Charles Tennyson, who evidently opposed the idea of a 'new school' in place of 'the old one', Darwin referred to teaching at Eton, where it was easy to differentiate between pupils with 'decorative' and 'formal' tendencies – the first went to 'Art School to become Painters, the second started off to be Architects. I had some half-dozen of each and they all ran true to type'.[11] He wrote that 'the Royal College remains essentially an Art School' and does not produce 'the 3D designers we want'. A 'school of quite a different character' was needed, to which 'architects and engineers will come as well as artists, and will feel at home'. Darwin also mentioned the essential concept of research, and the emphasis placed on it by Sir Allan Walton, chairman of the Training Committee. 'Research must go with a post-graduate institution. No-one really supposes the RCA is Post-Graduate'. He went on to suggest that art students should take the National Certificate in Art or Design at age 19 (after 3 years' study), then make a choice: two more years in the same institution would achieve a National Diploma or a scholarship to spend a year at the RCA, culminating in the award of Associate RCA. The alternative would be to study for a further two years at the 'new post-graduate school'.[12]

A second idea would be for students to attend a special 'monotechnic' industrial school in Stoke (pottery), Stourbridge (glass) or Manchester (textiles), allowing the RCA to remain an establishment from which graduates would expect to go into teaching or to be a fine or applied artist (the latter meaning 'the handcraft branches of design'). In addition, 'those very few who go to the

Darwin on arrival at Newcastle, as seen by student Peter Reed, 1946.

New School will meet others who have come by quite different routes', from architecture and engineering schools, or from industry. At this stage, Darwin felt that the 'New School' should teach light engineering, plastics and furniture; interior decoration (independently, or as a link with architecture); display and photography; and fabric printing. The ultimate target would be to produce designers of functional and aesthetically-pleasing goods. As Pevsner put it, 'We do not want the stylist-designer in Britain': a dig at American industry, where in his view saleability and commerce were put before the ideal solution.[13]

Many responses were received. The designer Milner Gray of Design Research Unit (DRU), a co-opted member of the Training Committee, was encouraging. Several correspondents agreed that 'aesthetic training' should take place in

London and should also be open to members of industry and retail whose limited appreciation of design could be improved. Darwin's second draft went out in April, backed up by a letter from Walton confirming the idea that a new institution was the answer to the educational question. With the copy that went to the chairman of the CoID, Sir Thomas D. Barlow, Darwin included a note mentioning that he would be staying over Easter at Gorringes, Downe, Kent – he must have been in desperate need of a rest. Not only had he been working on this extraordinarily demanding paper (which, though never actually published, was eventually discussed at length early in 1947 by the Ministry with the CoID and various educational dignitaries), he was once again busy making new career plans. Keen to get back into art education and having made, for the CoID, such a detailed survey of its needs at a higher level, he had made an application and been interviewed for a new post. On 8 March 1946 he was appointed to the chair of Fine Art at King's College, Newcastle; on 12 March it was 'recommended to Senate that Mr Robin Darwin be appointed Professor of Fine Art and Director of the King Edward VII School of Art [Newcastle] from 1 October 1946, or such earlier date as may be arranged, at a salary of £1,100 a year, rising after two years to £1,200 a year'.

Darwin's life was about to take a new direction.

7: NEWCASTLE, NEW CHALLENGES

THROUGHOUT APRIL 1946 AT THE CoID correspondence, favourable and less so, continued. Constructive and often encouraging criticism was received from luminaries in the worlds of art, architecture, academe and the industries, mainly engineering. E.M.O'R Dickey, Staff Inspector at the Ministry of Education, sent his very detailed comments. A letter passed on from Stanley Cursiter of the Scottish National Gallery came up with some very astute suggestions, particularly one that art school staff, as well as students, should be regularly examined. He also wrote, in doubtful reference to the idea of a Fashion School: 'it's up to God to supply people with a better sense of clothes than the French possess – otherwise, Paris will still remain the centre…'

Darwin was unable to wait until the new academic year, and in May he left for Newcastle, seemingly without Yvonne who evidently remained at Winson. Christopher Ironside took responsibility for his CoID duties, becoming Secretary with Darwin now a co-opted member of the Training Committee. It seems negligent that Darwin 'dumped' his duties in full flood, but when he was able (and particularly in July after the end of term) he honoured his previous commitments. In June, the second draft was circulated to Committee members and the Board of Education. Referring to the RCA, it included options for two routes: one from the particular to the general (for students from industry) and the other from the general to the particular (College and then industrial experience). On 5 July Darwin received a note from Dickey: '…can't resist sending a line of congratulations on having managed to retain so much freshness in spite of the innumerable criticisms and suggestions you have no doubt felt bound to meet. .. I think you have now made abundantly clear the role you think the RCA should play but I still don't quite see what you have in mind as a School of Fashion'.

10 July brought a response from Josiah Wedgwood (a member of the Council) who was 'out of his depth' in the training of industrial designers. 'Notes simply made from the point of view of one who has had to dabble in the matter from the manufacturer's end' (such modesty!) 'Good industrial design… is always the result of good team work. A cooperative personality is therefore one of the greatest assets of a successful industrial designer…Designers need work experience. Schools and colleges can teach a clear understanding of enduring principles.' Wedgwood concluded his letter with the comment that however sympathetic the factory, it cannot make a good technician into a successful industrial artist unless he has the opportunity to cultivate artistic talent in the right surroundings.

On 12 July 1946 the Training Committee, listed below, approved the final draft:

> Mr Allan Walton RDI (Chairman)
> Sir Thomas Barlow GBE
> Sir Charles Tennyson CMG
> The Hon. Josiah Wedgwood
> Mrs Margaret Allen
> Mrs Mary Harris
> Mr Milner Gray RDI
> Mr Kenneth Holmes

Although it was recorded that 'Professor R V Darwin acted as Secretary and wrote the report', Christopher Ironside was now receiving all relevant correspondence. Darwin continued to offer his services when available, prepared to attend important meetings. In December, Ironside wrote a substantial memo to be discussed in advance of a meeting with the Ministry of Education about the draft report. The message indicated that although it was a good idea to have the involvement of provincial centres of industry, and though this was beneficial to research, it was *not* an alternative to a New School. This establishment must cater for two types of student: those from industry, and those from 'a comfortable cultured background' (a comment which now appears surprisingly discriminating, but may refer to the previous institution rather than the student's home). Tellingly, the only disagreement with the Hambleden Committee's recommendations was that such training should be administratively separate from the Royal College.

On 20 December Ironside reported on the Ministry of Education meeting. '…Very enlightening. I had great sympathy with Darwin's final remark that much work could have been saved if we had known a little more earlier'. The Ministry had a 'cautious and realistic' attitude. [It] would help to introduce design into technical schools 'when the need for it is shown….The scheme outlined by the Ministry for the Royal College could meet all our requirements. More detailed plans will need careful scrutiny'.

The CoID had itself had an extremely demanding year, one which interrupted its cooperation with industry, albeit in a positive way. Its annual report for 1945/6 reports on its brainchild, the 'Britain Can Make It' (BCMI) exhibition which opened in the Victoria and Albert Museum in September 1945. Darwin, in addition to working on 'The Training of the Industrial Designer', also wrote the text for *Design '46*, the survey which accompanied this hugely successful show. It was masterminded by Gordon Russell who, with his roots in the Arts and Crafts movement and his modern attitude to design, felt it a national obligation

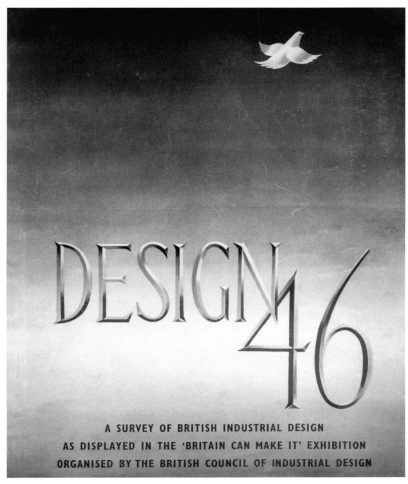

A SURVEY OF BRITISH INDUSTRIAL DESIGN
AS DISPLAYED IN THE 'BRITAIN CAN MAKE IT' EXHIBITION
ORGANISED BY THE BRITISH COUNCIL OF INDUSTRIAL DESIGN

Cover of *Design '46* for which Darwin wrote the text.

to support the tradition of British design and to show the public how it could improve everyday life. Although, in fact, lack of materials and skilled labour prevented many manufacturers from following up with mass-production, public morale was boosted by the imaginative and resourceful displays and the products they showcased. BCMI, with its team of top-rate designers back at work after the War, was to act as a useful dress-rehearsal for the South Bank exhibition in 1951's Festival of Britain. Meanwhile, Darwin had embarked upon his new life in Newcastle. He had arrived to find a school in which the work of the painting students, although competent and professional, lacked spirit and energy. This

may partly have been due to the government assessment system which required prescribed submissions rather than evaluating students individually on their own merit, consequently squashing any opportunity for creativity. Darwin obviously felt that the staff, too, were partly responsible for this apathy, and on becoming Professor one of his first acts had been to contact Percy Jowett for advice on suitable fine art tutors. However, two of the top positions were completely of his own choosing. He selected his cousin, Christopher Cornford, a painter and trained art teacher, as Master of Painting and Illustration (this method of recruiting, which some would describe as 'nepotism', was one which he would again and again employ in his future commitments) and his former Eton pupil and friend, Roger de Grey, as Lecturer in Drawing and Painting. De Grey's wife Flavia recalls that, in order for her husband to be interviewed, Darwin drove the two of them from Kent to Newcastle in his vast, draughty open car, stopping over to visit the artist Cedric Morris, in Suffolk. The journey took in 'lots of good antique shops', arriving in his cavernous flat at 2am to be supplied with a supper of 'peeled shrimps'(and, presumably, good wine) which continued almost till dawn.[1] De Grey, a little jaded, nevertheless managed to attend his interview at college the next day and must have impressed the panel enough to secure the job.

The remainder of Darwin's staff list appears to consist of some tutors appointed by him, some probably recommended by Jowett, and some retained from the previous administration. Master of Design was Leonard Evetts, who was a distinguished expert on stained glass and had advised the Camouflage Directorate. Louisa Hodgson, a Newcastle painter, was Teacher of Drawing; textiles and dress were also taught by local staff. The eminent J R Murray McCheyne was Master of Sculpture, with Geoffrey Dudley, a recent RCA graduate, as Lecturer. Metalwork and woodwork were again taught by local experts, and history of art and art teaching lectures given by Diana Metford.

Getting the department at Newcastle up and running, possibly even managing to do some 'hands-on' teaching himself, and still adding final touches to the CoID report, it is unsurprising that Darwin found little time to paint between 1946 and '49. He did exhibit at the New English Art Club and still managed to submit paintings for the Royal Academy Summer Exhibitions. His life was dedicated to his work and it seems, perhaps unsurprisingly, that his marriage was by that time disintegrating. He and Yvonne had seen little of each other in the war, and she appears to have remained at Winson during most of the time that Darwin was working with the Council of Industrial Design. Darwin, though dedicated to his work and enjoying a busy social life (he was a talented cook and loved to entertain) adored children and, quite naturally, had probably expected to be a father. According to Dosia Verney and Flavia de Grey,

Robin Darwin: the tranquil Paddington Basin on London's Regent's Canal, 1949.

Yvonne was the 'boss' in their relationship, and had no wish for children. There is a temptation to wonder if she may originally have directed herself at Darwin on the strength of his family background and his impressive social connections; they certainly enjoyed no shortage of dazzling house-parties (hugely enhanced after the arrival in their lives of Bryan Guinness) and holidays in the early part of the marriage, and a lively life at Eton must have seemed a splendid follow-up to the teaching days at Watford.

Under the bullish and blustering surface, hiding behind his 'mask' of moustache, glasses, sometimes even a pipe, Robin Darwin was in truth an emotional and sensitive person with little confidence in his looks, and what his domestic side really wished for was a lasting marriage with a family. Wanting to settle down and realising that the relationship with Yvonne was not to last, he had begun to have flirtations and relationships with other women when at Leamington, his pride being badly shattered if he was rejected. His affection was spontaneous and heartfelt, hiding an acute vulnerability. He was not tall and, with his love of good food and drink, was inclined to be overweight (an un-Darwin-like characteristic he may have inherited from his robust maternal grandfather). A comment he made to Dick Guyatt about one of his self-portraits, 'There is a fat white ugly man', clearly describes his low physical self-

Darwin's caricature of himself, superimposed on a ceramic figure of Lord Nelson.

esteem. However, the other side of his character showed an unshakeable and uncompromising confidence in his professional abilities to improve education in art and, even more, in design. Many of Darwin's acquaintances would never see his soft emotional side, only witnessing the bullying tyrant he could so often be in public.

The Ministry of Education and the Council of Industrial Design met in February 1947 to discuss 'The Training of the Industrial Designer', and opened their meeting with the announcement that the Royal College of Art would have a new Principal and Governing Body within the year. At that point the committee agreed that the College should put its emphasis not on training fine artists or teachers, but on educating design students with a course that included the practical study of the fine arts (with facilities for drawing, painting and sculpture) and possibly including architecture too. The job of Principal was eventually advertised at a salary of £1,800 p.a. for a successful male candidate, or £1,625 for a female. The Treasury had reduced the CoID's original suggestion of £2,000 after much shocked discussion, in spite of the Training Committee's reccommendation of £2,500 to include an expenses allowance[2]. At least one of the interviewing panel, Josiah Wedgwood, wrote to the Ministry criticising the trivial offer, but the advertisement went out unchanged. Time was short. Percy Jowett generously agreed to remain at the College until December. Thirty applications were received, and a shortlist of seven invited for interviews on 21

July. A further four were eventually added to this list. The candidates were from two main sources: practising designers with teaching experience, and senior staff from art colleges. The timetable for the day shows 20-minute interviews before a daunting panel which included Sir Thomas Barlow, Josiah Wedgwood, Gordon Russell, John Maud (Secretary of the Ministry of Education) and E.M.O'R. Dickey. On 23 July, a memo to the Minister explained that they also saw one additional candidate, Professor Darwin, who 'we understood was anxious to be considered although he had not applied in the ordinary way'. In fact, Darwin was the only candidate that the Board felt came anywhere near the requirements of the post, but they were concerned that, appearing at the last minute, he might not be a serious contender and were also a little nervous of his 'challenging personality'. He certainly demonstrated more drive, vision and passion than any of the others; the Board would make enquiries about his performance at Newcastle and his relations with staff and colleagues.

Investigations were made and the panel, if a little nervous, offered Darwin the post of Principal of the RCA. A few days later, Gordon Russell wrote to one of his fellow members of the appointment panel, endorsing the choice of Darwin as a man who 'will make the Royal College one of the very best schools of industrial design to be found anywhere. …There are few men of wide culture and great driving power who are deeply interested in both handwork up to the level of painting and sculpture and in machine design. Good luck to him'.

A combination of two recommendations, both of them from members of the panel, had ensured Darwin's last-minute place on the list of applicants. Russell, already familiar with his work on the CoID report, had met him at Newcastle during the CoID's first Design Week. Darwin had invited him to supper ('a good cook…excellent salmon')[3] and when approached with the idea had been doubtful, saying that he was not sure the Ministry would actually make the proposed changes to the college and, besides, that he was happy at Newcastle. John Maud, very aware of the shortcomings in the training of designers for industry and, incidentally, a distant Darwin cousin, inveigled him into a Ministry of Education 'meeting' which was, in fact, the appointments committee. By fortuitous coincidence Darwin's appointment as Principal, and Russell's as director of the Council of Industrial Design, were announced on the same day in adjacent columns in *The Times*.

Darwin, once he had accustomed himself to the idea, was delighted. His short experience at Newcastle had, in a way, been a 'dummy run', allowing insufficient time to put many of his ideas into practice. He immediately began to make plans for the staffing of the College. It would be so much easier to be based in his beloved London once more and to be able to call on his band of creative colleagues, all trying to re-establish themselves after the war. Evidently, Darwin

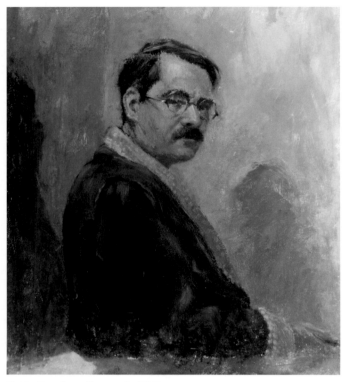

Robin Darwin, self-portrait, 1948.

spent an evening with Dosia and Barry Craig, working out a list of suitable senior staff. Dick Guyatt recalls that, almost immediately he had heard the news of his appointment, an excited Darwin arrived at his front door waving a bottle of champagne and singing out 'I'm going to make you a professor!'[4]

So, in a way, Darwin had unwittingly written his own future job description into the mammoth 'Training of the Industrial Designer'. Many decisions were still necessary, but he had demonstrated his complete understanding of the situation. The 'new school' and the Royal College would turn out to be one and the same. In fact, perhaps it was Christopher Ironside who pre-empted this. In his memo of December 1946 to the Director of the CoID he wrote: 'The establishment of a New School... should be in London' and 'not an extension of an existing School...The proximity of the V&A to the RCA is an educational factor of very great importance, and strong arguments could be found for placing the New School within the Exhibition Road area'.

Prince Albert would certainly have approved.

8: SOUTH KENSINGTON

O NE DAY LATE IN THE 1940s the painter Carel Weight was wandering around the National Gallery in London. At a loose end and looking for inspiring ideas with which to occupy himself after leaving the army, he happened to run into Percy Horton, an elderly and distinguished painting tutor at the RCA. The fortuitous result of this meeting, for Weight, was an interview with Professor Gilbert Spencer followed by a letter inviting him to take up a one-day-a-week job in the Painting School at the Royal College of Art. On his first day in the department of painting Weight was disappointed to find, in a still-life room full of eager students, a discouraging arrangement of some depressingly ancient vegetables along with other indications of a general malaise and lack of spirit. He began by encouraging the students to challenge themselves, to use their imaginations and to set their own subjects; they appreciated this simple, refreshing new approach to the previous lacklustre attitude. Little did any of them know that a storm was about to break.

The well-known story of Robin Darwin's arrival at the College is recorded in his lecture 'The Dodo and the Phoenix' given later to the Royal Society of Arts. On a bleak, rainy New Year's Day, 1948, he walked into the Exhibition Road entrance at the side of the V&A Museum, to find not a welcoming committee but a dismal deserted building painted 'the deadliest and most institutional grey'.[1] Wandering round a series of sad, more-or-less abandoned studios scantily furnished with antiquated Victorian fittings, a few pieces of obsolete equipment and the aforementioned decaying still-life, he came across two ancient stewards 'playing a game of shove ha'penny', and on being directed to the room which was to be his office (with walls in the same dreary grey) he found on his desk an attendance book which, he was informed by one of the stewards, he was required to fill in every day. He immediately threw it into the waste-paper basket. This symbolic act was to demonstrate one of Darwin's first major changes in the operation of the College: that, providing they fulfilled their responsibilities, its staff would be free to come and go at their will.

In choosing the two mythical birds as the appropriately Darwinian title for his lecture, Darwin was summing up his own view of the College. The dodo was, in fact, a member of a real but obsolete species, which had died out much like the spirit of the College; the phoenix was a creature of fantasy, an inspiration for the future rising from the debris. On hearing that he was to be Principal, Darwin had immediately applied himself to the College's transformation. Making use of his CoID contacts and his impressive personal network, he set up an Advisory

Council using his intuitive talent for choosing 'the right people'. As the College's main task in its new form would be to generate designers who could reinvigorate British industry, it was important to create a support system for each design subject. Rather like the CoID's structure of sub-divisions, a committee was formed for every prospective design school: each group comprised at least one eminent industrialist, a number of professional designers and a representative from the Ministry of Education. The chairman was a member of the Advisory Council. Each committee was asked to consider the recruitment capacity of the relevant industry, the required training for a young designer, and the necessary accommodation and equipment.

Having set up this enquiry system, Darwin's most important task was to look at the teaching situation. Thundering in with the tyrannical style which would become one of his signature characteristics, he famously terminated the contracts of all existing staff, in order to re-employ those he thought merited their positions. It is possible that the idea of this seemingly ruthless act had been suggested by Dickey at the Ministry of Education, even before Darwin's interview for the job and, in summer term 1948, teaching staff lived in terrified anticipation. At one point Edward Bawden, tutor in printmaking, commented to his colleague John Nash 'I'm getting tired of Darwin's war of nerves… I hope you are not a D.P. [displaced person] & don't have to have a red spot sewn to your arse. The whole business seems calculated to bring as much humiliation to the staff as can be inflicted, nor are the students immune to the quiverings and quakings'.[2] Though obviously unpopular, and devastating for certain unsuspecting incumbents, Darwin's action meant that he could not be accused of discrimination; in fact, he was appalled that the archaic rules allowed him so easily to sack people after years of service, and even more that these long-standing staff would receive no pension arrangements. He made sure at least that those he fired left with an acceptable pay settlement; in the case of Gilbert Spencer, former professor of painting, he went out of his way to help him find a replacement appointment and, when this was not a success, a second one. Darwin then set out to implement a contract system which would become a lasting model of its kind for art schools throughout the country.

The next job was the recruitment of new staff, to service what Darwin described as 'the most important change of all: the creation of a number of new Chairs and the appointment of some of the most lively and distinguished designers of the younger generation to fill them'.[3] Darwin's unique and confident philosophy was that if he found the people he wanted, he could then think of something for them to do. There is a theory that most domineering men surround themselves with nonentities, but this was far from so in Darwin's case. (Incidentally, this instinctive talent for selecting the right people was shared by

Robin Darwin: Carel Weight, oil on canvas, 1957.

Robert Buhler: *Madge Garland*, oil on canvas 1952.

Anthony Blunt whom Darwin had so admired when Drawing Master at Eton:
as the new Director of the Courtauld Institute, Blunt was concurrently setting
up his own teaching team. Like Darwin, he was proud that his staff were as
distinguished in their own fields as he was in his; in the words of one of them
the Institute became 'a federation of more or less independent specialists'.)[4]
Several of Darwin's new professors came from the group of acquaintances he
had made while working in Camouflage – talented qualified designers (some
with architectural training, supporting Darwin's belief that this was the ideal
background) who could if necessary adapt their skills to other disciplines than
those in which they were trained. So architects Robert Goodden and R.D. (Dick)
Russell became, respectively, professors of Silver and Jewellery, and Woods,
Metals and Plastics (later to become Furniture.) Dick Guyatt was brought in to
set up a new department of Design for Publicity. Robert Baker became head of
Ceramics and Allan Walton (sadly to die shortly afterwards) of Textiles; Madge
Garland, the only female choice, became the first-ever Professor of Fashion in
Britain. In spite of all the previous rumblings (and because of Darwin's own

feeling that painting should be the inspiration for every student) the College maintained its fine art courses: Rodrigo Moynihan took the chair in Painting, Robert Austin in Engraving and Frank Dobson was reinstated as Professor of Sculpture. Basil Ward was elected to head up the department of Architecture, which offered lectures to all first-year students so that Modernist theory could act as the backbone to all the courses; Basil Taylor, who provided this element, later became College Librarian and set up the General Studies department. All these senior staff, many of them with no teaching experience whatsoever, would select their own supporting team of tutors who would have day-to-day contact with the students. Darwin's brilliant idea that professors should be able to continue their private practice while teaching students at college engendered a 'drawing-office' environment where students could learn from staff members who were involved in real-life professional projects – as Pevsner had suggested, 'each master should have a spacious comfortable studio in the School'. Talking to an audience at the RSA in 1949, Darwin explained that 'all professors at the RCA are appointed full-time with half-time for "research", meaning their own work': thus, in spite of his own undergraduate failings, he referred to the ideals of a Cambridge college where teaching and research were mutually supportive, each indispensable to the other.

In July 1948 *The Times* announced that 'the Royal College of Art is to be a national college with its own council and its own budgetary provision… instead of being in effect a part of the Ministry of Education' which had been totally responsible for it up till then and which would continue to allocate its budget. A new Council was set up (including as its members some of the industrial giants Darwin had previously consulted) with full executive power as the governing body; it was responsible, with the Principal, for policy, financial and other decisions crucial to the running of the College. With the Orient shipping line's Sir Colin Anderson at its helm, its panel included such distinguished names as Jack Beddington, Barnett Freedman, Osbert Lancaster and Anthony Lousada; Geoffrey Dunn, Duncan Oppenheim, Gordon Russell and Arthur Stewart-Liberty were also members. John Piper's wife Myfanwy was one of the first female members. These would be supplemented or replaced in future years by an illustrious list including Hamish Hamilton, Anne Scott-James, Michael Ayrton, Bridget D'Oyly Carte, Sir Michael Balcon, John Crittall and Hans Juda. The Council in turn worked with the Academic Board, made up of professors, senior staff and nominees from each school. The Academic Board monitored four Faculty Boards, each one comprising a selection of representatives from the other departments – the faculties of Industrial Arts, Fine Arts, Graphics, and Fashion Design (evidently not seen by Darwin at that stage as an industrial subject.) Darwin's responsibility as Principal was to support and inspire his staff

RCA design studio in the Western Galleries, Prince Consort Road.

The JCR in its shed, with John Minton mural.

and to oversee all their departments without unduly interfering, but to have the right to 'the last word' should it be necessary.

The College was now set up with a new administrative system and teaching staff. The stumbling-block was accommodation. When Darwin first arrived, the original collection of 'shacks and mansions' which had housed the studios had downgraded (apart from the Exhibition Road building) into simply the 'shacks', which included a junior common room (JCR) in one of a group of large sheds in Queen's Gate – a 'great pre-fabricated barn, slumped in the back yard of the Science Museum'[5] which, legend had it, was designed during the Crimean War as a prototype military hospital for Florence Nightingale, and was therefore showing signs of age. Although the Exhibition Road building would remain the home of the schools of painting, engraving and graphic design, and sculpture was accommodated in the shed opposite the JCR, space had to be found for all other disciplines. The College managed to obtain the lease for

Edward Ardizzone: *The Senior Common Room at the Royal College of Art,* 1951.

two elegant if run-down houses, belonging to a local architect and developer, at 21 and 23 Cromwell Road (formerly the premises for the Royal College of Music) and at the end of 1950 these became the home for the Senior and Junior Common Rooms, some of the design schools and, later, the Library which was currently shared with that of the V&A. A large house in nearby Ennismore Gardens became the School of Fashion, and remaining schools were housed in the Imperial Institute's Western Galleries on Prince Consort Road, which had originally been built to accomodate overspill from the Great Exhibition of 1851. Before the Junior Common Room reluctantly moved to the first floor of 21 Cromwell Road, everyone met in the much-loved Queen's Gate shed where it had been since the 1920s. It was run by the dauntless Miss Vera Mackinnon and her staff who cooked a midday meal and generally ruled the roost, and with her encouragement the students set up a film society there as well as a lively drama group (which Darwin the theatre-lover continued to encourage on the move to Cromwell Road, providing it with a portable stage). The frequent parties were legendary. The whole operation was run by the students, and all proceeds were ploughed back into the management fund.

So, 'scattered over a square mile of Kensington'[6], the College took shape in its new if disjointed incarnation. The next big move for Darwin (demonstrating his image, as seen by Iris Murdoch while she was visiting tutor in General Studies, of 'eighteenth-century clubman'[7]) was to establish a Senior Common Room on the ground floor of 21 Cromwell Road where, in the Oxbridge manner he so revered,

Royal Visit to the SCR, c 1956. HM Queen Elizabeth the Queen Mother with (l-r):Hugh Casson, Robin Darwin, Robert Goodden, Sir Colin Anderson, and Dick Russell.

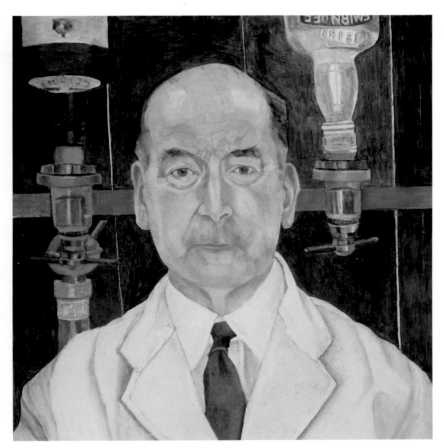

Portrait of Mr Alexander George, the SCR Steward, by painting student Brian Higbee, 1965.

staff and colleagues could meet over fine wine and lunch in grand, quite formal surroundings. This facility seemed an anomaly to many of them, particularly as Darwin's respect for tradition decreed that men were not admitted without a tie. A ragged little note, passed along the table one lunchtime from Darwin to visiting tutor Humphrey Spender, asked 'Why aren't you wearing a tie?' The bold response was 'I can't bear a tie – by the way, there is egg on yours.' Women, when they were finally allowed to join the club (where for several years there was no 'powder room') were forbidden to wear trousers. These rules eventually became obsolete with the approach of the 1960s, the sculptor Sandra Blow being the first woman to flout the 'trouser' rule.

Many would, and did, believe that the SCR was a snobbish and archaic establishment, but Darwin's main intent in setting it up was solid and far-

sighted. Before he had taken up the job of Principal he had been invited by Jowett to meet all his future staff, and he was shocked to realise that most of them barely knew each other. In addition to providing a place where staff could meet, discuss college issues and exchange ideas, the Common Room was the ideal venue for entertaining distinguished official visitors, potential sponsors and friends as Extraordinary Members: its membership books record the proposals for election of such eminences as Richard Hamilton, Mary Fedden, Stephen Spender, Laurie Lee and Hugh Johnson, seconded by members including as well as regular staff, Humphrey Spender, Barnett Freedman, Leonard Rosoman and Edward Ardizzone. Princess Margaret, the first female member, was proposed by Lord Snowdon and elected by the Registrar without the normal collection of members' signatures to second the proposal. The SCR's style embodied 'a respect for tradition with an entrepreneurial eye on the future, enhanced in the privileged ambience of a gentlemen's club'.[8] In spite of its incongruously conservative appearance, the atmosphere was far from 'stuffy' because of the staff and guests who ate and drank there, many claret-fuelled lunchtimes in the earlier days continuing well into the afternoon. (Ruskin Spear, on 'Desert Island Discs', declared for obvious reasons that he always did his best work in the morning). It could also serve as a high-profile gallery for college talent, with its silverware, glass and Phoenix china all designed by college staff and students, and with a changing exhibition of art by alumni on its walls. It exists in this form today.

One of the main reasons for the SCR was, of course, Darwin's love of good food. Living on his own in a flat on the first and second floors of 11 Brechin Place, within easy walking distance of College although he insisted on driving to work, he blossomed as a *bon viveur* and a generous host. A civilised lunch, however satisfying, was not for Darwin always the main meal of the day. He adored entertaining and a diary of his dinner parties starting in 1948, at the moment he began his RCA life, details the food, wine and guest-list for every one of his frequent gatherings. If the dinner was on a grand scale, he would install himself in the College kitchen (much to Miss Mackinnon's disapproval, as it was shared by both Senior and Junior common rooms) and entertain in the dining room. Unusually for a man at that time, Darwin found relaxation in preparing the sophisticated recipes he would serve to his friends, wearing a blue striped apron and fuelling himself throughout the process from a large glass of red wine. His knowledge of culinary skills may have developed during the war when he embarked on a bachelor life, or perhaps he took over the kitchen while living with Yvonne during his Eton days.

Darwin was a confident cook and once, asked by his friend Hans Juda for his mayonnaise recipe, was so convinced of its solid consistency he held the bowl

MAY 7 1949

Soup

Lobster + [...] eggs

Wild Duck aux olives

Marrons à la crème

Sketch from Darwin's 'dinner party diary', for his 39th birthday party.

upside down over his head, whereupon the whole lot plopped out and ruined his signature 'already rather dirty' chalk-stripe suit.[9] But mishaps were rare, and his meals became quite legendary amongst his friends. He served a fairly characteristic if quite lavish dinner-party menu for that time: an *hors d'oeuvre* (mussels and potted shrimps were popular) or soup followed by simply-cooked fish (often salmon or turbot, sometimes in a sauce), or a beef stew (ragout or goulash), roast chicken or guinea fowl with seasonal vegetables. Dessert was frequently fruit salad or melon; occasionally there was cheese or sometimes a 'savoury' to replace this – asparagus, or tomatoes stuffed with *foie gras*, to accompany the brandy which would inevitably follow a very impressive wine list. Darwin's menus, although usually based on English ingredients, show his growing appreciation for the French and Italian cuisine experienced on his travels, which writers such as Elizabeth David were currently making accessible to a Penguin-reading public. Sometimes he annotates his diary *(turbot & broad beans, white sauce en cocotte - 'v. good')* and sometimes he cheats, as in his cream soup which consists of '*1 tin cream of veg, 1 tin cream of tomato, 1 pint of milk, mint, parsley & 1 onion*'.

Postcard from Lizzie Guyatt, referring to the birthday menu.

The guest lists varied, but were underpinned by the presence of College staff with or without partners, indicating that Darwin enjoyed their company after hours (he probably saw little of them at work). They would be accompanied by Darwin's friends, often from the world of art and design, sometimes from other parts of his life. Single female names appear from time to time, particularly that of Ruth Cropper. Although Dosia Verney records that 'he decided to marry' her sister, the relationship only existed, sadly, in his romantic imagination. Generally it seems that he was living a bachelor life. On one occasion, at a fancy-dress party before the Royal Albert Hall New Year's Eve Ball of 1950, he (knowingly or not) acted as matchmaker. Amongst his guests, who included the beautiful Elizabeth Jane Howard in emeralds, were Emma Smith and Darwin's wartime 'landlord' at Cheyne Walk, Richard Stewart-Jones. It was their first meeting and they married four weeks later. Sometimes Darwin would entertain Ursula to lunch, and Yvonne's name occurs individually on May 12 1948. At one stage in 1949 the diary mysteriously records 'NB. From early in Feb until March 21 I was looked after by a resident cook housekeeper who knew so little abt. it that I had to give up entertaining'. Another even more cryptic note after May 7 records 'more or less ditto with other complications and distortions' and no entries appear until February 9 1950. Darwin and Yvonne were finally divorced in 1949 (although her name appears on January 16 1951) and quite possibly this disruption in his domestic life, along with his huge College responsibilities, made it temporarily difficult for him to continue being such a generous and creative host.

There were lunches, dinners, post-cinema suppers, parties at Christmas and after the College play, birthday celebrations (sometimes with other staff – Darwin and Robert Goodden shared a May 7 birthday and Dick Guyatt's was May 8) – all with generous 3-course menus cooked by this prodigious chef with an extremely demanding day job. Often, if it was term-time, Darwin would make his way back to his office afterwards to work quietly late into the early hours. It was well known that, contrary to the reputation that he 'ran the College from his SCR armchair' he returned to work after dinner most nights. The reorganisation of the College was more than a full-time job, and Darwin threw himself into its renaissance. The Ministry of Education's control ceased on 31 March 1949, and *The Times Educational Supplement* reported that the College would be 'given as much freedom as its maintenance from public funds will allow, broadly on the same lines as national colleges set up for various branches of industry'. Darwin believed that the RCA should train none but the best students – to produce 'a handful of great designers' was preferable to 'hordes of mediocre ones'. In April, a printed pamphlet: 'DesRCA. A New Diploma for Students of Industrial Design', announced that the former, general School of Design 'has now been divided into 6 separate schools each under the charge of a Professor of high standing as an Industrial Designer, and with adequate supporting staff'. The qualification would be awarded after three years' study, with graduating students in the Fine Art disciplines receiving the equivalent award of ARCA.

When Darwin arrived at the College, he was mildly irritated to find that the student population was largely made up of the ex-service contingent, men and women mostly in their late 20s, demob-happy and ready to complete the education they had been promised before the war. Clifford Hatts, who had enrolled in 1946, remembers Darwin as 'a man with a voice and the look of thunder. He set about his task with a will, wielding his new broom with grim vigour, mostly among the staff of the painting school and those teaching the classic crafts – no more calligraphy, no more mosaics'. Hatts admired Darwin's attitude, understanding that it was the only way to get the College's status raised; and particularly important to Hatts was the arrival of Professor Dick Guyatt, who would transform the former School of Design into a modern Graphic Design department, bringing in the most prestigious selection of visiting tutors and lecturers.

The ex-service students, most of whom graduated during Robin Darwin's first two years, were able to observe the changes taking place. An unusual group, their wartime experiences had given them a worldliness rare amongst students, and most of them were highly appreciative of the new attitude. Norman Adams had been a conscientious objector and was imprisoned for some time during the war. He had delayed his entry into the painting school until 1949, finding

Principal and students on staircase with mural decoration, 1953.

himself 'suddenly thrust into the RCA with staff who actually had their own exhibitions'[10]. He found Darwin remote and frightening, although he 'seemed to quite like' Adams' work. The new tutors (several of whom had been at Newcastle with Darwin) were stimulating and exciting, particularly John Minton, and although amongst some students there was a disappointing feeling of post-war depression, the work of Adams' contemporaries, such influential painters as Derrick Greaves, Derek Hirst, Jack Smith and John Bratby, created a new dynamism. The fine art students were not really interested in those from the 'industrial' schools, and Adams loved the fact that the studios were so close to the V&A where he could use the library and draw from the many exhibits.

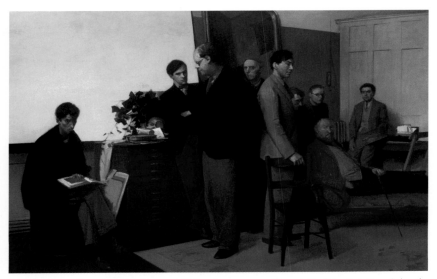

Rodrigo Moynihan: *Portrait Group*, 1951, oil on canvas. The staff of the Painting School, l-r: John Minton, Colin Hayes, Carel Weight, Rodney Burn, Robert Buhler, Charles Mahoney, Kenneth Rowntree, Ruskin Spear, Rodrigo Moynihan.

The place where students from all the departments came together was the JCR. When, in 1949, Darwin announced that the building was 'a pigsty' and that it should be closed, he was met by a mutiny. The 'mildly bolshie' ex-service crowd rebelled, rudely reminded by Darwin's abrasive behaviour of their military staff sergeants. They immediately organised a 'pigsty hop' where everyone who attended had to enter by climbing over a five-barred gate, and then put on an end-of-term burlesque in which Robin Darwin was the name of an evil and tyrannical Victorian melodrama villain (a characterisation which no doubt would have appealed to him).

The graduation ceremony was something else on which Darwin was keen to make his Oxbridge mark. In 1949 he upgraded the occasion to a grand formal Convocation held in the concert hall of the Royal College of Music, in which to a fanfare of trumpets he preceded a procession of professors and tutors in their academic hoods and robes (John Minton in jeans), all walking behind Mr George, the Senior Common Room steward, who as Beadle carried the College's ceremonial mace. Darwin loved the almost ridiculous pomp of the ceremony (which would outdo even its own grandness in later years) and could see the comic side of these new traditions he had invented for the College. Naturally, the occasion served as a magnet for student pranks. Pat Albeck, in Textiles, remembers a particular convocation day when all the students on the platform, seated behind Darwin and the staff, were waiting to receive their honours.

Portrait Group, pastiche 1, a birthday gift from the Painting staff to Darwin (seen bursting through the canvas above Francis Bacon's head sizzling on a plate).

Wearing masks on the backs of their heads, it was a dramatic moment when they all turned round with Robin Darwin faces. Darwin, who frequently drew caricatures of himself, would have enjoyed this, but his self-parody and his formidable appearance still hid a vulnerable, rather insecure and sometimes even unworldly inner self. Totally in control when chairing small groups or committees, he was very nervous at big formal occasions – his hands would shake and his voice would falter, particularly when speaking to large groups of students. But he could also appreciate the absurd aspect of these new traditions and ceremonies he was inventing for the college.

Darwin came over as a large and terrifying presence to most of the students, although they saw him infrequently. On rare occasions when they were called in to his office they knew they were in trouble. Otherwise he was a distant, patrician figure, a fierce and belligerent dictator in his chalkstripe suit (the studied bohemian look of his student days long replaced), his glowering look masking a hidden kindness and generosity of spirit. Generally, they were probably unaware of his status as a painter and certainly of his more sensitive side. He was a formal man and felt it incorrect to socialise with students, leaving this to his staff who had no trouble in building informal friendships. However, there was a great respect amongst the students for the enormous efforts their Principal had

Portrait Group, pastiche 2, mid-1950s. In addition to Buhler the artist, Weight and Spear, this version includes Merlyn Evans, Sandra Blow, Donald Hamilton-Fraser, Roger de Grey, Colin Hayes, Leonard Rosoman, Bateson Mason and (seated) Peter Blake and Jean Bratby.

made to put the College back on its feet, and for his loyalty, which they often only experienced after graduation when he would tirelessly support them in their search for employment. Pat Albeck recalls that he seemed to be personally interested in his students, appearing to be aware of each one's individual work and perhaps asking about degree show progress, or how a thesis was going. He would continue his fierce support once the students had graduated, always encouraging them to stand up for their ideas and intervening if he thought an employer was taking advantage or diluting the spirit of a student's work.

The staff, though he could frequently be equally aggressive to them, saw him in a different light. Robin Darwin's trust in his professors and his policy of not interfering with their courses meant that there was a huge amount of mutual admiration, and they knew that if they were working well any untoward behaviour from the Principal would be shortlived and probably inconsequential. Although it was well-known that Darwin's decisions were often autocratic (in meetings, the words 'I think we're all agreed' meant that it was pointless continuing a discussion or debate) the staff respected his unerring knowledge of

what would work, his tireless pursuit of the highest standards, and his dedication to his job, arriving early and working well into the night, with those important breaks for lunch and dinner. Darwin's notorious outbursts were violent and alarming but he never swore and rarely used abusive language, and the staff began to witness his explosions with cautious amusement, some even finding an absurd side to his snobbishness and his predilection for surrounding himself not only with his relations but also with the security of fellow Old Etonians – John Moon, his faithful registrar, and Wilfred Tatham, the College bursar, who had been a housemaster; Roger de Grey, Peter O'Malley (tutor in ceramics) and, later, David Queensberry. (This network, which he fully intended to use to the college's advantage, extended to his easy relationship with various influential members of the Cabinet and the Civil Service). Contrary to the snobbery was his attitude to the 'browncoats', the college stewards, to whom he was always very polite and considerate: they, like Mr George in the Senior Common Room, adored him and called him 'the Skipper'. The boiler man, Mr Long, was allowed to drive, service and clean his precious car. Darwin felt as comfortable with this mutually respectful if hierarchical relationship as he had in his childhood with the family servants, the children's 'best friends'.

At this point Darwin's life was almost completely dedicated to his work, but he still had time for family commitments. His nephew Philip Trevelyan remembers that Darwin would drive to Gorringes, where Ursula and her family were living with Bernard and Eily, for Christmas and other festive occasions. He would involve himself in the kitchen, carve the turkey, and play the magician 'spinning sixpences into the air' which clattered all over the room but would be found in mysterious and surprising locations such as on Eily's head or under a candlestick. He would also thrill his nephew by taking him out in the Rolls and driving as fast as possible in the country lanes – behaving as a 'sweet proper uncle' to a seven-year-old boy. If Nicola, who had become a professional singer with the Bach choir (with which she remained until her marriage in 1956 to David Hughes, when she relocated to Cornwall), was at Gorringes she would practise at the piano in the drawing-room, leaving her dachshund Rufus whining outside the door. When Ursula, Norman and Philip went to London to the circus, a Christmas treat, they in turn would stay with Robin and would tune in to radio broadcasts of the Bach choir, listening out for Nicola's soprano solos.

In spite of the pressures on his time, Darwin still managed to continue painting. He had had a painting selected for the 1949 Royal Academy Summer Exhibition and *The Times*, 24 January 1950, reported on an exhibition of 'English Watercolours, Constable and Girtin' at Agnew's where, in the modern section, Darwin showed no less than nine watercolours. The critic's opinion was that the work was 'firmly drawn with an excellent definition of space and some

real felicities of colour'- the latter aspect continuing the direction his work had begun to take before the War had interrupted his progress.

At the College, the senior tutors and visiting staff in the new arrangement were no less illustrious than the professors by whom they were appointed. After his initial clearout, Darwin had begun by reappointing Carel Weight, Rodney Burn, Edward Bawden and John Nash as tutors in painting and illustration. Robert Buhler was head-hunted from the Central School, and Weight himself recommended, from the same course, Ruskin Spear and ('no-one better') the soon-to-be legendary John Minton. Colin Hayes and Kenneth Rowntree arrived as staff the following year. Printmaking staff included, in addition to many of the above, Edwin La Dell (elected Head of School in 1955), Julian Trevelyan, John Piper, Keith Vaughan, Barnett Freedman and Alistair Grant. Darwin, although he had become, at least outwardly, very much an 'establishment' figure, retained an understanding of a more bohemian existence and 'had a profound respect for people who painted'[11]. He felt he could exert his influence in this school and continued fiercely to believe that all good art and design schools should have a fine art department. He left the new professors of design to recruit their own choices, interfering by handwritten note only if he felt the selection was a mistake: 'For God's sake don't have that visitor in again'.[12] In the schools of design, senior and visiting tutors in Darwin's early years included David Pye, Ron Carter, Humphrey Spender, Janey Ironside, Edward Ardizzone, F.H.K.Henrion and Abram Games. Almost everyone who was anyone was teaching at the College, and its reputation was unsurpassable.

Robin Darwin: *Et in Arcadia Ego*, selected for the RA Summer Exhibition, 1949.
Brasserie interiors were a recurring subject.

9: COLLEGE LIFE

ONCE DARWIN FELT COMFORTABLE that the college was back on its feet and operating smoothly, he began to develop the plans which had been forming in his mind since he took over as Principal. In 1951, with the opening of the department of interior design (after two years of discussion) he invited Hugh Casson to be professor. They were delighted to renew their wartime acquaintance: respect was mutual, and Casson tolerated Darwin's more volatile moments with a gentle sense of humour. He admired the tremendous energy Darwin put into the job, his ebullient if impatient manner and his impressive skills of organisation without which the College in its new form would have achieved nothing.

Doodles drawn by Hugh Casson in a Senate meeting.

ARK, February 1952. David Gentleman's cover, with references to the Lion and Unicorn Pavilion and an early-1950's interest in Victoriana.

Casson, as Director of Architecture for the 1951 Festival of Britain, commissioned staff at the College to design and create one of the pavilions on the South Bank of the Thames. For London in its austerity, the Festival was a tremendous excitement, the first chance since the war for many architects and artists to use their skills and, even better, to be paid to do so. The Lion and Unicorn Pavilion, designed by Robert Goodden and Dick Russell with interiors masterminded by Dick Guyatt, became the College's contribution to the Festival and because it contained so much work generated by College staff and students (Hugh Casson remarked that the College came to be the main source for Festival requests which others could not achieve) Darwin came to believe that it was actually the College and not its staff which had received the commission. The design for the Pavilion was conceived in the Prince Consort Road studios, in a long open-plan drawing-office situated on the floor above the Science Museum's aeronautical display. Ray Leigh, one of the young architects working on the interior, remembers it as the perfect example of an office/workshop environment, the ideal setting for students to learn alongside professionals. The Lion and Unicorn was one of the most popular of all the South Bank exhibits, illustrating the story of British tradition and heritage. When the new Conservative government of 1951 condemned the whole site to demolition, *The*

Ceramic Lion and Unicorn produced for the Festival by Darwin's sister Ursula and her second husband Norman Mommens.

Times published an impassioned letter from Darwin suggesting the idea that the pavilion, specially designed to be fully demountable, could be re-erected as an annex (albeit temporary) to the Arts Council or the V&A, on the island site opposite the museum. This brilliant idea was rejected and the Lion and Unicorn demolished, with the disappearance of its spectacular Edward Bawden mural and many other important works.

When Margaret (Reta) Casson joined the staff in 1952 as a part-time tutor in her husband's new department (Darwin's favour of nepotism evidently extending to some of his staff) she was one of a small group of female tutors. Although Robin Darwin liked women and had a wide circle of female friends, he was uncertain in his attitude and found it difficult to treat them as equals at work. It is not clear whether this failing stemmed from childhood experience of a strong mother: perhaps Eily had valued her independence too much to have been outwardly affectionate to her first son, but there is no indication of a difficult relationship with him. On the contrary, his mother and her family, particularly his uncle Jack, must have done a lot to encourage Darwin's artistic talent. He loved his sister Ursula but was not at all close to Nicola, in spite of the fact that Nicola was musical and became soprano soloist with the Bach Choir (perhaps her close friendship with their cousin Ralph Vaughan Williams, whom Darwin worshipped, was a source of jealousy though this seems unlikely). Roger de Grey commented that Darwin was terrified of women and Dick Guyatt

described his attitude as 'lethal' – he approved of Guyatt's wife Lizzie but as a rule women were regarded as being subordinate to men, particularly when it came to the Senior Common Room where at first they were not allowed. Once they were, he often publicly berated them. The formidable Madge Garland was an exception to this rule: although Darwin could be cruel to her too, making fun of her lesbian tendencies, his snobbery drew him to admire her for her social background and the fact that she had so many influential friends. Over the years a great mutual respect grew up between them.

Reta Casson became an extraordinary deputy to her husband, holding the school together when he was away on his frequent assignments. Darwin would pointedly ask Casson (as he slipped off to do something else): 'Any chance you might drop in to do some work?' The Cassons became friendly with Darwin, beginning to see him socially outside College; he would often drop in after work to their house in Kensington. The older Casson girls, Carola and Nicky, were 'quite scared of him', not finding him outwardly affectionate, but Reta's impression was that he was very sweet to them – he adored children and perhaps still hoped for some of his own. His presence in the house was always noticeable by the smell of cigar smoke: Reta remarked that his heavy smoking, which continued all his life, must have been a reflection on an insecurity in his character (but not a lack of confidence).[1] She loved his 'wonderful humour' and the giggles they would have. The girls would interrupt when Darwin was having a drink, always whisky, 'with Mum, after work', sensing that he was attracted to her. The Casson marriage was a fairly relaxed partnership: Reta had several admirers who would visit her at home, amongst whom the girls only really approved of 'Henri' Henrion, while Hugh Casson openly had a series of 'girlfriends' although his didn't call in 'except occasionally for dinner'.[2] There was a point late in the 1950s when Darwin, desperately wanting to settle down in a secure relationship, imagined that he might be able to marry Reta, but common sense on the Cassons' part soon defused this idea without too much damage to the friendship.

Reta's compassionate nature enabled her to have a deep understanding of Darwin, whom she described as formidable-looking but very shy – the cause of much of his difficulty with certain people, resulting in the sometimes 'spectacular rudeness' inherited from his father. She understood his character, knowing that the outward image was very different from the inner self, and realising that his snobbishness was partly a protective shell, partly cultivated as a means of having influence in high places. She recognised his fear of the limelight and his terror of public speaking, though he felt it was necessary to help the status of the College: alcohol helped him through this, to the extent that he began to rely on it, sometimes a little too much. His clear idea of the targets in his life meant that

Menu covers, 1952 (left) and 1960s, designed by Richard Guyatt for the annual tradition of 'Darwin Dinners', originally conceived to commemorate the founding of the SCR.

he got the results he wanted. Reta was also aware that Darwin's first real love was painting; a piece in *The Sunday Times* remarked that 'His own paintings … reveal an extreme sweetness of feeling which, elsewhere in his nature, would seem to have gone underground' [3]. It seems slightly uncharacteristic that he was drawn, at this stage, to the work of the French/Russian artist Nicolas de Stael whose colourful, abstract landscapes bore little resemblance to his own work; perhaps the redirection of Darwin's life in the 1940s and 1950s had allowed him too little time to experiment with the new techniques he had been looking at in the 1930s, and perhaps the fact that he would never be a modernist allowed him to admire the spirit of those who were. He had a romantic attitude to art, and because he did not rate himself too highly (although many saw him as a competent watercolourist) he took vicarious pleasure in being with the staff of the Painting School whom he respected and understood, even though he may have classed some of them as excessively bohemian in their attitude. His strong belief was that designers were to a great extent pinned down and shaped by their disciplines, whereas painters were to be regarded with awe and respect because of their independence; the fine arts were fundamental to design. The 'painters' table' in the Senior Common Room exists to this day, the *bon viveur* spirit of Darwin sitting at its head revelling in the company of his 'arty boys' who, in turn, revered his presence. Their signatures are recorded on the menu cards of a series of dinners held annually to celebrate Darwin's birthday.

Although Robin Darwin's policy was to give his professors a free hand in the recruiting of their tutors, he felt he understood the subject of painting enough to have an influence in the selection of Fine Art staff. Many of the visiting tutors also taught at the Slade, cementing a strong relationship between it and

the College. The list of painters teaching at the College in the 1950s reads as a summary of all that was happening in British art. At one point, looking for new young tutors, Darwin grudgingly admitted that 'I suppose I'll have to have one of those painters whose work I don't like on the staff' (an abstract modernist?) The arrival of John Minton was to be a valuable influence on the students. He worked alongside them in the studio, painting huge figurative canvases as well as creating vast backdrops for the JCR parties while encouraging the students to make outsize decorations. Everybody, including Darwin, loved Johnnie, a 'tremendously live wire'[4] whose enormous vitality was so inspiring. His clear way of interpreting and explaining made it easy and fun for students to understand, and by his own example he indicated to those interested how teaching should be approached. Darwin was always puzzled by homosexuals, once enquiring of lecturer Richard Chopping 'Dicky, what on earth do you *do* with each other?' but Minton's homosexuality did not mar Darwin's affection for him as a tutor. The one thing that got in the way for Minton was his heavy drinking which became more and more extreme as his career developed. When he went away on 'one of his trips'[5] abroad to work on illustrations for a book, Minton recommended his friend Francis Bacon as a substitute tutor. Norman Adams found Bacon 'interesting, but a rotten teacher – polite and encouraging', spending little time in the studios but inviting students to see his work in progress (at that point his series of 'Screaming Popes') in the basement studio in Cromwell Road which the college had allowed him to use. The story was that his own studio had been destroyed by a fire, but Dicky Chopping's later version of events was that Bacon's boyfriend George Dyer had, in a fury, trashed the studio and ruined all his work by pouring wine over it in the bath. Whatever the truth, when Bacon gave the College the famous 'Study from the human body – man turning on the light' in exchange for his studio accommodation, he stipulated that if needs be it could be sold to help a student through College. Five decades later, its impressive auction proceeds went some way towards creating much-needed new accommodation for the College, which was not, contrary to Chopping's wicked suggestion, christened 'The George Dyer Building'.

In the mid-50s, Johnnie Minton's drinking became so out of hand that Darwin suspended him until his recovery. He never returned. His demons got the better of him, and he reportedly took his own life in January 1957. Darwin's obituary of him, one of many he wrote over the years for *The Times*, beautifully sums up the love and respect that this sweet, generous, talented, extravagant character commanded in his students and his friends on the staff: he had 'a magical quality…which will for us remain unique. It is impossible to imagine him growing old, and perhaps in some indefinable way he acknowledged this logic for himself'.

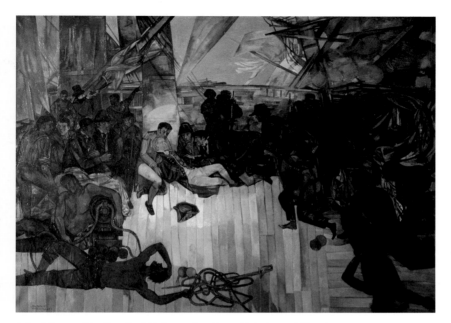

John Minton: *The Death of Nelson: after Daniel Maclise*, 1952, oil on canvas.

By all accounts Darwin had few interests outside the College. It may have acted as a substitute for marriage (it practically was one) but it did not hinder his social life, although he constantly talked about it when visiting friends. In addition to his dinners, his love of parties encouraged him to arrange, with the help of a committee of distinguished lady friends such as Lady 'Kirsty' Hesketh, several huge fancy-dress charity balls (to support the Artists' Benevolent Fund) in the JCR, once it had taken over the former ballroom of its Cromwell Road home. These events were successful not only as fundraisers for charity, but also as a means of putting rich benefactors and potential sponsors in touch with the College. There were legendary College parties there too (music usually provided by the resident band, the Temperance Seven) although Darwin's diffidence stopped him from socialising much with the students. Ballet and theatre were important to him (he was a 'marvellous actor', according to former student and industrial design tutor Bernard Myers) and like many in his family he had a great appreciation for music, sometimes spending a peaceful evening enjoying the choral singing at Brompton Oratory. He often preferred to play his own silver flute, at which he excelled, rather than to listen to the music of others. He was 'not unproud'[6] of his background, and very aware of his famous surname, to the extent that he was outraged in situations where official personnel made no reaction to it. Darwin was not 'bookish' and although he could have been

Robin Darwin: *Near Horsmonden, Kent*, 1955.

no closer to the arts world he did not intellectualise about it, never having seen himself as an academic. He continued to exhibit his paintings regularly at Agnew's and the Leicester Galleries, as well as having work accepted almost every year in the Royal Academy Summer Exhibition; his one-man show in July 1955 was not well-received critically ('the best are gay and effective furniture pictures' – the *Times* review would have infuriated him) and it must have been that his schedule did not allow his painting to really flourish at that stage. Occasionally he took up commercial commissions, one of which (for the J.Lyons' catering company in 1951) resulted in a vibrantly-coloured lithograph of a fishmonger's shop – the subject would have delighted him, but the result suggests a lack of ease with the unaccustomed technique. Another later example, reproduced from a painting, is much closer to his normal style: a poster showing an atmospheric riverscape of Westminster for a 1960 collaboration called 'The Power of London', set up by the London Electricity Board and using the skills of such RCA fine art staff as Ruskin Spear and Geoffrey Clarke.

Darwin continued to adore travelling, always delighting in new places, their local cuisine, and the opportunity of fresh subjects to paint. His Christmas cards sent out throughout the 1950s record holidays spent in Venice, Valencia and Cahors as well as closer to home at Castle Howard in Yorkshire. In order to indulge several of these favourite activities he often visited friends who owned holiday property in France. With the Guyatts he went to La Roquette-sur-Siagne,

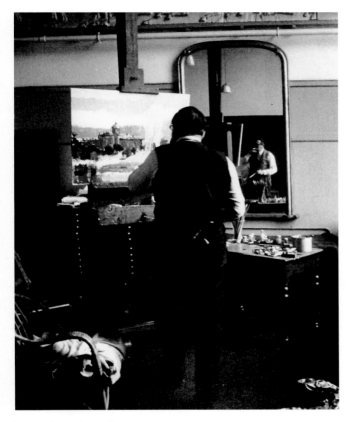

The artist in his studio.

close to Grasse in the Alpes Maritimes, to stay in a pretty Provencal cottage probably belonging to Madge Garland. He would also accompany Elsbeth and Hans Juda on trips to the south-west, possibly visiting the house of Roger de Grey; according to Elsbeth, he 'simply wouldn't drive a car' abroad, so the Judas would fly their car across the channel, Elsbeth acting as chauffeur. Hans Juda would usually stay three days, and then the relentless drinking of Darwin and such friends as Robert Buhler would get too much for him; if pre-dinner drinks went above the number of three, Juda would advise his wife to 'take out the wine and put in the plonk'. Elsbeth was left to drive everyone around and the appearance of this unorthodox group must have been strangely entertaining for the French neighbours. Darwin, although 'very elegant'[7] in a robust sort of way, was in rural France an unusual sight in his one suit which he wore (in a manner inherited from his father) nearly all the time. At his easel one day, a glass of wine by his side, his stool collapsed and his trouser seat ripped open, to the noisy

Holiday postcards from Darwin to
the Guyatts, with familiar caricature
superimposed.

Robin Darwin: untitled, possibly La Roquette, c.1950.

Robin Darwin: watercolour sketch of La Roquette sur Siagne, Madge Garland's home in southern France, sent to Lizzie Guyatt.

Holiday reading, photograph by Robert Buhler.

The boathouse at Syon Park.

delight of a group of local children who were observing '*l'artiste-peintre Anglais*' at work.

Darwin's 'dinner party diary' stopped abruptly in 1951, which indicates that this was the moment he found and fell in love with a small romantic Palladian-style pavilion on the Thames, the boathouse of Syon Park which was owned by his Old Etonian friend the Duke of Northumberland and had previously been inhabited by the Dowager Duchess, the Duke's mother. A rental on this was negotiated and Darwin moved in. The classical eighteenth-century building, its façade designed by James Wyatt, had already been converted into a house with a domed circular central reception room flanked at each side with a lower wing, one of which Darwin took over as his bedroom, bathroom and a spare bedroom. As the Pavilion was some way from London, Darwin found that it was impossible to entertain in the evenings and began to invite friends at the weekends instead. There were family parties too, and Darwin's nephew Philip Trevelyan remembers an 80th birthday celebration for Bernard where Darwin picked up his flute and played 'a terrifically fast and difficult piece of Bach'. He would often drive to Richmond to collect his guests, and Joan Warburton's diary for September 26 1953 records: 'Spent a delightful week end at Robin Darwin's, at Syon …We did as we liked – Peter [O'Malley, Joan's husband] dug in the

Joan Warburton: pastel drawing looking towards Richmond from the Pavilion, 1953.

garden, Twig [their son] played for hours on the muddy shore of the river. I did a lot of pastel drawings outside and indoors. From the circular drawing room French windows you look out right on to the river which straight ahead goes up to Richmond and to the right branches…as Isleworth creek. A brick terrace is the only barrier to the river. In the evenings fish would rise and leap right out of the water every minute…Pleasure boats go constantly past and a loud-speakered voice calls out "the little pink house on your right is where Anne Boleyn left by boat to be beheaded".

Darwin took great pleasure in renovating the Pavilion's interior, and began to work on the fairly large garden too. A plant list and planting plans still exist, generated by James Russell who had been one of Darwin's pupils in the Drawing Schools at Eton and had won a prize for botanical drawing; he was now in charge of garden design at Sunningdale Nurseries. While Darwin adored the house and its surroundings, he may have felt isolated there, the Pavilion being several miles away from the College and from social life in general. It seemed he had to work at persuading his friends to visit. Weekends were fine, but it was lonely going home in the evenings until the arrival of a significant newcomer who would completely change the pattern of Darwin's domestic life.

Elena Maineri, born in 1925, came from an aristocratic and cultured background in Venice. Early in the 1950's she moved to London to take up a position as *au pair* for the family of Eric Newton, art critic of the *Manchester Guardian*, and his fashion historian wife Stella. Although the girl in Darwin's 1949 painting 'Et in Arcadia Ego' (exhibited that year in the Royal Academy Summer Exhibition, where *The Times* saw it as a 'large and most carefully planned design') strongly resembles a young Elena, it seems that the muse in the painting uncannily pre-empted her. Through the Newtons and their circle, Darwin met Elena and her one-year-old daughter Pepita (born in London after an earlier relationship) in 1954 and was immediately charmed by this beautiful, highly-educated Venetian and her entrancing little girl.

Although Elena's family background was sophisticated and worldly, it had not been happy. Her Genoese father, colonel in the élite *Alpini* mountain corps, was an impulsive gambler and though Elena undoubtedly loved him he was unpredictable and sometimes violent. Even more devastating, her mother eventually committed suicide.

Escaping to London, Elena must have found respite in the Newtons' welcoming family while enjoying the stimulation offered by the artistic and cultural atmosphere surrounding the household. Through them and via the Italian embassy in London, she found herself amongst visiting European intelligentsia as well as British Italophiles, and her ability to communicate in five languages was a natural advantage. Always keen to further her education,

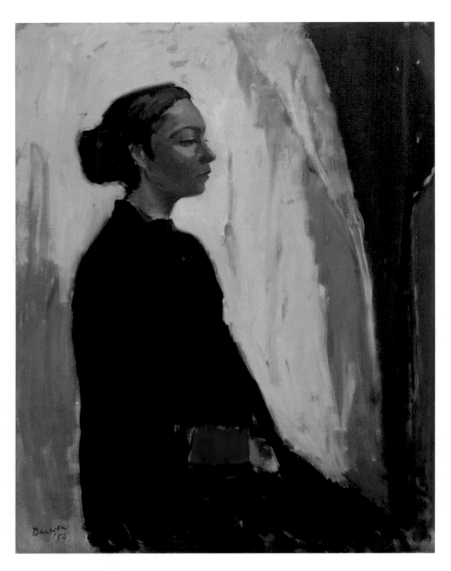

Robin Darwin: *Elena*, c.1954. One of Darwin's most emotionally-charged portraits.

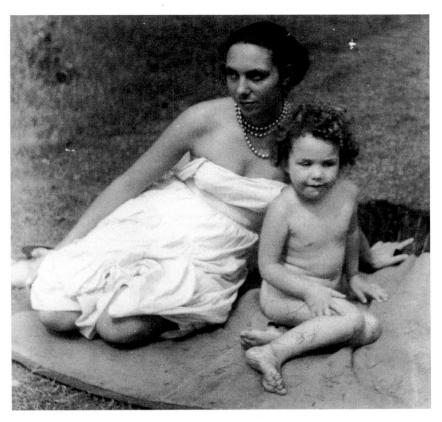

Elena and Pepita, c.1956, photograph by Robin Darwin.

she applied herself to study and, amongst other subjects, developed a substantial knowledge of Dante.

Darwin was enthralled, and he made sure that he and Elena began to see each other more frequently. For her, the evident stability of an influential, entertaining and generous older man, with his romantic Italianate house on the river, must have been an attractive idea. A relationship developed, and eventually Elena decided to leave her home with the Newtons and she and Pepita moved into the Pavilion, where the two of them took over the second wing which almost seemed to have been reserved for them. Philip Trevelyan remembers the arrival of Elena at Syon as a momentous event for Darwin; she was always 'full of gaiety and life', and Darwin was enchanted by her and Pepita, whom he treated as his own small daughter. Weekend guests always enjoyed seeing them as a family at Syon: everyone adored Pepita and Elena, in addition to her academic interests, was a wonderful cook. Darwin, overjoyed, had achieved what he had craved for

On the balcony at Syon, c.1956, photograph by Robin Darwin.

so long - a mother and child in a stylish and comfortable home, to welcome him back after long days at work.

In the summer of 1956 Darwin, Elena and Pepita joined Robert Buhler and his family on holiday in Spain. It appears that while they were there, something occurred which was to fundamentally change the relationship. The most likely supposition is that Darwin proposed marriage and that Elena, wanting to maintain her independence and imagining a future where she might be anchored unwillingly to a certain way of life, refused him; whatever took place, the partnership underwent a drastic change and things started to become less stable and much less comfortable. In October 1956 Joan Warburton's diary records a birthday celebration at Syon for Elena, after which Darwin, obviously still desperately in love with her, drove them all to London so that she and Pepita could go 'back to Regent's Park' where they appear to have been staying with friends. Elena, keen to get away from Darwin, had begun to create a new life and in order to make money, had taken on paid work – she began giving evening classes in Italian literature and language (she later became a lecturer at the University of London), and from time to time posed as a clothed life-model for drawing classes at the RCA. In January 1957, while still officially living at

Syon, she met Jonathan Kingdon, a painting student who had previously studied at the Ruskin School in Oxford and had been persuaded by the staff there (who included Rodrigo Moynihan and John Minton) to apply for the College, where his tutor happened to be Robert Buhler.

The ever-welcoming Casson family, understanding the predicament for both Darwin and Elena, offered her refuge at their house in Victoria Road, Kensington, where she and Pepita (whom the girls thought was adorable) stayed for almost two years until they moved to a flat in South Kensington. By then, Kingdon and Elena were a couple, and when he eventually decided to return to Uganda, where he had spent his childhood, they married and settled in Africa to begin a new life. They started a family and eventually produced four brothers and sisters for Pepita. Elena became a competent artist and produced many vibrant, almost *fauve* drawings in pastel of African wildlife and natural history.

By all accounts Elena really was the love of Darwin's life. For a while it must have seemed to him that his prayers had been answered, and for a few years the balance between his leadership of the College, and family life at Syon, must have been perfection for him. There is no record of the devastation he must have felt at Elena's leaving (he continued to see her on his frequent visits to the Cassons'), but the palpable passion shown in his portraits of her makes it clear what an extremely special part of his life she was.

There was, however, one consolation. In spite of the crushing blow Darwin must have suffered, a mutual respect, largely engendered by a common adoration of Elena, began to grow between Kingdon and himself. In 1962 Darwin was invited to Makerere University, Uganda, to be external assessor in Kingdon's department there. He stayed with the family (Elena by then was pregnant with their second son) and came home feeling reassured that everything was progressing well for her and for Pepita, whom he would continue to remember with enormous affection for the rest of his days.

In spite of this great loss in Darwin's life, and probably to help ease the pain, he continued to entertain his close friends (at this point his support system) at the Pavilion. As well as the Casson family, other weekend guests included the Ironsides and their small daughter Virginia. Christopher was by then teaching life drawing to painting and sculpture students at the College. His wife Janey, already on the staff due to Darwin's efforts and an 'old friend'[8] of many staff, had been Madge Garland's deputy in the School of Fashion. Madge, although offered a further 5-year contract by Darwin, resigned in 1956 'because of advancing age and declining health'.[9] It was a difficult decision to take as she and Darwin had an affectionate relationship; she had adored her years at the College, and she was the first of the 1948 cohort to leave. On her resignation Janey was offered the job of Professor. This appointment was at the very start of a period which

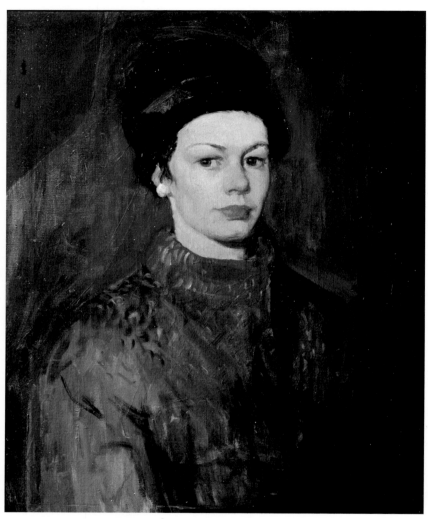

Christopher Ironside: *Janey Ironside*, 1957.

would change the face of the already unrecognizable College. The early 1950s 'kitchen sink' style had lightened up, revealing a brighter world of American-inspired abstract impressionism which would develop into the Pop movement. The design schools, having looked at what was happening in Scandinavia and Europe, collectively began to create a special and unique English *zeitgeist* which over the next few years the world would try to imitate. When the exacting Madge Garland was Professor she was determined to give fashion designers (too often misjudged as intellectually lightweight) an education which would provide them with the same status as designers in other disciplines. Her academic legacy, encouraging students to write essays and to discuss their work in other departments (the painting students, quite bizarrely and probably reluctantly, attended Friday afternoon tea-parties in Fashion) was immediately thrown out by Janey who believed that the talent of a strong fashion student would not be enhanced by attending lectures in cultural studies. She instantly established important liaisons with the fashion industry and the national press who, always on the lookout for a good story, began to promote the school and follow its every move. Everything the Fashion School did was influential. These external links pleased Darwin, who had always encouraged his staff to make sure that there were frequent exhibitions of student work and who now saw that the publicity was the perfect form of PR for the college.

Incidentally, Darwin's encouragement of youthful enterprise went further than the support he put into his school. In 1958 there were no London galleries which would accept the work of young unknown artists, making it extremely difficult for college graduates to find exhibition space. Darwin had met the resourceful Madeleine Grand at a fancy-dress ball, and she approached him for advice in starting up a concern which would give talented painters and sculptors a central London showcase. Darwin approved of the idea and suggested a support panel led by himself with John Rothenstein, Kenneth Clark, Colin Anderson and William Coldstream, all of whom except the latter agreed to be involved. Darwin offered to be trustee. With this illustrious group behind her, Madeleine found backing from clothing manufacturer Michael Lewis and acquired premises in Sloane Street for an annual rent of £350. Darwin arranged for the invitation to the Grand Opening to be designed at the College. The first exhibition was a mixed show, much of its novelty and excitement emanating from work by RCA graduates and staff. The gallery, appropriately christened the New Art Centre, was a huge success and remained so for many decades, and Madeleine, with her position at the cutting edge of modern British art, became a long-standing member of the College council.

By the late 1950s the College was energetically fulfilling its promise of a new reputation – the most exciting school of art in the world, the place where

Peter Blake: *Children Reading (Comics)*, 1955.

everyone wanted to be. Darwin had been thrilled to receive the honour of CBE in 1954 for his groundbreaking educational reforms. The staff, 'so busy learning for themselves that the students couldn't avoid picking up some knowledge by the wayside'[10] were happy with their freedom, their renewable contracts, their pay and their very good pension plans. The students were excited to be there, and the dynamics they created had a tonic effect on London and the world. Peter Blake's prophetic 'pop' pieces created while a student in the early 1950s, contrasting with the darker, less optimistic canvases of fellow students such as Frank Auerbach and Leon Kossoff, had pre-empted the colourful explosion of art by Robyn Denny, Ron Kitaj, David Hockney and Allen Jones, which was to ignite all the design disciplines. Students and staff were fulfilling Darwin's vision of making the College the source for the best in industrial design, and procuring highly prestigious commissions in many disciplines, including substantial commissions for interiors of both Orient and Cunard line cruise ships. Graduates such as David Mellor and Robert Welch were changing the face of modern metalware, and the architect of the new Coventry Cathedral, Basil Spence, followed Hugh Casson's Festival example by calling on College talent: in this case, commissioning the stained-glass department to create ten massive windows for the nave. The ingenious work of students like Alan Fletcher interpreted the moment in a way that would have an enormous influence on British graphic design, in turn affecting visual creativity in Europe and, full-circle, in America whose colourful graphic culture had been the original inspiration for Pop. The College was leading a worldwide design revolution. Its gracious South Kensington mansions suddenly seemed too fragmented, too cramped and much too genteel. The spirit of the 1960s was approaching, and things were about to change.

Student design for one of the 10 nave windows of Coventry Cathedral.

10: KENSINGTON GORE

B Y THE END OF THE 1950s and the first decade of Darwin's leadership, the College was really on the map. Darwin's directional thinking and reorganisation had put in place many of the systems that would become common practice in Britain's schools of art, having therefore created a template for art education which in many respects survives today. The students were producing work which would influence the world, and going on to take up prestigious jobs or to set up their own companies in the optimistic and opportunistic atmosphere of the early 1960s.

Although Darwin was often seen by staff and students as a terrifying bully, his frequent aggressive moments were often unintentional and nearly always because he desperately wanted the best for the College. He had an unerring sense of what would work, and went to all lengths to achieve this; he was immensely determined and confident in his beliefs, although very occasionally he would concede if someone managed to convince him of a better way. He was a natural leader and his enormous pride in the College influenced everyone. A series of letters written to the editor of *The Times* throughout the 1950s and 60s shows his passionate support for the students and the world they were about to enter – complaints about the inadequacy of student grants, dismay at talk of the closing of Oxford University's Ruskin School of Drawing and Fine Art, disgust at the suggestion of art gallery charges. Darwin's diffidence with the students

RCA students, c.1960.

Ruskin Spear's sketch for his portrait of Robin Darwin, 1961.

had grown into a fondness for them, even if they were irreverent: by then he felt that they were his 'family' and although he still had limited contact with them, he was as unshakeably loyal to them as he was to his staff. The latter in turn began to understand his nature, to realise that though impatient and quick to anger he was secretly a kind, caring man and would often be full of remorse immediately after his outbursts. They admired his skill in chairing the many important academic meetings; he was a magnetic speaker and a tactician with a knack for getting to the point of difficult arguments. Although he knew when to throw a tantrum, he also had the ability to defuse a difficult situation. If there was disagreement and deadlock, Darwin's decision if not tactful was final, and he was almost always instinctively right. Darwin's compassionate attitude to his staff is illustrated in an exchange[1] with Julian Trevelyan (divorced since 1949 from Ursula who had left him for the sculptor Norman Mommens, and happily remarried, with Ursula's strong approval, to Mary Fedden). Trevelyan, after a

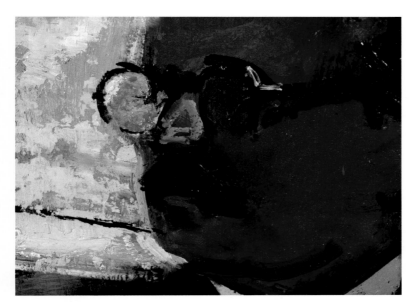

Ruskin Spear, detail from *Sir Robin Darwin*, 1961, oil on board.

serious operation for throat cancer, wrote a letter to announce his resignation, on receipt of which Darwin tried to persuade him to rethink and 'leave things in suspension' until the end of the following academic year. He offered Trevelyan a small studio where he could see 'a few students whom you especially like' and also the use of the Department's equipment, although no commitments could be put in place until decisions were made on 'space… available to us one day in 21 Cromwell Road'; the school of Fine Art was still based in Exhibition Road. Darwin then wrote to Mary Fedden about this idea, suggesting that if Trevelyan felt 'jealous' about her continuing as a painting tutor, her College job could also be held open in a similar way. However, another letter dated 10 February 1964 sadly accepts Trevelyan's resignation, but suggests that he will still be able to continue his connection with the College: 'In all the years I have been here I have not found anyone who is such a born teacher and can inspire students so well.'

In addition to showing such concern and respect for Ursula's first husband, Darwin also gave great encouragement to her second. He recognised and encouraged Norman Mommens' talent as a ceramicist, arranging a London exhibition for him and inviting him and Ursula (their home was in Sussex) to RCA parties where, appealing to Darwin's love of the theatrical, Mommens' extraordinary skill as a mime artist would amuse and delight guests in the Senior Common Room.

One of the surprising contrasts in Darwin's character was its odd mixture of conservative views with an often liberal sensibility, reinforcing this unusual case of establishment supporting the artist. This, along with his fierce loyalty, was shown strongly in an episode concerning David Queensberry, who had succeeded Robert Baker as professor of Ceramics. In the early 1960s Queensberry, realising British ceramics were not keeping up with modern developments, began to forge links with such progressive European companies as Rosenthal. At this time he was offered an exclusive position as consultant to Wedgwood (then under the direction of Sir Arthur Brown) and, when he declined this, Brown wrote to Darwin declaring that Queensberry was 'unsuitable' as a professor because he was 'working for foreign powers'. Darwin, incandescent, 'went for Sir Arthur like a savage boxer'[2] showing both his belief in his staff and his extreme disapproval of Brown's despicable attitude. A vicious correspondence ensued, with Darwin's cutting and eloquent barrage naturally having the last word.

In spite of his being a 'marvellous administrator'[3] and an accomplished writer, he relied on his Registrar, John Moon, to back up everything he did. Their relationship was 'like a good marriage which had rows'[4] – in his high-handed manner, Darwin would blast through the committee meetings, steamrollering everyone into agreement, and John Moon (the target for much of Darwin's shouting) would calmly smooth the way and tidy up after him. He was a vital antidote to Darwin's volatility and his dedication to his job, not an easy one, really made it possible for Darwin to run the College as he wished. The staff worried about John Moon; after a devastating wartime experience as a prisoner, the college had become his life (in this, he and Darwin understood one another perfectly), and when he became seriously ill many may have wondered if the stress of his job could, in addition to his previous sufferings, have contributed to his decline. His practical and often droll responses to the many queries, outrageous or otherwise, in the Senior Common Room suggestion books sum up his quiet, sensible and positive nature.

The revolutionary administrative measures that Darwin had put in place were working well. His professors were happy with their contracts and their freedom to continue their own work, this being an important factor in their dedication to their posts; there was little competition for their jobs from outside, as the College would have proved too demanding for most professionals (a fact that has been illustrated several times in more recent years). This solid, 'iconoclastic and unconventional group'[5] gathered around Darwin, sharing an objective and creating a radical yet practical environment to support his visionary ideas. The students, not only thrilled to be there, were being cared for in terms of welfare, with facilities for accommodation and medical services, and in 'the peculiar spirit of the early 60s'[6] the tutors treated them as equals. Schools

Pages from the SCR suggestions book.

Darwin in the SCR, simultaneously negotiating an oyster and a cigarette

such as Ceramics and Glass, which may have floundered a little in the first years of the College's rebirth, found new life. Industrial Design, hitherto covered to some extent by the other design schools, finally became a technically-based subject in its own right in 1959 under the charismatic Professor Misha Black, whose Design Research Unit (DRU) was the first British professional design group. Graphic Design, rechristened by Dick Guyatt, flourished under his belief that what design students needed was technique to uphold their ideas, growing into the biggest and, by its nature, most broadly influential school.

Darwin, realising that many students had little academic background in cultural studies, had from the beginning wanted the College to become a place of 'higher learning', and to this end had asked Basil Taylor to run the course of first-year lectures which developed in the Second Year into a series of special studies. High-calibre speakers – Isaiah Berlin, Julian Huxley, Iris Murdoch, Anthony Powell and others– were brought to the V&A lecture theatre, and students were expected to write one essay a month with a formal submission at

the end of the year. After the rather unpredictable Taylor left early in the 1960s, depressed at the lack of student interest in the programme (perhaps there were other attractions on a Friday afternoon) to become the first director of the Paul Mellon Foundation, Darwin again recruited his cousin Christopher Cornford (perpetuating the theme of 'keeping it in the family' where he could) to replace Taylor. Cornford proved a maverick choice, with his anarchic agenda and liberal point of view, so General Studies, if less traditionally academic, became perhaps more diverse and interesting to the students of the 1960s. One of its regular lecturers was Dicky Chopping, well-known for his meticulous *James Bond* book-jackets, who was already teaching Textiles students to draw from nature (having first been employed in Ceramics until Queensberry decided that dainty floral-patterned china was no longer appropriate): with his outrageous charm and flamboyant character he always managed to fill the lecture hall, and as queen of the JCR parties (particularly for the annual 'Miss RCA' competition) his drag appearances became legendary. Darwin, never quite sure how to deal with him, treated him with wary amusement. They communicated in a 'unique kind of verbal sparring'[7] and enjoyed winding each other up. When Joy Law took over Dicky's place on the SCR Committee, Darwin commented 'We always have a woman on this committee so we'd better have a proper one this time!'

The new General Studies lectures were not popular with all of the students. The story of David Hockney and his diploma has become art-school legend. Hockney entered the College in 1959, and decided early in his first year that 'too many lectures'[8] in General Studies were preventing him from doing what he was there for – painting. He stopped attending lectures in order to work in the studio, and when it came to his final examination in 1962, he rushed off a sketchy thesis on Fauvism which resulted in a failure in General Studies. This meant he would not be eligible for a College Diploma. In spite of this the College, unable to ignore him and recognising his talent, decided to award him a special Gold Medal for his exceptional work. In a famous 'up yours' gesture Hockney duly arrived at Convocation freshly bleached blonde, in a gold lamé jacket and brandishing his own now priceless home-made diploma.

The College's own private press was started up by Dick Guyatt in 1953. The Lion and Unicorn Press was a non-profit, self-financing venture suggested by Darwin. Its original aim was to give graphics students a practical training in book production, 'assigning a student to design each of the books published and to see it through production in the College's own printing and binding workshops'[9]. Initially it produced limited editions of 200 copies for a series of three books, selling by private subscription for 5 guineas (£5.5s), increasing in 1961 to an edition of 400 selling for 7 guineas. The hope was that these pilot editions would reach a wider public by being reissued by established publishers,

Peter Blake: *Portrait of Richard Guyatt 1981*, mixed media on board.

and to some extent this worked in its early days. Joy Law, who joined the College in 1963 as Publications and Exhibitions Manager, took over the publications side of the operation. For the students it was very exciting to be designing books in collaboration with the best illustrators of the time, often college staff or graduates (John Piper, David Gentleman, Paul Hogarth, David Hockney amongst them) and the Press continued as a teaching facility for several years before its closure, which eventually took place as a result of the departure of Joy Law. Its crowning glory (although a creation in which the students were not involved) was the majestic 'Captain Cook's Florilegium', a close collaboration with the Natural History Museum, on which work began in 1961; it was finally published in 1973.

The regular student magazine, *ARK*, was quite a different operation. Produced and edited entirely by the students, it started in 1951 with three issues per year and its vibrant influence grew with the development of the College. By 1954 its circulation was 3,000 and according to Darwin there was hardly a college or designer worldwide without a subscription to it. Its repute grew, and in the early to mid-1960s it became the eagerly-awaited indicator of everything

ARK autumn 1962 – a radical change from the neo-Victoriana of the 1952 issue.

Queen, June 1967, cover by student Rod Springett. The issue was entirely edited by RCA students and staff.

Mid-1960's illustration for The Sunday Times by RCA student Michael Foreman, of Britain's most influential people. Robin Darwin middle right as Batman.

that was happening in art and design in London, which by then was officially 'swinging'. It was to keep going for 25 years, until finally a lack of enthusiasm and a very different student atmosphere put an end to it.

The importance of the College in the cultural atmosphere of 1960's London was underlined by major press appearances. A substantial fully-illustrated article in *Tatler*, January 1959, praises ten years of Robin Darwin's 'reforming rule'. *Queen* magazine (under future rector Jocelyn Stevens) gave over a complete issue, cover and all, to the students and staff in June 1967, while the entire 1969-70 issue of the highly-respected international journal *Graphis* was dedicated to the graphic design department. The College and its students were a magnet to the media, and it was several times used as a location or backdrop. In 1968 Mike Sarne's film 'Joanna' had several scenes filmed in the coolest location in London, the Royal College of Art studios. Darwin's conservative-sounding 'reforming rule' had led the College into a personification of the state of the art.

The school of Film and Television, according to Reta Casson, began in the Graphics department with students wanting to use animation in their work. Dick Guyatt had fought hard to start a course in photography, and this developed into film with the students' growing interest in moving image. The Film School's early accommodation was in the Queen's Gate shed vacated long before when the JCR had made its reluctant transfer to Cromwell Road: in fact, one of the first films to be made at the College was a student production about the move. Darwin was always wary of the department and its staff – his snobbish insecurity in an unknown world led him to believe that film people were 'vulgar', but he had enough trust in the idea to cajole his government friends into granting Treasury money for it, therefore bypassing the College Council who were unsure about the proposal. The Department of Film and Television was opened in 1962. Darwin became staunchly supportive of the Film School's output, alerting its students in the same way as he had in other departments, to the dangers of the commercial world. One graduate, later making a documentary for television, remembers his fierce advice that TV executives must never be allowed to 'dilute' the nature of a serious production in order to transform it into light entertainment. Virtually every student left the college to go on and make an impression; '…very few of us left without achieving things.'[10]

With new departments and fast-expanding student numbers, the College had become too big for its elegant but motley premises. Most of the design schools were now in Prince Consort Road, although Interior Design had moved (losing its proximity to Furniture and Textiles, to which it was so closely related) to Cromwell Road, and Painting was still next to the V&A with Graphic Design. Sculpture and Film were now in the Queen's Gate huts. Although a new building had been under discussion since Darwin's arrival, a

site and the means of funding it had never been confirmed. Darwin's deputy was the mild-mannered Robert Goodden, his shy formality the perfect foil to Darwin's bluster; during the first half of the 1950s Goodden, an architect by training, had applied himself to a study in each department of what was needed in a school relating so closely to industry. This schedule of accommodation was converted by him and Darwin into a brief for a new purpose-built school where professional equipment and technicians would be situated next to studio space, anticipating the college's needs over the next twenty-five years. The fact that the Imperial College of Science and Technology wanted the return of the Prince Consort Road building for its imminent restructure acted as an impetus for the Government to finally allow the RCA to use the site next to the Royal Albert Hall, 'set aside by the Ministry of Works' in 1949, for its new building, which would house 'all the departments of industrial design and the administrative offices of the College'. Fine Art and Graphics had to wait until a second part of the site, towards Queens Gate, had become available much later. The run-down terrace of beautiful Regency houses along Kensington Gore, used up till then as student accommodation, was (unbelievably today) given a demolition order along with the mews behind it, and design began on the College's new home.

Darwin, after considering various outside architects, chose Hugh Casson as main consultant for the new building. Not wanting to overload his practice, Casson selected visiting tutor and South Bank architect, the resolutely modernist H T 'Jim' Cadbury-Brown to create the design. (There was no thought in 1956 of a competition for the design – Darwin, as usual, used his network and his personal convictions to deal with the project; and anyway, if the College could not design its own premises, who could?) The strictures of site and budget, as well as the brief, made it a challenge. The budget was small, the figure allowed by the Ministry of Education for construction being so low (less than £500,000) it would only permit 'a building of uncompromising austerity…hardly worthy of…site or standards which it is the College's duty to uphold'. Casson, who could not help dashing off some preliminary sketches, was interested more in the appearance while Cadbury-Brown's main concern was function, and together with Goodden they developed a plan for a 'sort of building'[11] where services were of prime importance – different heights for different purposes, higher ceilings on alternating floors (created by dividing and dropping the floor-slab every alternate storey) where industrial machinery was required, with the resulting lower height for adjoining design studios. One of Casson and Goodden's aims was to get internal cross-fertilisation, with students passing through other design disciplines to arrive at their own studios. Immediately facing large cuts in the already-minimal budget, Darwin procured a generous grant of £75,000 from the Gulbenkian Foundation in order to include designs for an exhibition hall,

Bill Culbert: *Kensington Gore 1961*, oil on plywood. The Regency terrace behind a demolition hoarding, with the Albert Hall in the background.

Kensington Gore under demolition.

library and common-room block which would soften the necessary austerity of the main building. These would be built on the southern part of the site which at that point housed a small working garage, and two ancient plane trees which unlike the Regency terrace were not condemned to demolition.

The design was evolved and the plans finally accepted early in 1958. The building committee consisted of Robin Darwin, the Registrar John Moon, the College's Bursar Wilfred Tatham, the quantity surveyor and the three architects. Although there was only two years' difference in their ages, Darwin treated Cadbury-Brown 'like a schoolmaster with a sixth-form pupil', and he never really felt he was 'in' with Darwin until he received a birthday telegram from Rome, prompted by Darwin's reading the notice in *The Times* while travelling. Although Cadbury-Brown saw Darwin as a bully, he found it was possible to withstand his aggression by not giving in. He recalls that meetings would often take place after lunch, when Darwin appeared to go to sleep but would miraculously wake up at crucial points in the discussion – '...as I was saying before Jim so rudely interrupted...'

In Cadbury-Brown's opinion, the only example up till then of 'RCA architecture', Goodden and Russell's Lion and Unicorn Pavilion, had been 'charming but not brave new world' – the College needed a strong, modern image and he had been brought in to toughen up the design. His admiration for Le Corbusier and also for Charles Rennie Mackintosh could be said to have given the design a kind of 'baronial modernism'. The austere charcoal-grey construction, thoughtfully designed in expensive dark engineering brick to match its sombre begrimed neighbours, began to rise through the Victoriana of Kensington Gore. Some years later, when the soot was cleaned from the Albert Hall and its neighbours, the moderately brutalist look of the 'black monolith' would stand out in unintentional contrast and antagonise the locals as much as it had when first planned. To balance the existing architecture it was similar in scale and bulk to Norman Shaw's Albert Hall Mansions, each one thus 'bookending' the elegant rotunda of the Royal Albert Hall, and its tall rectangular bays also reflected the angularity of the highly-decorated Royal College of Organists to the south, whose detailed ceramic ornamentation had been designed by RCA students in the 1870s. Cadbury-Brown felt that the College's interior should be very plain, 'to act as a background to art'[12] while the budget should be spent on studio space and workshop facilities. The ground floor accommodated a large open gallery in addition to the main administrative departments of the college, and each floor above it had purpose-designed studios and workshops, with departmental offices including enough space for each professor to continue a professional practice. The top floor of the 8-storey tower would be a double-height 'parapet', a brick-and-glass castellation (with bars across the gaps to calm

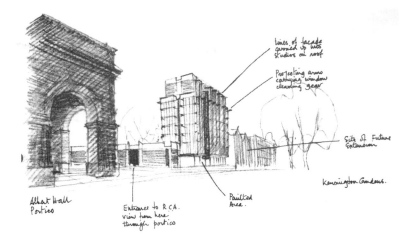

Design sketch for the RCA building by H.T.Cadbury-Brown, 1958.

Darwin's fear of heights) housing, for natural history drawing, a spacious south-facing greenhouse and aviary which had obscure glass up to seven feet high so that the sky was the only visible outside element. On the north side a large studio for the Principal (which must at the time have seemed a little galling for painting students, still annexed in Exhibition Road) overlooked the park. The frames of the gigantic top-floor windows were actually surplus ones created for Coventry Cathedral, made by Crittall Windows who supplied the RCA building's substantial quota of glass which formed most of its exterior surface. The installation of the equipment for the cleaning of this was to throw up a potentially serious technical problem, resulting in a painful and damaging court case between the College and its architects and engineers. Darwin, appearing in his usual manner to have trusted his chosen team and therefore not being totally aware of the situation until the press reported on it, was absolutely mortified; he wrote Casson two compassionate letters in order to try to calm the situation. The writ was withdrawn and eventually the uncomfortable matter was closed.

The imposing new 'monolith', albeit rising out of a muddy building site, was ready for its first cohort of students in 1962, and work began on the exhibition and lecture-hall space of the Gulbenkian wing. This, horizontal and gentler in character, formed a corner of the excavated courtyard at an oblique angle to the library, stacked next to which were the Junior and Senior Common Rooms. The Gulbenkian Hall was an airy double-height galleried space extending to the left of the main entrance to the College, with a raised stage at lower ground level; a floor was subsequently built at ground level, dividing it in two. The library and common room buildings were finally completed in 1964.

Reta Casson, now installed in the School of Interior Design on the fourth floor of what became known as the Darwin building, was asked by him to design the interior of the space which, in his view, was one of the building's most important elements, the Senior Common Room. It was situated above the students' common room and College bar, with the canteen below that, and consisted of a large formal dining room and a more relaxed seating area, separated from each other by a fairly traditional bar of which Darwin became very proud. Reta enjoyed working with Darwin, whose 'really good eye for interiors and furniture' she appreciated. The furnishings were a mixture of pieces from the Cromwell Road SCR, with modern additions commissioned from College staff and students, many of which are still in use today. The walls of the bar were clad in handmade rust-red flocked wallpaper designed by two students from Textiles and engineered to the space in huge numbered panels, giving the bar a classic dark, warm appearance contrasting with the more open spaces each side. Cadbury-Brown has remarked that Darwin, although a 'monumental establishment figure' in so many ways, was endowed with extraordinary vision. Having made frequent site visits during the construction, during which his terror of heights often necessitated him to crawl rather than walk around the higher levels, he appreciated the finished building which was perhaps a stronger, less compromising statement than he had expected. Throughout his time as Principal he always kept an eye on the departments, 'taking the lift up and walking down'.[13] He would constantly be in touch with what each school needed, listening to his staff and extracting Ministry money where possible for equipment, although no budget was available for refurbishments. On Friday afternoons he would make a habit of passing through the departments looking for trouble, mischievously asking to see absentee professors when they arrived in their offices on Monday morning.

The vertical nature of the building had one major problem – it did not, as Casson and Goodden had wished, encourage departments to mix with one another. The lifts put paid to this idea, as did the two staircases, each one looking onto some of the most beautiful views in London, both situated at some distance away from the studios. Lionel Esher, when he succeeded Darwin as Rector, was to comment 'we have a vertically segregated building where ideally we would have a horizontally divided one.'[14] But in the mid-1960s nothing, even this unintentional segregation, could inhibit or restrain the output of brilliant ideas generated in this purpose-built 'factory'. Far from it, the end-of-year shows when all the departments came together and the whole College transmuted into one energetic, exciting, gigantic gallery became (and continue to be) one of the unmissable summer destinations in London's cultural calendar.

In recognition of his services to art education, Darwin was awarded the

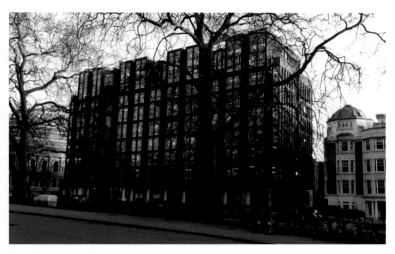
The Darwin building completed.

bicentenary medal of the Royal Society of Arts in 1962. It was a fitting tribute to his single-minded dedication in reviving the College's fortunes and his vision in the creation of a purpose-built home in which to nurture its students. But other events had also affected Darwin during the development of the new building. A letter from his father dated 18 July 1961 reveals that Darwin was admitted to a private ward in Westminster hospital with complaints which were diagnosed as diabetes – an 'accursed complaint' according to Bernard Darwin, but the fact that it was not going to affect Darwin's eyes was a great relief to everyone (the accompanying fact that Darwin was asked to moderate his consumption of whisky was, to him, less pleasing.) In a second letter a week later Bernard exclaims 'You do explode news on us with alarming bangs. I do hope you are going to be happy'. Darwin had announced the arrival in his life of an influential new friend.

Never immune to the sight of an attractive woman, during 1961 he had noticed the repeated presence in the SCR of a stylish and vivacious newcomer. Ginette Morton-Evans had been in a ten-year relationship with Leonard Rosoman, a tutor in the painting school at the College, and was consequently a frequent lunchtime visitor. Over time she had become friendly with many of the staff and was noted for her warmth and sociabiliy. Although her father, Frank Hewitt, was English, she was born and brought up by her Italian mother Adriana (Ady) *née* Pelliccioni, whose family had settled in Paris early in the 1900s; Hewitt apparently also lived in Paris before he and Ady were married. The marriage had ended immediately after the First World War. Ginette's first language was French, which was spoken at home in spite of the Italian staff, and

she had the typical education of a young French girl of her generation. This was followed by a year's education in England and then a period of study in Munich. After this, Ady, having always had many English as well as French friends, arranged for Ginette to be 'brought out' in London; as a divorced woman Ady was unable to present her daughter at Court herself. There was little to suggest Ginette was by nationality British. Darwin found himself strongly attracted to this smart, exotic cosmopolitan, got himself introduced to her by Robert Buhler, and asked if she would sit for a portrait. The portrait was never painted.

Ginette had been living in Britain since her pre-war marriage to Kenneth Morton-Evans. When she met Darwin she, her husband and their two children Michael and Angela were living amicably in Hamilton Terrace, St John's Wood, although the couple were partly leading separate lives. Darwin, having regretfully decided to tear himself away from the seclusion of Syon shortly before, had moved to 8 Redcliffe Road, Fulham, a spacious house where he had instantly reinstated himself as the perfect bachelor host, with the chance once more to make the most of London social life and to entertain his friends. Soon Ginette decided finally to leave her husband and move to Tregunter Road, just a few streets away.

Darwin married Ginette Morton-Evans in Caxton Hall on 22 November 1962. They celebrated with an evening reception at the newly-opened College, a huge party in the Gulbenkian Hall. Darwin must have felt an enormous sense of pride that he was able to bring together two of his great ambitions: at long last a glamorous new wife, and the perfect excuse to personally 'christen' the building of his dreams, the remarkable project on which he had worked for so long.

Although he had always found it easy to enjoy the company of others, at the age of fifty-two he must have found this change a lively and diverting challenge. The warm-spirited Ginette was enormously sociable and had a genius for friendship and fun. She adored company, loved entertaining and did so in the continental manner she had learned from her mother (one of the characteristics which must have drawn her to Darwin). Weekends were often spent with family and perhaps visitors at 'The Willows', the cottage in Surrey which had belonged to Ginette's mother. Darwin had always been fond of young people (though he continued to remain relatively remote from his students) and up till then his nephew Philip Trevelyan, who describes him as his 'dear dear uncle, equally mischievous, generous and opinionated as my mother', had been his nearest young relative. Ginette's children, though almost grown-up, added a new dimension, and Darwin became a close stepfather to Angela, the younger of the two, who was eighteen when he and her mother married. Later on, in 1966 when Angela was looking for work, he managed in typical style to engineer a job for her as secretary to Carel Weight in the Painting School.

Wedding photograph,
November 1962.

In 1964, Ginette decided to sell 'The Willows' and she and Darwin began to look for a weekend home to share. They found a large Victorian rectory at Ham, near Marlborough in Wiltshire and began to make a proper home together where they could enjoy their love of the country. They both enjoyed transforming the house into a comfortable and welcoming home, helped in their choice of interior décor by current Professor of Textiles Roger Nicholson. Ham became a place where they could relax away from London, where Darwin could paint and where they could invite their wide circle of friends to stay. Their relationship was developing into a positive and affectionate liaison, both of them delighting in the company of one another as well as of numerous friends. The marriage, never dull, has been described as 'sparky' – both sides enjoying a sparring-match, neither one giving in easily. They were generous hosts: the Ham visitors' book records guests almost every weekend, and more in the College vacations. Some of them liked it so much they bought property close by – Dick (in slight trepidation in case it might not be the right move) and Lizzie Guyatt became neighbours, enjoying time off and occasional holidays abroad with the Darwins. The house was frequently full of family, particularly at festive times such as Christmas when they loved to play parlour games. It delighted Darwin to become a conjurer and perform magic tricks for his audience, and there were often 'Charades' – Angela Macfarlane remembers one occasion when Darwin, dancing in beaming broadly and clutching a bottle of brandy, eventually affirmed (to nobody's surprise) that the answer was 'Blithe Spirit'.

For a change of air and surroundings, Ginette would take a house in Spain

every summer, where friends came to join the family party. Leonard Rosoman was a frequent guest, and would also often be invited to Ham. Over the following years other members of staff and friends of the College were regular visitors to Wiltshire – Roger Nicholson, Robert and Lesley Goodden, Duncan Oppenheim, Christopher and Lucy Cornford, photography tutor John Hedgecoe and his wife Julia, the de Greys, Robert Buhler, Richard Chopping, David and Alexa Queensberry. Paul Reilly, director of the Design Council, and his wife Annette were guests (she commissioned Darwin to paint Reilly's portrait) as were Ginette's old friend Nicolette Devas and her artist husband Rupert Shephard. George and Cecilia Howard, parents of one of Darwin's numerous godchildren were often there. But major changes were occupying Darwin's mind; even with the demanding social diary at weekends and the numerous commitments of work during the week, he was beginning to form a grand and ever more ambitious plan for the College.

The Old Rectory, Ham in Wiltshire, as it was when the Darwins found it.

Robin Darwin: *Valencia*, watercolour sketch, 1961.

11: TRIUMPH AND ADVERSITY

T HE NEW YEAR HONOURS LIST FOR 1964 announced Darwin's knighthood for his services to art education. He still nurtured one ultimate dream: relentless in his quest to raise the profile of his unique and world-renowned institution, his aspirations for the College were growing with its reputation, and now what he really wanted for his achievement was university status – the parity with the great universities of Oxford and Cambridge that, in his Darwinian way, he had always felt was the ultimate mark of success. The recommendations, in which he had been involved, of the 1960 Coldstream Report on art education had resulted in a huge improvement in the quality of regional art schools on the introduction of a Diploma in Art and Design, and the College was already unique in that since 1963 it had given diplomas only at Masters' level. Darwin felt that this distinction should be acknowledged by university funding for the College and he set out on a mission to achieve this upgrade.

Darwin at Buckingham Palace, with Ginette on his left and her daughter Angela on his right.

The journey began with the appointment of a committee selected from members of Council, professors and tutors in order to set up the statutes and terms of reference for the Royal Charter application. The whole process was a massive undertaking, and many of the staff, although they appreciated the idea, considered that the administrative work required by its formalities kept them away from the real reason they were there – the students. Darwin, however, took the whole business extremely seriously; he loved meetings, was a member of all the relevant educational bodies and adored the prestige and involvement of sitting on the boards of the Coldstream and Summerson academic committees. The scholarly side of the College's output (research, general studies, the Library) was the aspect most discussed, the practical side being genuinely beyond compare as its courses were already, uniquely, of totally postgraduate status. The Charter document, in its draft form, was sent to and from the office of the Privy Council over the next two years, being adjusted and readjusted. One of the issues under extended discussion was the idea of tenure in staff contracts, with which Darwin disagreed, believing that staff teaching art and design subjects should not be allowed to 'stagnate' in their jobs; another was the age of retirement, which Darwin democratically and futuristically wanted to fix at 63 for all, but which was set at 60 for women and 65 for men.

Although some of the members of the University Grants Commission could not quite understand why such a place should be awarded higher academic status, John Maud (now Lord Redcliffe-Maud) recommended the College be granted by Royal Charter the power to award degrees to all courses considered appropriately academic. But there was one stumbling-block – Fashion. Perhaps Professor Janey Ironside had unwittingly jeopardised its status when, echoing David Hockney's feelings for General Studies, she had insisted that design talent was far more important than an academic mind. This may have given just the excuse needed by the Commission and by Darwin (who described the subject as 'ephemeral') to sideline Fashion Design as flippant, lightweight frippery, in spite of the school's illustrious reputation and the genius of recent graduates who included Ossie Clark, Foale and Tuffin, Antony Price and Bill Gibb. As Hugh Casson later pointed out, 'The word 'fashion' stuck in academic gullets'.[1] Even with shocked support from eminent members of the trade, letters to *The Times* signed by the likes of Mary Quant, Geoffrey Wallis of Wallis Shops and the textile manufacturer Miki Sekers, major articles by the fashion press including Beatrix Miller, editor of *Vogue*, and a protracted effort by the Student Union, it was decided that Fashion was not worthy of degree status and that the school's students would continue simply to be awarded a diploma on completion of their studies. This discrimination may have been helped along by Darwin's need to settle an old score.

Robin Darwin: portrait of Janey Ironside, 1959.

Janey, while being a driven and inspiring professor, had a somewhat colourful reputation amongst the male staff of the College and Darwin, whose introductory 'old friend' reference to her may have been a little oblique, had been one of the numerous colleagues who had had affairs with her behind Christopher's back. Darwin had behaved abominably. First of all he betrayed his loyal friend and advisor Christopher with an account of Janey's infidelities – not forgetting to announce his own part in them. He followed this by forcing Professor Bernard Meadows (Frank Dobson's successor) to sack this popular and dedicated tutor from the Sculpture department, on the grounds that a divorce was surely imminent and the Council would not approve divorced couples on the staff of the College. Christopher, naturally, was devastated. Once Janey had left Christopher, Darwin had proposed marriage, an idea which Janey found difficult to contemplate. Insulted and hurt by her rejection, Darwin had retaliated by always being horribly rude to her in public. In addition to this verbal revenge, he also punished her by deciding that, once the Fashion School

Edward Bawden's linocut of the College crest, originally made for Expo 58, Brussels.

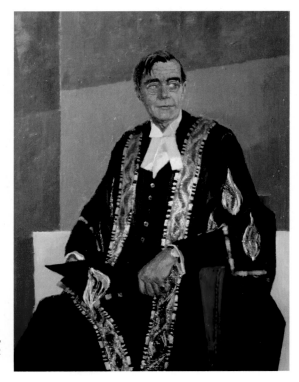

Robin Darwin: *Professor Robert Goodden*, 1967. Oil on canvas. Goodden wears his ceremonial robes, designed by textile student Joyce Conwy-Evans.

was happily installed in the new building, it should give up its space for the new School of Stained Glass The bewildered students of Fashion, the College's main source of admiring publicity, had to make a humiliating move back to Cromwell Road. It seems that exclusion from the Charter was Darwin's final act in getting his own back. The matter must have been uncomfortably divisive amongst the College's senior staff: Christopher Cornford, Robert Goodden and John Moon all understood the immense value of the Fashion School and, to Darwin's disapproval, gave Janey their backing. The students showed their disgust at the situation by reacting strongly, with David Hockney in particular demonstrating his support. A letter from the Student's Union to the Chairman of the Academic Advisory Committee sums up the general feeling: '…if once the cause of fashion or contemporaneity were to be denied, the work of the College as a whole would be swiftly impaired'. But prejudice won and Janey Ironside, broken by the whole unjust and miserable experience, handed in her resignation late in the spring term of 1967.

The Royal Charter was finally granted in August, to be conferred on November 2 1967. It was 'the apogee, Robin's top achievement'[2] and he must have been buoyed up with excitement, if slightly anxious, about the grand formal ceremony of 'Charter Day'. The organisation of the event became the major occupation for some months of Joy Law, now seconded to the post of Ceremonies Secretary, and a considerable number of senior and administrative staff. HRH Prince Philip, the Duke of Edinburgh, had agreed to be the College's official Visitor (a commitment which survives to this day), and Robin Darwin became Rector and Vice-Provost with Robert Goodden as Pro-Rector. Sir Colin Anderson, influential director of the Orient Line, was Provost. These senior officers of the College followed the College Beadle, the Chief Steward, carrying the ceremonial mace (or 'yardstick' as it became known) in a splendid procession into the Gulbenkian Hall, wearing sumptuous robes embroidered in precious metals by students in the Textiles department. They were followed by the College's first Honorary Doctors, a roll-call from the most distinguished names in 20th century art, design and media – the film-maker René Clair, sculptors Naum Gabo and Henry Moore, and designers Alex Moulton and Timo Sarpaneva. Gio Ponti was unable to attend and was honoured later. Lord Robbins, who so strongly upheld the British university system, represented the world of education. The opening fanfare was played by a guardsman on a silver trumpet designed by student Charles Hall, and the whole of this drama took place under the heraldic and watchful eyes of Edward Bawden's giant Lion and Unicorn mural from the Brussels 1958 Exhibition.

The occasion was followed the same evening by a 'soirée', where the Queen and the Queen Mother joined Prince Philip as guests of honour. Darwin had

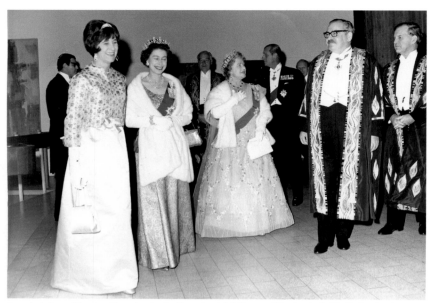

Royal visit on Charter Day: l-r Lady. Darwin, HM Queen Elizabeth II, Sir Colin Anderson, HM Queen Elizabeth the Queen Mother, HRH Prince Philip, Sir Robin Darwin, and Sir Duncan Oppenheim.

achieved his most passionate wish, for the College to be on a level with its Oxbridge counterparts – an institution of the greatest excellence, whose accomplishment would be rewarded with the highest possible honour. His handwritten notes for his Charter Day speech record his pride in his achievement: 'It is more than possible…that most academic opinion is totally unaware of the achievements of the RCA over the last 15 years or so. Apart from the 'noble' subjects of painting and sculpture in which its contributions have been recognised throughout the world as electric…those in relation to research and development in industrial design are the best index of its usefulness.' He later concluded triumphantly: 'We have made our entry into this university jungle with a style and panache unequalled by any parvenu'.[3] In his proud opinion, the College had arrived. The grand celebrations, considered by some staff and students more than a little absurd and out of character with the college's message of modernity, continued for three days, and Darwin's ultimate vision had at last become reality.

Although he had achieved his supreme ambition, the Charter had made debilitating demands on Darwin's health. Over the years he had paid little attention to his wellbeing, and it is surprising that he was rarely ill. Never inclined to exercise, he always drove wherever possible and the effects of his great love of food and, even more, drink, began to show. He had always smoked heavily

and became more reliant on cigarettes and on the frequent, comforting support of a large glass of whisky, claret or brandy, to the extent that his dependence was beginning to affect his public appearances. (Cadbury-Brown has the story of a lecture at the ICA, where Darwin, swaying gently, appeared to be speaking while asleep: Darwin insisted later it was his new pair of bi-focal glasses that was hindering him.) Burnt-out, exhausted and vulnerable, his resistance finally failed him and he succumbed to pneumonia which confined him to hospital in Bryanston Square. He was extremely ill for some time, but in true Robin Darwin style he defied the matron in order that his secretary, Rosemary Wilson, could frequently visit with college papers so he could keep on top of his work. He could not bear to be out of touch and though Rosemary kept control of the amount he saw, the fact that he felt involved must have helped his recovery.

Rosemary had worked with Darwin for five years, during which she was witness to private meetings as well as public behaviour. She saw him as a Churchillian figure, much like the BBC broadcaster Gilbert Harding in temperament and physique. He needed his secretary as he had 'no sense of organisation', and was very appreciative of the specially-cut pink slips of paper left on his office desk each evening with details of the next day's diary. The morning meetings with Robert Goodden and John Moon were 'a useful gossip shop', where Goodden's attention to detail would complement Darwin's drive and force. Rosemary appreciated Darwin's dedication to his work, but later admitted to occasionally landing him in 'some terrible predicaments…which he always turned to his advantage and enjoyed the difficult situation'.[4] Hans Juda had advised Rosemary to 'stand up to him and don't let him bully you', and although she did not often personally experience his aggression, he wrote to apologise for it (and she was a great admirer of his letter-writing style) after he retired.

Darwin looked forward to Rosemary's hospital visits, not only because he could feel that he was continuing to do his job but also because he enjoyed the company of 'a feminine and amusing woman'. She was able to fill him in on all the gossip and they could have a giggle together, although Ginette laughingly warned her 'Rosemary, you're killing him!' When he came out of hospital and eventually returned to work, he appeared a different person: very tired, with little energy, he worked shorter days but still gave the College his full attention, always on the phone, working and networking.

It must have seemed immensely unfair that hard on the heels of the Royal Charter, Darwin's ultimate and costly achievement, there came a serious problem. The timing of the Charter was portentous. Late 1967 was the last moment of relative calm before the violent upheavals of student revolt that were to take over Europe. Although the College had been painfully divided on the

issue of a degree for Fashion (and it was finally decided to grant the School the award of MDes RCA less than a year later in April 1968, with the appointment of Professor Joanne Brogden, who had been Janey Ironside's deputy) it had been relatively well-behaved over the years, with no more radical revolution than could be expected of a London art school. But against a background of worldwide social unrest and, in May, the devastating student uprising which decimated the centre of Paris, the students of Hornsey College of Art organised a six-week 'sit-in', which brought the north London college to a close. Dissent is infectious, and the College students suddenly found they had a lot to complain about.

The rumblings started in the summer vacation of 1968 and, possibly because he had been less involved than some with the College 'grapevine', took Darwin by surprise. The subjects of the complaints were varied: lack of sporting facilities (even though the Park was across the road), restrictions on student use of the Hall; more political issues such as student representation on the College's decision-making committees, the subject of fees and whether they should be waived, and the abolition of final examination grades. There were many more issues, almost giving the impression that things were being stirred up for the sake of destroying the balance. Darwin returned to College, calling members of his staff back from their holidays, and worked all summer building up a base in order that the militant attitude would not take control of the College. At the same time, he wrote a letter to *The Times* in which he highlighted his offer to accommodate up to one hundred Hornsey students for six weeks while their local authority temporarily closed the accommodation, 'in order that they can continue to work'. This act of true generosity (and clever political understanding) at such a time must have made the RCA students think, but it did not stop the revolution.

Years before, in the RCA Report and Accounts of 1959, Darwin had written an unknowingly portentous piece on student progression entitled *The Beat Generation*: '…the student of today is less easy to teach because the chips on his shoulder, which in some cases are virtually professional epaulettes, make him less ready to learn'. This report, mainly generated by discontent amongst the fine art students, had put into context the 'new' student attitude of revolt against a managerial system. Nine years later, the students leading the revolution were again, according to accounts of the time, mainly from the school of Fine Art, a double disappointment for Darwin the painter although he did admit to having been a rebel himself at the Slade. In the main part, as in 1959, the majority of design students just wanted to get on with their work (though solidarity and *zeitgeist* dictated that they had an obligation to be supportive of what was going on.) The militants' attitude was that 'all art is conflict' and therefore one must

fight. It is interesting that in the midst of all this discontent, the fine art tutors continued to use the Senior Common Room and its 'painters' table', a hierarchical symbol in the students' eyes of much that was wrong with the College. Did the painting and sculpture students feel isolated, hard-done-by at being excluded from the modern facilities and camaraderie of the Darwin building? Almost ten years before, Darwin had also prophetically written: 'It will only be by the most determined self-discipline and sense of purpose that the Fine Arts will be able to bring their vital influence to bear on the college's other activities. Under these very difficult conditions it may, indeed, be hard to combat that sense of superiority which can only too easily be nurtured by enforced isolation'; and, one suspects, by the nature of the course: a less structured timetable than that given to the designers for industry, more of the independence hitherto admired by their leader, and more time to consider dissident ideas. The General Studies department, one of Robin Darwin's dream achievements, had a certain amount to answer for. In his own words he had himself inherited a 'distinct strand of anti-intellectualism' from his father but in spite of this he had arranged to back up the students' practical education, the real reason they were at college, with an academic element. His provision for the addition of this component to the courses, in order that the students would become articulate and informed members of society, had rather backfired on him, enhancing their political and cultural awareness with the renegade support of Professor Christopher Cornford at their head. This lack of Darwin family solidarity must have added to his dismay at the situation, and, albeit brief, a student occupation of his office did more to damage his privacy and his pride. Dissent continued to fester throughout the autumn term, refuelled by the dismissal of staff at Guildford Art School, long after the Hornsey visitors had left the RCA and the students, supposedly, were back at work. Meetings and more meetings were held, rector and staff trying to find the most democratic answers for the Student Union. Darwin, not the robust character of previous years, found the whole thing upsetting and very wearing. Never having been close to the students, he could not understand how to deal with it, and was forced to admit in despair 'We have our backs to the wall'.

It was at this time that the vastly overburdened Darwin was invited to give the annual design oration to the Society of Industrial Artists and Designers (SIAD). Titled 'One and Twenty' in recognition of his years at the RCA, the main theme was the reform of the College and the future of art schools within the polytechnic system. Darwin's astute and predictive message, informed by his constant dialogue with industry, was that the educational world should wake up to the fact that 'there is breaking upon us a tremendous technical revolution which is not only going to reflect the way we design but...the number of people we need to design, and thus...the type of training provided for designers'[5]. He

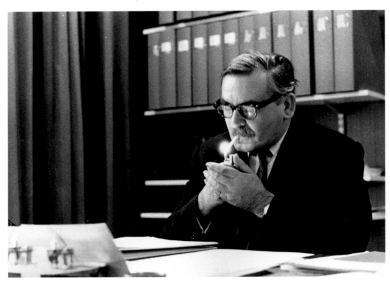

Robin Darwin in his office, photograph by Crispin Eurich.

went on to say that the Coldstream and Summerson councils, though they were the main bodies representing art education, appeared strangely unaware of this need for a radical and urgent change of attitude. His prophetic view, again accurately forecasting the future, was that the study and development of design would only be possible if underpinned by serious research which should begin at undergraduate level and become more and more specialist as the designer's skills evolved.

Perhaps this undercurrent of change was fuelling the students' unrest. Whatever was causing it, things came to a head during the spring term of 1969. The rebellious atmosphere of discontent caused frequent upheavals. The staff were desperately trying to resolve matters and the 14 February issue of the students' fortnightly *Newsheet* contained a long report written by the Rector on 'How the College works'. This gave a detailed but readable explanation of the College's administration and all its systems, from the Royal Charter and university status right through all the committees – Court, Council with its non-academic sub-committees, Senate including the JCR Committee, the Professorial Board, Faculty Boards, the external Academic Advisory Committee under the Ministry of Education, and the many relevant sub-committees. He also flagged up how staff welcomed the students' interest in administrative matters, a new direction 'which is now current', and explained how a small self-governing college takes time to address issues, not being equipped to give immediate results.

However, in spite of all these efforts, hostilities continued. A letter from Roger Nicholson, head of Textiles, mentions an 'incident during rehearsals in the Hall' with a 'quite despicable follow-up' in *Newsheet*. Evidently the JCR drama group had commissioned a previous graduate to direct a show for them – or, as seems more likely, he had talked them into it. Preparing the Gulbenkian Hall for a performance which was to be filmed for a TV channel, he had had the insolence, against authority, to remove the safety rail around the gallery and, more dramatically, the coffer-like panels which clad the ceiling. These units had contemptuously been piled up in the entrance hall, obscuring an exhibition of second year painters' work. His behaviour and that of the participating students had triggered the sudden resignation of two extremely long-standing senior stewards. Darwin, increasingly alarmed, was in constant dialogue with the representatives of the JCR; on 26 March he invited the trio (elected in place of a single president) to an informal meeting with drinks in the SCR. The staff were working night and day to try to resolve student complaints: the issue of student representation on College committees (Council and Senate) was under discussion, and Robert Goodden, having for some time been making a study of the college grading system, came up with a report which recommended that degrees should eliminate grades and be 'pass' and 'fail' only, 'pass with distinction' being awarded in deserving cases. The result was to be endorsed in April/May 1969 for the final exams that year. Darwin then found that, in addition to the students' militancy, some disloyal members of staff were fanning the flames by speaking in public at other art colleges. Enough was enough. Fatigued, overstrained and livid at the students' continuing behaviour and the staff betrayal, he agreed to talk to the students in response to a request to address four particular topics.

The JCR had made a comprehensive enquiry titled 'The RCA Redefined', which had sent a working party round each department in the College to gather student opinion and information. The overwhelming general findings were that though the students had nothing but praise for their technicians and visiting tutors, they had little confidence in the full-time teaching staff whom it seemed they rarely saw. From this enquiry, four main points were highlighted to which they demanded answers. Firstly, what was the purpose and spirit of the RCA? Secondly, was the Rector an administrator, a helmsman or a teacher; why was he so distant and what were the nature and extent of his powers? The third item was to discuss the initial purpose of the 'disciplinary committees' and the circumstances leading to the name of 'commission for enquiry into recent events'; point four was to register little confidence in the College's administration, particularly the mishandling of departmental orders and 'loss of goodwill' with suppliers. Additional issues were the expansion of the college

Admissions board for the School of Fine Art in the Gulbenkian Hall, showing the coffered ceiling.

crèche (already a unique and generous privilege) to accommodate the offspring of Imperial College students; the restructure of the Common Rooms (including the technicians' Middle Common Room), the music room and the student bar; and the meaning of 'Disciplinary Procedure'.

On the afternoon of 7 May 1969 the Gulbenkian Hall was full to bursting. Over four hundred students turned out to hear what their Rector had to say, although the quota of staff was reduced by some distinct absences. Darwin began by thanking them all for attending, and saying that in twenty-one years this was the first time he had spoken to the whole College at one time. Not one for 'harangues and lectures', he nevertheless felt that it was better to 'do things rather than to vaporise about them'. Admitting that their ideas were more modern than his ('you can't expect an old dog, nearing retirement, to change his tricks') he assured the students that he and the staff had an 'absolute respect' for their ways of doing things.

Darwin continued with a short history of the college as it was when he took over, and the radical changes he had made in order to transform it into the

post-graduate institution it now was. Answering the first point about 'purpose and spirit', he reiterated the original brief of a 'school promoting the direct application of arts to manufacture' or, in modern terms, to industrial design and technological research. This was not to forget the fine arts, which continued to be a source of inspiration to the College as a whole, in spite of the fact that there had been a move to eliminate them when he arrived as Principal. The spirit of the college lay in its independence and the way in which the departments, as well as organisations like the JCR, were run by individual teams. 'Many differences exist between them' and this variety, monitored by the Faculty Boards on which technicians and students were represented, created the College's unique identity. In Darwin's view this increased democracy while preventing dictatorship. He remembered how when he arrived he had been an 'absolute dictator', able to do virtually whatever he liked. His first act had been to set up the Faculty and Academic Boards, and a Staff/Student Committee (a revolutionary new idea in higher education) in order to limit his own power and distribute it to his heads of department, all first-rate practitioners, all there to nurture young talent for small financial return. These committees were the bodies 'from which all else will germinate' and the intention was not to engender an 'us and them' situation but rather to have open discussions which would result in democratic decision-making.

At this point Darwin cleverly suggested that perhaps it was, in fact, the **lack** of structure that was causing the current worldwide unrest – barriers may 'have to be imagined in order to justify the revolt from authority which every succeeding generation always feels.' An impassioned passage followed, in which he condemned the use in other countries and at other universities of force against the students; it was also appalling that, unlike at the College where staff were looked after in terms of contracts and pensions, contractless staff at other colleges could be 'thrown in the gutter', therefore demoralising the nature of the institution. 'This is the beastly world…Do let us try to prevent any reactions from your own actions. It is all so pointless…' He then referred to the 'despicable' recent issue of *Newsheet* in which he had been grossly insulted and remarked that, though it did little to hurt him, it would do the perpetrators no good at all in the public eye.

In answer to the second question, Darwin referred the students to the formal statutes of the Charter, highlighting that 'the Rector…is responsible for promoting and maintaining the efficiency and the good order of the College'. He added that the JCR's question was 'frankly inept' – he had not had time for twenty years to teach, and with the list of his activities on behalf of the College 'I suppose…you must call me an administrator, and a successful one'. The reason the students, and many of the staff, did not personally see him was because of

this workload: as the institution grew, 'the position of the Rector becomes more lonely and isolated'. Darwin mentioned that soon he would retire and 'see more people… and incidentally get back to my easel'. The fact that he was himself a painter and therefore more able to be objective about the situation may have escaped many of the students, some of whom, hardly considering that senior staff had other lives, had seen him purely as a remote and unapproachable figure of authority.

The third question was dealt with by Darwin's explaining at some length that any democratic society has laws and regulations to protect human dignity and to safeguard individual freedom. The committee members of the JCR had themselves opted to change the title of the 'disciplinary committee' and this wish had been respected. Darwin then briefly highlighted the two cases which had sparked the question – the first concerning the drama-group episode, which he emphasised was a JCR and not a College issue, although he stated that the College Fund Committee would generously pay for the damage to the Gulbenkian ceiling; the second case dealt with a student who had been accused of being in possession of cannabis, whose plea of 'not guilty' had been accepted. At this point Darwin chose to explain why pot-smoking in the College's leased accommodation at Evelyn Gardens was forbidden; it was against the law, and the College as a small institution would not only lose its reputation if students were guilty of disobeying – it could be closed down. The habit could also lead to hard drugs and much more devastating results. At this point certain members of the audience, dragging on home-made roll-ups, began to look shifty and embarrassed.

Sidelining the students' fourth point, which Darwin had already said he did not remotely understand, he referred to the common room, bar and music room issues with which he was already dealing. He then began the final part of his speech. He outlined the dedicated service given by the senior committees of the College, the honorary doctors, fellows and members of Council who freely offered such generous support, the technicians and the administrators, and the academic staff whom the students appeared to distrust: '…the distinction you must be prepared to understand is between those who come to a postgraduate college for two or three years and those who devote their whole working lives to it because they love it'. The greatness of the institution was surely engendered 'between this fleeting and abiding loyalty'. He went on to say that some full-time staff, distressed by the protracted 'subterranean warfare', had even talked of resigning, which would be a disastrous admission of failure.

Darwin finished with a cunning criticism of how the representatives of the JCR had not been entirely consistent in their attack on the College. It was the students' choice to have three 'consuls' at their head instead of one

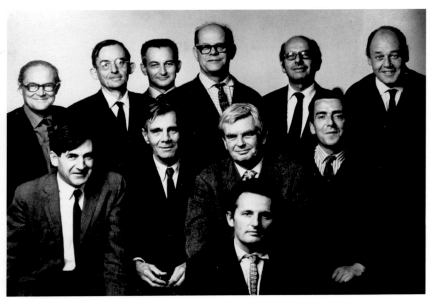

Photograph by John Hedgecoe of eleven senior members of staff, 1967. Back row, l-r: Hugh Casson, David Pye (Professor of Furniture Design), Keith Lucas (Reader in Film and Television), Carel Weight, Misha Black, Richard Guyatt. Middle row: Roger Nicholson (Professor of Textile Design), Robert Goodden, Bernard Meadows (Professor of Sculpture), Christopher Cornford. Front, David Queensberry. Janey Ironside was unable to be present.

in place of a sabbatical president, which was not sensible or efficient, causing frequent disagreement. Two examples were also given of recent undemocratic behaviour within the JCR committee, which would no doubt discourage staff from involving 'students who often seem to be volatile and unsteady' in the management of their courses.

Before closing, Darwin thanked the students and staff for attending. His parting shot was to divulge that, as it was his birthday as well as that of 'the Pro-Rector [Goodden's sixtieth], Mr. Brian Robb and, bar half an hour or so, of Professor Guyatt', they were going upstairs to split a bottle of champagne before going home 'to receive those socks and ties and other such masculine presents' from their families. In the manner of the great politician he was, Darwin had defused the debacle. The majority of students rose to their feet: cautiously they began to applaud and this, the first mass demonstration of their feelings, grew into a standing ovation under cover of which the JCR reps slunk out humiliated, their bravado and confidence badly damaged.

Exhausted by the emotion and effort of this whole episode, Darwin was however encouraged by the students' immediate reaction and by several

letters of congratulation he received afterwards. His speech was described as 'a masterpiece' and 'Churchillian', playing on every emotion and denouncing the rebel leaders. Hugh Casson sent a sketch of a nervous but determined Darwin balancing on a tightrope, underlined with 'many congratulations'. Frank Height, full-time tutor and Reader in Industrial Design, noticed that students were 'beginning to discuss the post-Darwinian period…with some apprehension'. Having involved themselves in the heat of the revolution, they were now concerned that a handful of extremists should have appeared to be representative of the College as a whole. The pendulum had swung, but only after the impotence of the JCR leaders had been exposed by the Rector's masterful speech.

On 20 May Darwin received a letter announcing the resignation of the members of the JCR committee. Evidently this met with the students' approval and there was a further and peaceful general meeting on 27 May. In the design schools at least, the students were greatly relieved to be able to settle down at last and to get on with urgent work for their Degree Shows the following month. On Darwin's part, however, although he had 'won', the extreme effort had broken his spirit, and there was no way he would ever again want to be involved in the intractable and perplexing world of student politics.

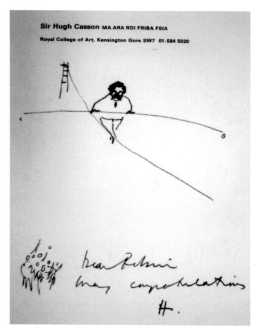

Hugh Casson's admiring impression of Darwin's balancing act.

12: FAREWELL TO THE COLLEGE

T HIS YEAR OF COLOSSAL STRAIN straight after the rigours of the Royal
Charter and the ensuing illness affected Darwin's health. The distress
at the students' behaviour and the overtime dedicated to the effort of
understanding it had really damaged his previously quite resilient constitution,
and he added to the effects by continuing to drink heavily, smoke and generally
ignore ominous signs and warnings. He had sold the flat in Redcliffe Road, and
he and Ginette now owned individual apartments on separate floors of Sloane
Avenue Mansions, where he would often get home very late after working. In
Carel Weight's words of long before, even though Darwin now had a delightful
wife and a comfortable home, he was still 'married to the College', and Ginette
found this difficult. Used to people making a fuss of her, she liked a lot of
attention and she was competing with the other great love of Darwin's life, which
had been around a long time. While they had lived at Redcliffe Road in the early
days of their marriage, life had not been easy and Ginette had felt neglected. At
one point, visiting family in France, she had found herself reluctant to return to
England at all, having become close to a male friend of her cousin's who offered
her the kindness and attention she craved. David Queensberry remembers this
period as being 'stormy – not a good example for prospective candidates of
marriage'. Darwin's drinking became more and more of an issue between them,
and Ginette served dinner early in the evening so as to 'limit the gin and tonics'.
He would then nod off, and Queensberry also recalls an occasion at Ham when
Darwin went to sleep bolt upright in his chair, cigarette ash down his front,
giving Ginette a chance to complain about him. Never allowing himself to be
entirely out of touch he woke up, berated her for being rude, and promptly
dropped off again.

It may have been at this time that they found their extravagant generosity
was leaving very little in the bank account. There appears to have been no
consideration of selling one or two of the valuable antiques they owned, such
as the Wedgwood 'Napoleon Ivy' dinner service that had belonged to Charles
Darwin, which had been in regular use at Syon but which was still boxed up
in a storage room. The wine and spirits bill must have been impressive, but
cutting down was not to be contemplated. Darwin, confiding in Dick Guyatt
that they were 'absolutely broke', admitted that he was trying to think of ways
in which they could economise. His absurd and naive conclusion was that the
only sensible way they could see of cutting down was 'to change from gold-top
milk to silver' – an economy which would of course have been barely noticeable.

Ginette and grandchild in the garden at Ham.

However, the marital relationship cannot have been helped by the stresses of this financial crisis.

Darwin's reference in his 7 May speech to the retirement of the 'old dog' was a serious consideration. He truly had given his all to the college, and the events of 1969 had so shaken his belief in the integrity of the students, for whom he had worked so resolutely, that his confidence was shattered. He began to make plans for the College's future without himself at the helm. Discussions were held with his colleagues on Council and Senate, and he spent much time consulting his oldest friends, people who would completely understand him, such as George Howard with whom he would go and stay at Castle Howard in Yorkshire so as to discuss the future. Throughout 1970 the senior staff and governing bodies of the College had numerous meetings with eminent figures from the arts elite of Britain as possible candidates for Darwin's replacement. He himself spent a great deal of time talking with the Pro-Rector in order to plan the College's immediate future, to prepare the staff for his retirement. Morale and motivation were not high, and for the first time, Darwin had to send out a message noting the unforgivably low turn-out of staff at Convocation. Early in the academic year beginning September 1970 he announced his resignation from the College.

In the first week of December, an urgent call from Ginette brought Dr

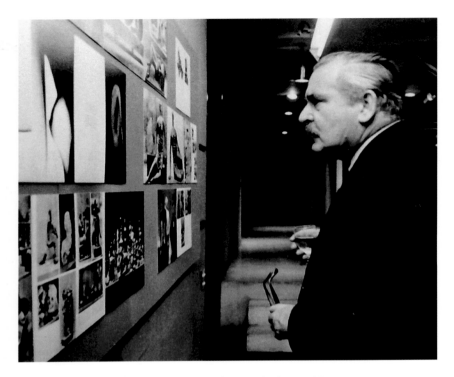

Darwin, deep in thought at an exhibition of the work of Henry Moore.

Maurice from the local surgery in Marlborough to visit Ham, where Darwin was suffering acute abdominal pain. His treatment for diabetes had continued since 1961 and added to this he, Ginette and the doctor were all aware there was considerable damage to his liver. He had been warned in 1967 but had done little about it, continuing to drink heavily as the stresses of his work increased. Dr. Maurice made several tests, reiterating the 1967 warnings. He advised Darwin that it would be prudent to visit the London consultant he had seen before, but Darwin politely refused to cooperate, confirming that as he had by now been given the same warning twice he should make a big effort for '8-10 weeks' and then see Maurice again. Darwin mentions in his letter to the doctor that 'surprising tho' it may seem, the tests for lungs, heart and diabetes were fairly reasonable for someone of my age who has…overworked for 25 years' and he goes on to say that he does not intend 'to suffer from two doctors <u>and</u> a strong-willed wife all at once!'

The 'strong-willed wife' was doing her best to be compassionate and understanding, but the fact that she had an equally strong-willed husband meant that she was not able to influence him. Although he did not admit it,

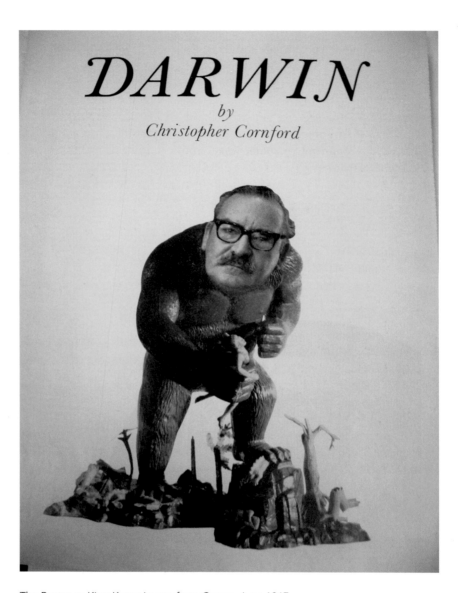

The Rector as King Kong: image from *Queen*, June 1967.

Darwin was vulnerable and probably worried that the discomfort might be caused by something more serious. Dr Maurice's diplomatic reply to Darwin's letter made no bones about the fact that he had chronic cirrhosis of the liver which could be alleviated somewhat by cutting out alcohol, but he also divulged that, occasionally, malignant change could take place in cirrhotic cells and this was the 'very likely unfounded' suspicion he had in Darwin's case. He therefore continued to recommend a second opinion from a consultant.

Darwin's response to this was again to delay the referral, saying that although the impending farewell parties which were about to begin at the College would make it 'difficult…to go on the wagon', he would do his best. Assisted by Dr Maurice's prescription he had lost seven pounds in weight and a previous skin irritation had almost gone. The diabetes, thankfully, was kept in check by daily drugs for which Darwin was grateful, as he worried that the possibility of changes in his eyesight would really affect his ability to paint. At this point in his letter, Darwin was reminded of an episode about ten years before when, in a tennis match, he had careered so hard into the net that both posts had fallen and he had ended up with 'an appalling scar', causing a hospital visit and the discovery of his diabetes. And (he added hopefully) perhaps this could have damaged his liver too…This oddly impercipient effort to divert the doctor's attention, and perhaps his own, indicates how desperately vulnerable Darwin must have felt.

True to Darwin's prediction, the farewell parties and valedictory events began. Fiona MacCarthy's article in the *Evening Standard* heralded the start of his final term with the remark that everyone had expected him to be there 'until his dying day…he seemed as much a part of the fixtures as the Ernest Race chairs in the Senior Common Room'.[1] *ARK*'s special issue, headlined 'END OF AN EVOLUTION – Rector retires!' was in a new tabloid format and written, in a gently ironic but all the same respectful tone, by 'an outsider who has no previous connection with the College' – a writer selected for a neutral point of view, in order to 'record what the College thinks of Robin Darwin'.[2] The Rector's commanding self-portrait as a young artist stares inscrutably out on the front cover, and the editorial describes how Darwin's 'democratic tyranny' has driven the College to its present success.

The general idea of the *ARK* special was to record what the College thought about Robin Darwin – 'you could scour the College from the basement at Exhibition Road to the top floor at Kensington Gore and you would be unlikely to find anyone entirely neutral'. Every member of staff, every student was prejudiced and committed - 'either to his point of view, or to fighting it by any means'. Overall, the tone of the paper was admiring, but for every positive comment there was a critical riposte. The message that came through was that however Darwin was seen by staff and, more importantly, students, it was his

19 ★ Menu ★ 71

RCA

You will eat:

Taramasalata
Blanc Fumé de Pouilly 1967

Noisettes de Veau
New Potatoes　Endives
Château Bel Orme 1962

Bouchées de Fromage

Coffee
Port

Robin Redbreast menu for a retirement dinner, summer term 1971.

extreme loyalty to the college and its purpose that was his real strength, the way he got things done. 'His dedication to the college was pathological – anyone who got in his way, or the College's, would be trampled underfoot'. The counter-message was that times had changed and the modern student, rebelling against formality, wanted a different type of leader. The centre-page spread, entitled 'Some People', may not have done a lot to calm some of the current student issues – it was a collection of staff portraits, several with spouses and children, photographed at their often large and beautiful homes. Although a mixture of formal and informal shots, it cannot have helped (and was not meant to) the students' ideas of democracy.

The leaving parties took numerous forms, all of them spectacular. Many evenings were spent at various gatherings in the SCR, all of them, as Darwin had foreseen, making it difficult for him to abstain from drink. The menu of one special dinner is fronted by a glowering robin redbreast, complete with moustache and black spectacles, the menu written on his pink breast-feathers. Another party, arranged by Roger de Grey, took the form of 'a lantern lecture presented in the Senior Common Room' in the presence of guests of honour Sir Robin and Lady Darwin. Christopher Cornford, aided by 'two girls in tutus', played a marine biologist delivering the lecture 'Your Life: the origin of a certain Species', the subject being Darwinus Darwinianus. A spoof resumé of Robin Darwin's life then followed, tracing the 'species' progress through the Slade, Fleet Street, Eton and the war, Newcastle and the 'deafeningly loud' report that got him leadership of the Royal College of Art. The finale was a poem with the closing lines:

> …it would be very hard to select a
> More astounding or more popular rector.

In a pastiche of the popular TV programme 'This is Your Life', Darwin was then presented with the elegantly bound script of 'Your Life' and Ginette, to her pleasure, with a large and extravagant bouquet.

The elegant silver covers of the programme for Darwin's last Convocation as Rector, on 9 July 1971, contain the information that he was giving up his leadership of the College for the double honour of being made an Honorary Doctor, in the company of the great French film director Jean Renoir and five other distinguished honorands, and a Senior Fellow. His twenty-three year reign was over. His dedication, determination and sheer personal drive had, with the support of a team that only his intuition knew how to choose, revived the spirit of an ailing Victorian institution and transformed it into the most prestigious school of art in the world.

An emotional salute at Darwin's final Convocation *ARK*, 9 July 1971.

13: CONCLUSION

I T IS ALWAYS VERY DIFFICULT to make a major change in life, particularly when that life has been almost completely dedicated to one cause. Amongst RCA alumni there is a theory that 'you never really leave the College' – its character is such that it continues to have a hold over the students and staff who have loved it and been part of its structure, essential elements in its unique system. Even more complicated is the act of turning away from one's own work of art, and the College was Robin Darwin's *oeuvre* which he had conceived, developed and perfected over so many years. So it is not surprising that he found himself returning over the summer after his final Convocation, ostensibly to clear out his office and his studio but truly because he was so much a part of the place he could hardly bear to let go.

Darwin asked Rosemary Wilson if she would help him go through his accumulation of office papers while he dealt with his studio equipment – canvas, paints, brushes, stacks of paper. There were boxes and boxes of photographs, his own mixed with other family ones even including some by the great Victorian photographer Julia Margaret Cameron (evidently another distant Darwin cousin). When the studio was finally clear, Darwin continued to employ Rosemary informally for 'secretarial work' but really it was because he wanted to hear all the College gossip; he could not bear the thought of things happening there without him (though he would no doubt have been very disapproving of some of the changes if they had been divulged to him). There were thoughts of an autobiography, but this never materialised.

Social life went on at Ham, visitors almost every weekend and now that Darwin was retired, sometimes in the week too. Sporadic gaps in the visitors' book show when he and Ginette went on travels of their own – France, Italy, Spain, Greece and further afield. He was delighted that now, at last, he had the perfect partner with whom to travel abroad – someone to share the excitement, who would understand his points of view and enjoy the same experiences. Adventure brought out the best in both of them. Darwin would record these trips with hundreds of photographs, possibly in order to preserve subject matter for painting although he preferred working on the spot with his easel. Since his youth he had continued to take huge pleasure in travelling, loving to escape and discover new places – years before on a College wine trip to Trier, organised by Hans Juda, his thank-you letter said 'Only once before…have I ever giggled so much or felt so carefree'. Robert Goodden later remembered him as a 'marvellous travelling companion'.

DEAR Hans
This is a thank you letter from
the Wine Committee for the
most wonderful Week End
That we as a corporate body,
or as individuals, have ever
spent.
 We arrived at Luxemburg
joyfully expectant of the
 good
 things
 to come.
 For three
 days we
 ate well;
 were well
housed; travelled in an Arcadian countryside
in golden Weather and tasted some
seventy examples of Mosel Wines, many
of such splendour & rarety that the
like of which we will never drink again.
 On the third day we left for home,
a happy and replete band of brothers,
each sharing a vinous experience
granted to few men.

Edward Ardizzone: a 'thankyou letter' from the RCA staff who, with Darwin, accompanied Hans Juda on a wine-tasting trip to Germany (mid-1950s).

It seemed that Darwin was almost back to his old physical form, and much more relaxed without the stresses of his former life. He returned to his easel, and the RA Summer Exhibition of 1971 showed a total of five of his paintings. With more time available, he enjoyed the many official committees on which he sat. He was on the Royal Mint Advisory Committee, the Arts Advisory Committee and the advisory councils of the V&A and Science Museums. His educational expertise was invaluable to the National Council for Diplomas in Art and Design, the National Advisory Committee on Art Education, and the Executive Committee for the City and Guilds of London Art School. He was latterly the President of the Royal West of England Academy, and he was also elected Royal Academician in 1972. Council meetings at the RA as well as frequent lunches with his old Academician friend Roger de Grey suggest that Darwin was being lined up to take over the post of President which would become vacant in a few years at Thomas Monnington's retirement. It would have been a fitting appointment to endorse the close ties between the Academy and the College. A letter to Rosemary, 4 February 1972, with a reference to a prospective engagement there in the following week, makes a strangely prescient comment: '...assuming I'm still alive after an RA dinner & staying chez Bobby Buhler!' He asks her to book a table in order to join him the day after that for lunch at the Café Royal grill, the happy scene of many of his earlier paintings.

The Darwins visited Morocco in March 1972, finding it spectacular but 'v.v. expensive', and a letter to Rosemary (mainly about batteries for Darwin's clock – strange at last to have time for domestic matters!) indicates that he was about to make a journey to America in April. After this a much longer trip was on the cards. One of Darwin's many official commitments was as advisor to the Pacific Area Travel Association, and the company invited him, with Ginette, to visit the

On holiday.

Making plans in Taiwan.

Far East in November for six weeks in order to paint scenes in Macau, Hong Kong, Taiwan and Thailand. The Darwins were delighted with the full VIP treatment that was supplied throughout the trip, and a letter from Hong Kong to Rosemary describes the Repulse Bay Hotel as 'the best I've ever dreamed of'. It continues: 'I don't think even Mr. Lee Trevino could hole a putt from one end to the other' of their palatial room, which served them as bedroom, drawing room and studio. They were stunned by the beauty of the country with its bays, beaches and countless islands, its abundant flora and particularly its wonderful butterflies, but shocked by the 'appalling hugger-mugger congestion of skyscrapers scrambling up the mountains' of Hong Kong itself, although this gave dramatic night-time views. Macau, on the other hand, retained Colonial elegance – 'still lovely – mostly colonnaded and 2-storey'. The weather was terrifically hot and humid, and the air-conditioning so keen that Darwin got 'flu and quite severe rheumatism down one side, which stopped him from painting. They looked forward to arriving in Taiwan, the next stop, where the climate would be more temperate.

Once in Taiwan, they found the people charming but '...obstinate and hopelessly inefficient' so that plans were altered and the Darwins returned to Hong Kong in mid-December, leaving a week later to spend Christmas in Bangkok. From there it was back to the Hong Kong Club for a glamorous New Year's Eve, and finally home to Ham in the early days of 1973. It had been an unforgettably rare, exotic and special experience, and the watercolours that Darwin produced as a result showed that his painting talents were restored.

Far East sketchbook pages, 1972.

Mountain landscape, Far East, 1972.

Pacific islands, watercolour, 1972.

Retirement work.

Relaxed, with fewer restrictions and diversions, he had begun to make experiments and to develop new techniques and approaches to the medium in which he was so competent.

A late summer holiday that year took them to the beloved Spanish house at Almunecar which Ginette had continued to rent every year from its English owner. They had so many friends there that it was an extension of home and they spent most of September there, returning to Ham in October via a short visit to Portugal. Darwin loved autumn in England, taking pleasure in the 'lovely soft and silent weather – "Tints" in all their glory'.

That winter was exceptionally cold. Ginette's daughter Angela and her family spent Christmas 1973 at Ham, which was a joy for Darwin as he took great pleasure in the company of his small step-grandchildren. Just after New Year 1974 Darwin sent Rosemary (still engaged in secretarial work for him) an excited letter: 'Off …for 2 weeks to the Indian Ocean – mercy be'. He explained that they had to go away because (as a result of the 1973 oil crisis) their 'allowance' of oil for heating and hot water, being based on last year's consumption when they were abroad for six weeks, was 25% of what they needed – 'Enough, with luck, for a bath a week…' So they had made plans to go to Mauritius, where they stayed happily until late in January.

The next excitement in Darwin's life was to be a trip to Galapagos in the footsteps of his great-grandfather. Animated discussions about it were held with Dick Guyatt, whose portrait he was painting at Ham. Darwin was delighted with

the idea of working on a series of watercolours there; he saw it as a distinguished step towards becoming President of the Royal Academy, and they talked about that possibility too, as well as Darwin's plans for a new series of portraits he wanted to paint. Guyatt thought he was 'on good form', back to his old self but less aggressive and contentedly settled in his new life.

The portrait was left unfinished and the Galapagos expedition was never to take place. Towards the end of January, Gordon Russell had seen Darwin at the College and had noticed that his voice had a tone of urgency when he said 'Don't forget to let me know next time you're coming to London'. The following week there was a convivial lunch in the Senior Common Room, followed by a meeting at Burlington House of the Council of the Royal Academy. Darwin seemed his normal self, enjoying the company of some of his oldest friends. Minutes after the meeting closed, he felt a sudden severe pain but he insisted it was not serious and persuaded Thomas Monnington to take him to Robert Buhler's house where he was to stay the night. Ginette, on her way up from Ham, was to meet him there. Monnington noted that Darwin's extraordinary fortitude helped him 'retain his true quality as long as his mind was able to control his body', but even his great spirit was unable to overcome the final attack on his hitherto indomitable system. He died in Westminster hospital that evening with Ginette at his side. The incandescent flare of his life which had lit the path of so many had finally, abruptly, been doused.

Many of the hundreds of eulogies which followed Darwin's sudden death used the metaphor of light to describe his spirit. For some who 'lived within his blaze', even those who had been burnt by it, it was impossibly sad to imagine the flame extinguished. Others saw him as a true force of nature, an inspired leader who made people look up to the stars and want to achieve greater things. Humphrey Brooke, former Secretary of the RA, remembered him in artists' terms: 'Much colour has gone out of the world for many'. He had left in as dramatic a manner as he often arrived, busy until the end and then leaving without notice. Philip Trevelyan felt that the exceptional intensity with which Darwin embraced life was almost fatalistic, making it impossible to continue; Darwin's cousin Thomas Barlow sadly reflected that it seemed barely possible that someone who had enjoyed living so much should depart so suddenly.

Dr Bayliss, Darwin's London consultant, told Ginette that the infection, officially diagnosed as bronchopneumonia, had been overwhelming and nothing more could have been done for him. In Dr Maurice's view, although he had not expected him to go on for much longer (had Darwin carefully hidden this from his wife?) it was a blessing that the illness had not been drawn-out as 'he would not have taken kindly to that'. His sister Ursula commented that he would have been intolerable as an ill man, and impossible for Ginette to deal

with; while Hugh Casson was realistic – 'He would have been a terrible invalid wouldn't he…bedclothes on fire, whisky in the medicine glass, pillows on the floor, yells for help and comfort and argument'.

Ginette, though devastated, must have been given respite and support by the many, many genuinely affectionate and admiring letters of condolence. Shocked family, close friends, official and academic colleagues, staff and students, arts and business acquaintances, former domestic employees and some who barely knew him, all wrote with heartfelt grief, love and respect for her husband and for her. His sister Niccy (now divorced, and living with Hugh Fenn, a colleague from student days) stayed away from the funeral but sent a fond memory of his tender feelings for her, the younger sister who had perhaps grown up in the shadow of two strong and devoted siblings. Edward Bawden considered his death a national loss, and Duncan Oppenheim that 'one of this country's rare personalities has gone from our midst'. On the subject of Darwin's work, Bernard Myers acknowledged that he had given it the 'deep emotional involvement that men only reserve for their most personal and private lives', always expecting his staff to do the same; Joan, wife of Edwin La Dell, remembered how Darwin 'built up the College but left the kernel - fine arts - intact…this typifies his whole attitude'. At the College, although he had retired several years before, there was a palpable feeling of sadness and respect amongst the staff. Humphrey Brooke recognised that 'he had the rare and magical touch that commands success' and that he was 'the major colossus of art education for many an epoch'. Darwin was a cornerstone who stood firm whatever else tumbled down, and on the occasions when he was wrong 'even his faults had style'.[1]

There were many letters too which acknowledged the support that Ginette had given him through their cruelly curtailed marriage. He had been a hugely challenging husband with his extreme dedication to the College, his volatile nature, and his health problems mostly caused by his own excesses. In spite of frequent differences and difficulties she had been the perfect companion for him, with her intelligent understanding of a very complex man; a vital stimulus for his creative personality especially after his retirement, and if not indulgent, a pillar in moments of need. The marriage had worked because their strong wills matched each other, making it a partnership of equals. Roger de Grey said afterwards that '…for all their ups and downs it was a relationship which really existed and Robin was a person who really filled your life'. Christopher Cornford wrote to her: 'Your goodness and warmth light up the sadness'.

A strangely inappropriate note arrived from Yvonne, who was still living at Winson Manor, which she appears to have preserved as a virtual shrine to Robin Darwin, keeping all his belongings, his piano, even his Rolls Royce unused on blocks in the garage. After opening with '[Robin] always seemed indestructible'

she could barely hide her jealousy. She could not help telling Ginette that 'I had my sorrow in two phases – the parting many years ago and now the finish – which brings memories of the happy days of our youth and quite washes away the later unhappiness'. This unnecessary statement cannot have been of much comfort to Ginette, but surprisingly she kept it amongst all the other communications she received. Yvonne's last words were 'He was not an easy man but he was indeed a great one'.

The funeral took place at the church of All Saints in the parish of Ham, Wiltshire, on Tuesday 5 February 1974. The congregation, still very much in shock at Darwin's sudden departure, was restricted to family and close friends who included all his professors and senior RCA colleagues. It was an emotional ceremony with glorious music, and in the modest village church the massive number of floral tributes must have been an overwhelming sight. One of the mourners later claimed how at the burial, at the dismal moment when the coffin was lowered into the grave, the song of a robin was heard in the yew tree above.

In the days after the funeral, Ginette did her best to divert her grief with plans for a special memorial ceremony, after which she planned to escape to Spain. Many years before, Darwin, perhaps influenced by close friends, had converted, in spite of his agnostic background, to Catholicism. He was not a regular churchgoer but would attend from time to time, appreciating the ritual and regalia of the service. His memorial was fittingly to be in Brompton Oratory, the calm of which he had so often enjoyed while quietly reflecting and listening to the wonderful choral music. On 26 February 1974 the Oratory was full to overflowing, and to the splendid background of music by Bach, Palestrina, Monteverdi and Brahms, a grand pageant took place. Robin Darwin would have been thrilled to see the procession of twelve Senior Fellows of the College resplendent in their Charter robes, followed solemnly by the clergy and the choir to the accompaniment of the magnificent music played and sung in his honour. The address was by Sir Duncan Oppenheim and the final piece of music was Bach's Organ Prelude in C Minor.

This paradoxical man, educator, awe-inspiring politician, *bon viveur*, gentleman artist and off-duty comic, left behind so much for so many. Generations of students had passed through his reforms and generations to come would be affected by them. His understanding of the educational needs of his time had brought the RCA firmly into the twentieth century and set it up for the twenty-first; his far-reaching influence still shapes the pattern of today's art and design education. His 'penetrating mind and … persistence in achieving his objects'[2], the way his love of tradition was tempered by the results of his radical and forward-looking imagination, gave the College its unique and special spirit. He was a true Taurean with his outward belligerence hiding his love for a warm

Robin Darwin: summer landscape, c.1970.

domestic environment, a real romantic whose emotional soul was often hidden by a mask of pomposity. He loved children, never being blessed with his own but enjoying the company of his young relations, his numerous godchildren, step-grandchildren and (to a certain extent) the surrogate family of students provided by the College. The contrasting aspects of his oversized character came equally from his two parents – on Eily's side the artistic ability, the fascination with ceremony and drama, and the impressive physical stature which echoed that of his maternal grandfather; and from Bernard's the pride in his provenance (at his death he was about to embark on discussions to decide the future home for the papers of Charles Darwin), the 'distinct strand of anti-intellectualism' and the combination of a sensitive inner self contradicted by spectacular outbursts – his Welsh great-grandmother's 'fine flash of indignant fire'. Forbears on both sides of the family, in particular Erasmus Darwin and Aubrey de Vere and, more immediately, his father, had contributed to his love of words and the ease with which he used them. His resolute commitment to his work was also inherited from both parents, but his extreme ambition was a characteristic of his own making, the result of an unswervingly determined spirit, and its supreme outcome was the pinnacle of his success, the Royal College of Art.

As an artist, Robin Darwin has not received sufficient acclaim. It is interesting that he himself remembered that Hogarth, who was '… perhaps of all British painters the one who delights us most with the loose and fluid handling of his

paint',[3] trained for six hard years as the apprentice to a silver engraver. Always believing in the cross-fertilisation of two disciplines, the value of great art as a background for design, it seems somewhat sad that Darwin's professional life, which he dedicated to this conviction, did not allow him to fulfil his own artistic potential. Carel Weight commented that 'he would have been great if it hadn't been for the College'. He was considered by some a conventional Sunday painter who, if he had had time, would have been an artist of note. Many knew him as a competent amateur (in the original sense of the word) whose development had been interrupted by the war and then by the demands of his profession. Curiously modest about his painting, he did not rate himself too highly, and although he would have liked to be remembered as an artist, his dedication to the College eclipsed that idea. Lord Esher, his successor at the College, wrote that he painted 'in the relaxed, unobsessed mood which has produced some of the most enjoyable British art of the last century'[4]. The tragic curtailment of his life happened just when he might at last have had time to fulfil his promise.

There are numerous epitaphs to the Darwin name, many of them in the service of education. Wychfield, the house that Francis Darwin built in Cambridge, was bought by Trinity Hall as student lodgings. The riverside residence of his brother George, Newnham Grange, became the graduate Darwin College. As a lasting tribute to the vision of its originator, the dark monolith at Kensington Gore, overlooking the great park to the north and the splendid spires and cupolas of Albertopolis to the south, overseen royally by Prince Albert's gilded presence across the road to the east, bears the name 'the Darwin Building'. Robin Darwin's resolute belief that romance was as important as reality, that students must simultaneously keep 'their feet on the ground and their heads in the clouds';[5] his undeviating dedication to his cause, and his determination to make every RCA graduate 'one of those few…on whom the rest of us depend'[6] have all been endorsed over and over again by the flow of genius generated by the College, ever since he first crossed the threshold. A demanding leader and an optimist intolerant of negativity, he listened to his colleagues' advice but always made his own decisions. On the rare occasions when his judgement of a person was faulty, he could 'hardly forgive the victim of his own mistake'[7] and for counsel he went 'nowhere but the top – and always knew his way there'[8]. He gave respectability to art education. Admiration for tradition did not prevent him from always seeking bigger and better achievements: in his own words, 'The past is always scurrying to keep up with the future, usually without success. All progress is born of divine despair, of intellectual restlessness and dissatisfaction of one kind or another'.

The splendid portrait of Darwin by Ruskin Spear, painted in 1961 and hanging today in the RCA's Senior Common Room, clearly sums up Darwin's attitude.

Cigarette in hand, he stands majestically in front of an elegant classical fireplace, facing the painting which is reflected in the mirror behind him: modernity, in the form of William Scott's semi-abstract *Reclining Nude*. Darwin's words to a young tutor, a Rector-to-be on his first day at the College, were 'Always remember that the College is about the future, and that it is also about a very distinguished past.'[9] The last sentence would seem an appropriate mantra for the students who, reaching for the stars, experienced the Darwin years at the RCA. He was a leader who wanted nothing but the best, and raised the bar to achieve it. The Royal College of Art is his great work of art, his masterpiece. No-one could have a nobler memorial.

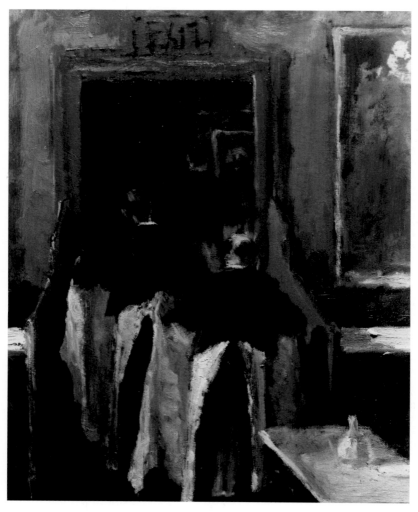
Robin Darwin: waiters in a brasserie, undated.

ENDNOTES

1: FAMILY BACKGROUND

1. Gwen Raverat, *Period Piece*, Faber and Faber London 1952.
2. Gwen Raverat, *Period Piece*, Faber and Faber London 1952.
3. Sir Francis Darwin, *The Story of a Childhood*, Edinburgh, Oliver and Boyd 1920.
4. Bernard Darwin, *Life is Sweet, Brother*, London, Collins 1940.
5. Bernard Darwin, *Life is Sweet, Brother*, London, Collins 1940.
6. Margaret Monsell, Monsell Collection ADD 9437, Cambridge University Library.
7. Mrs. Dew-Smith, *Tom Tug and Others*, London, Seeley & Co Ltd, 1898.
8. Margaret Monsell, , Monsell Collection ADD 9437, Cambridge University Library.
9. Peter Ryde *Mostly Golf: a Bernard Darwin anthology*, London, A & C Black 1976.
10. *The Times*, 22 November 1961.

2: GROWING UP

1. Bernard Darwin, *Every Idle Dream*, London, Collins 1948.
2. Bernard Darwin, *Pack Clouds Away*, London, Collins 1941.
3. Bernard Darwin, *Every Idle Dream*, London, Collins 1948.
4. Philip Trevelyan, December 2013.
5. University of Cambridge, Trinity College Library/ JOT papers 33/53-57. The Nabis were a group of avant-garde post-Impressionists who studied at the Académie Julian in the late 1880s.
6. University of Cambridge, Trinity College Library, JOT 33/27.

3: MARRIAGE AND RESPONSIBILITY

1. University of Cambridge, Trinity College Library, JOT 33/37.
2. University of Cambridge, Trinity College Library, JOT 10/39.
3. University of Cambridge, Trinity College Library, JOT 33/35-40.
4. By permission of Stephen Keynes.
5. University of Cambridge, Trinity College Library, JOT 33/43.
6. By permission of Stephen Keynes.
7. University of Cambridge, Trinity College Library, JOT 33/20.
8. University of Cambridge, Trinity College Library, 33/11(i).
9. Watford Boys' Grammar School, *The Fullerian*, Spring Term 1932.
10. University of Cambridge, Trinity College Library, JOT 33/18.
11. University of Cambridge, Trinity College Library JOT 33/17.
12. University of Cambridge, Trinity College Library, JOT 33/73.

4: ETON DAYS

1. Trinity College Library, JOT 33/13.
2. Dolmetsch – the French-born Dolmetsch family, based in Surrey, promoted the making and playing of early musical instruments.
3. R.Y.Goodden, 'Darwin, Sir Robert Vere [Robin](1910-1974)', *Oxford Dictionary of National Biography*, Oxford University Press, 2004.
4. *The Times*, July 1938.

5: WARTIME

1. Imperial War Museum 83.9(41)3.5.
2. Richard Guyatt to Angela Macfarlane, May 1994.
3. Sir Hugh Casson to Angela Macfarlane, February 1994.
4. Robin Darwin, 'The Role of Artists in Camouflage',18 February 1943. TNA/HO 186/1648.
5. TNA/HLG/83/1.
6. TNA/HLG/88/1.
7. Sir Hugh Casson to Angela Macfarlane op.cit.
8. Sir Hugh Casson, *Design* Magazine, obituary 1971.

6: THE COUNCIL OF INDUSTRIAL DESIGN

1. Council of Industrial Design, First Annual Report 1945-46, University of Brighton Design Archive/CoID Papers.

2. Nikolaus Pevsner, *Memorandum on the Position of the Designer for British Industries after the War*, University of Brighton Design Archive/CoID Papers.
3. Christopher Frayling, *The Royal College of Art, one hundred & fifty years of Art & Design*, London 1987 Barrie & Jenkins.
4. Christopher Frayling, *The Royal College of Art, one hundred & fifty years of Art & Design*, London 1987 Barrie & Jenkins.
5. Council of Industrial Design, *report on The Training of the Industrial Designer*, July 1946, University of Brighton.
6. Nikolaus Pevsner, University of Brighton.
7. Robin Darwin, paper to the RSA, 16 February 1949, University of Brighton.
8. Robin Darwin, paper to the RSA , 6 May 1949, Royal Society of Arts.
9. Robin Darwin, paper to the RSA , 6 May 1949, Royal Society of Arts.
10. CoID File 670/45-46 Education Policy, University of Brighton.
11. CoID File 479/series 7, 1945-6, University of Brighton.
12. CoID file 479/series 7, University of Brighton.
13. Nikolaus Pevsner University of Brighton.

7: NEWCASTLE, NEW CHALLENGES

1, Flavia de Grey to Angela Macfarlane, November 1995.
2. The National Archives, ED 23/941.
3. Gordon Russell, *Designer's Trade*, London 1968 George Allen and Unwin.
4. Richard Guyatt to Angela Macfarlane, May 1994.

8: SOUTH KENSINGTON

1. Robin Darwin, *The Dodo and the Phoenix*, Royal Society of Arts Journal 1954.
2. Peyton Skipwith, October 2014.
3. Robin Darwin, *The Anatomy of Design*, London, RCA 1951.
4. Miranda Carter, *Anthony Blunt – His Lives*, London, Macmillan 2001.
5. Clifford Hatts, August 2012.
6. Robin Darwin, *The Dodo and the Phoenix*, Royal Society of Arts Journal 1954.
7. P.J.Conradi, *Iris Murdoch, a Life*, London, Harper Collins 2001.
8. Clifford Hatts, August 2012.
9. Elsbeth Juda, August 2012.
10. Norman Adams to Angela Macfarlane, December 1993.
11. Carel Weight to Angela Macfarlane, May 1994.
12. Hugh Casson to Angela Macfarlane, February 1994.

9: COLLEGE LIFE

1. Margaret Casson to Angela Macfarlane, May 1994.
2. Carola Zogolovitch and Nicky Hessenburg, November 2012.
3. *The Sunday Times*, 6 February 1955.
4. Carel Weight to Angela Macfarlane May 1994.
5. Norman Adams to Angela Macfarlane, December 1993.
6. Elsbeth Juda, August 2012.
7. Elsbeth Juda, August 2012.
8. Robin Darwin, RCA Report and Accounts 1956.
9. Madge Garland to Ginette Darwin, February 1971.
10. Robin Darwin, *The Anatomy of Design*, London, RCA 1951.

10: KENSINGTON GORE

1. University of Cambridge, Trinity College Library JOT 33/3,33/4.
2. David Queensberry to Angela Macfarlane, October 1995.
3. Bernard Myers to Angela Macfarlane, May 1994.
4. Joy Law to Angela Macfarlane, February 1994.
5. H T Cadbury-Brown to Angela Macfarlane, March 1994.
6. David Queensberry to Angela Macfarlane, October 1995.
7. Richard Chopping to Ginette Darwin, February 1971.
8. Christopher Frayling, *The Royal College of Art, one hundred & fifty years of Art and Design*, Barrie and Jenkins 1987.

9. Ed. Joy Law, *The Lion and Unicorn Press, a short history and a list of publications*, Royal College of Art 1978.
10. Philip Trevelyan, March 2013.
11. H T Cadbury Brown to Angela Macfarlane, March 1994.
12. Christopher Frayling, *The Royal College of Art, one hundred & fifty years of Art and Design*, Barrie and Jenkins 1987.
13. Rosemary Wilson to Angela Macfarlane, October 1993.
14. *Design* Journal, 1972.

11: TRIUMPH AND ADVERSITY

1. Virginia Ironside, *Janey and Me*, Fourth Estate 2003.
2. Margaret Casson to Angela Macfarlane, May 1994.
3. RCA Special Collections, A2 'Darwin Papers'/A3.
4. Rosemary Wilson to Ginette Darwin, February 1971.
5. 'One and Twenty', SIAD Annual Design Oration, 25 February1969.

12: FAREWELL TO THE COLLEGE

1. Fiona MacCarthy, *Evening Standard*, 21 April 1971.
2. ARK, Journal *of the Royal College of Art*, 9 July 1971.

13: CONCLUSION

1. David Queensberry to Ginette Darwin, February 1971.
2. RSA Journal 1962-23, vol. III.
3. Council of Industrial Design,Report on *The Training of the Industrial Designer*, July 1946, University of Brighton.
4. Foreword, Lord Esher, *Robin Darwin, a memorial exhibition of paintings and water colours*, June/July 1974, RCA, London.
5. Council of Industrial Design, Report on *The Training of the Industrial Designer*, July 1946, University of Brighton.
6. Council of Industrial Design, Report on *The Training of the Industrial Designer*, July 1946, University of Brighton.
7. R.Y.Goodden, 'Darwin, Sir Robert Vere [Robin](1910-1974)', *Oxford Dictionary of National Biography*, Oxford University Press, 2004.
8. Hugh Casson, *Design*, February 1974.
9. Sir Christopher Frayling, September 2013.

SIMPLIFIED ANCESTRY

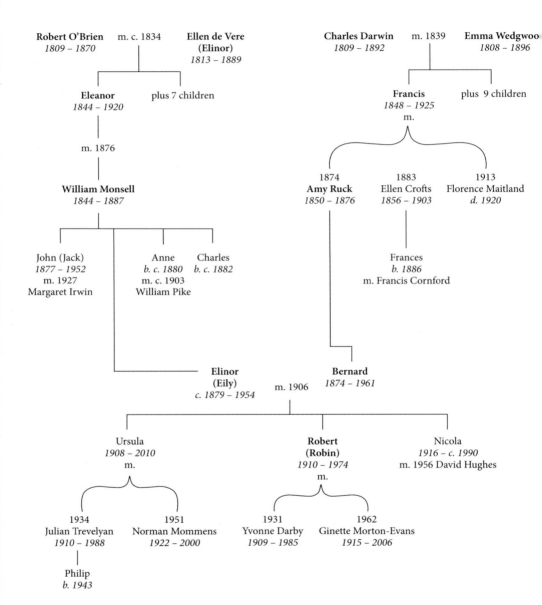

Robert O'Brien
1809 – 1870 m. c. 1834 **Ellen de Vere
(Elinor)**
1813 – 1889

Charles Darwin
1809 – 1892 m. 1839 **Emma Wedgwood**
1808 – 1896

Eleanor
1844 – 1920 plus 7 children

Francis
1848 – 1925
m.

plus 9 children

m. 1876

William Monsell
1844 – 1887

1874
Amy Ruck
1850 – 1876

1883
Ellen Crofts
1856 – 1903

1913
Florence Maitland
d. 1920

John (Jack)
1877 – 1952
m. 1927
Margaret Irwin

Anne
b. c. 1880
m. c. 1903
William Pike

Charles
b. c. 1882

Frances
b. 1886
m. Francis Cornford

**Elinor
(Eily)**
c. 1879 – 1954 m. 1906

Bernard
1874 – 1961

Ursula
1908 – 2010
m.

**Robert
(Robin)**
1910 – 1974
m.

Nicola
1916 – c. 1990
m. 1956 David Hughes

1934
Julian Trevelyan
1910 – 1988

1951
Norman Mommens
1922 – 2000

1931
Yvonne Darby
1909 – 1985

1962
Ginette Morton-Evans
1915 – 2006

Philip
b. 1943

SELECT BIBLIOGRAPHY

Wilfrid Blunt, *Slow on the Feather: further autobiography 1938-59*, Michael Russell Publishing Ltd, 1986

Miranda Carter, *Anthony Blunt, His Lives*, London, Macmillan, 2001

P.J.Conradi, *Iris Murdoch: a life*, London, Harper Collins, 2001

Mrs Dew-Smith, *Tom Tug and Others*, London, Seeley & Co Ltd, 1898

Bernard Darwin, *Life is Sweet, Brother*, London, Collins, 1940

Bernard Darwin, *Pack Clouds Away*, London, Collins, 1941

Bernard Darwin, *Every Idle Dream*, London, Collins, 1948

Sir Francis Darwin, *The Story of a Childhood*, Edinburgh, Oliver and Boyd, 1920

Christopher Frayling, *Art and Design – 100 years at the Royal College of Art*, London, Collins & Brown, 1999

Christopher Frayling, *The Royal College of Art - One Hundred & Fifty Years of Art & Design*, London, Barrie & Jenkins, 1987

Henrietta Goodden, *Camouflage and Art – design for deception in World War 2*, London, Unicorn Press, 2007

Henrietta Goodden, *The Lion and the Unicorn: Symbolic Architecture for the Festival of Britain 1951*, London, Unicorn Press, 2011

Andrew Horrall, *Bringing Art to Life – a biography of Alan Jarvis*, Montreal, Queen's University Press, 2009

Virginia Ironside, *Janey and Me*, London, Fourth Estate, 2003

John Lewis, *Such Things Happen – the life of a typographer*, Stowmarket, Unicorn Press, 1994

José Manser, *Hugh Casson: a biography*, London, Viking, 2000

José Manser, *Mary Fedden and Julian Trevelyan*, London, Unicorn Press, 2012

Gwen Raverat, *Period Piece – A Cambridge Childhood*, London, Faber and Faber, 1952

Tori Reeve, *Down House: the Home of Charles Darwin*, London, English Heritage, 2009

Paul Reilly, *An Eye on Design*, London, Max Reinhardt, 1987

Gordon Russell, *Designer's Trade*, London, George Allen & Unwin, 1968

Peter Ryde, *Mostly Golf: a Bernard Darwin anthology*, London, A & C Black, 1976

Philip Trevelyan, *Julian Trevelyan: Picture Language*, Farnham, Lund Humphries, 2013

Silvie Turner, *Julian Trevelyan: Catalogue Raisonné of Prints*, Aldershot, Scolar Press, 1998

Ed. Robin Darwin, *The Anatomy of Design: a series of Inaugural Lectures by Professors of the Royal College of Art*, London, Royal College of Art, 1951

Ed. Paul Huxley, *Exhibition Road - Painters at the Royal College of Art*, Oxford, Phaidon.Christies Ltd., 1988

Ed. Joy Law, *The Lion and Unicorn Press, a short history and a list of publications*, Royal College of Art, London 1978

Ed. Octavia Reeve, *The Perfect Place to Grow: 175 Years of the Royal College of Art, London*, Royal College of Art, 2012

Oxford Dictionary of National Biography, Oxford University Press, 2004

Who was Who Online © Oxford University Press

JOURNALS

Architectural Research Quarterly volume 10, Cambridge University Press 2006

Royal Society of Arts Journal 1954, 1963

ARK, Journal of the Royal College of Art, 9 July 1971

Graphis no.146, The Graphis Press, Zurich, 1969-1970

Design, month unknown, 1972

INDEX

References to picture captions are in italics